A RETROSPECTIVE

Ralph STEADman

Exhibition organised by the
Cartoon Museum
London

Published by order of the Trustees of the
Cartoon Museum
35 Little Russell Street
London WC1A 2HH

www.cartoonmuseum.org
info@cartoonmuseum.org.uk

Text: Chris Miles and Anita O'Brien

This catalogue is published
to accompany the exhibition
Ralph STEADman: A Retrospective
2016
ISBN 978-0-9537263-9-4

Cover design by Henry Steadman
Design and typeset by Simon Russell at
boinggraphics.co.uk

Measurements indicate the size of the
whole sheet of paper.

Back cover:
Self-Poortrait, 2006

CARTOON MUSEUM

Contents

Sponsors' Foreword(s)

One can count on one hand the greatest geniuses of our time, and then there is Ralph Steadman – *ba dum chhh!*

At United Therapeutics, we believe that non-conformity + creativity + hard work + dedication + skill + having fun + a desire to question authority = innovation. All of these qualities are oozing in Ralph's work and life as well, so we leapt at the chance to help celebrate the storied and stellar career of our kindred spirit and friend.

We take this approach to how we develop life-saving technologies, imbued with the irrational belief that we can achieve what we set out to do. Like creating an unlimited supply of transplantable organs.

Genius and madness are inextricably linked in how Ralph works to make his art that matters and in how we work to reduce suffering from illness.

Martine A. Rothblatt
Chairman & CEO
United Therapeutics Corporation

Ralph Steadman is a free-spirited inspiration to us all. His art combines passion with humor, and he continues to invent new artistic techniques. Ralph has deep compassion for the oppressed, and he confronts head-on the visceral horrors and suffering caused by wars. Ralph hates bullies and tyrants and he is fearless in his caricatures of scheming, self-serving politicians. Ralph is deeply committed to justice and never strays from his principles, while at the same time he is generous, humble, caring and loving.

Ralph Steadman you are a TRUE artist!

Love,
Jim Caruso
Flying Dog Brewery

Footnote: In 2009 the state of Michigan banned the sale of Raging Bitch, a Flying Dog beer with inimitable Ralph Steadman label art. Flying Dog sued the state of Michigan for violating its First Amendment right to Freedom of Speech. In 2015 the United States Federal Appeals Court ruled in favor of Flying Dog and against Michigan, setting a legal precedent for every state in America that freedom of speech applies to beer, wine and spirits labels. Flying Dog used the damages it was awarded by Michigan to create the 1st Amendment Society. To Freedom of Speech and Creative Expression!

Ralph is one of the great geniuses and wonderful human beings I've had the pleasure of knowing over two long careers.

When I met him as a 23-year-old foreign correspondent for *Rolling Stone* based in London, where he was a contributing editor for the magazine, he was already celebrated as one of the best political cartoonists of the 20th century and well known to my baby boomer generation as the brilliantly gonzo illustrator of Hunter S. Thompson's *Fear and Loathing in Las Vegas*. Over the years, Ralph would produce brilliant illustrations to attend my words in magazines, including an indelible depiction of "The King of the Ferret Leggers" clinching his belt as bulges of ferrets raged inside his blood-sprayed baggy pants.

At its best, Audible is imbued with the élan I experienced during those years, a sensibility derived from the act of imprinting the culture with something new and disruptive. That's something Ralph has done throughout his scintillating career.

Don Katz,
CEO Audible

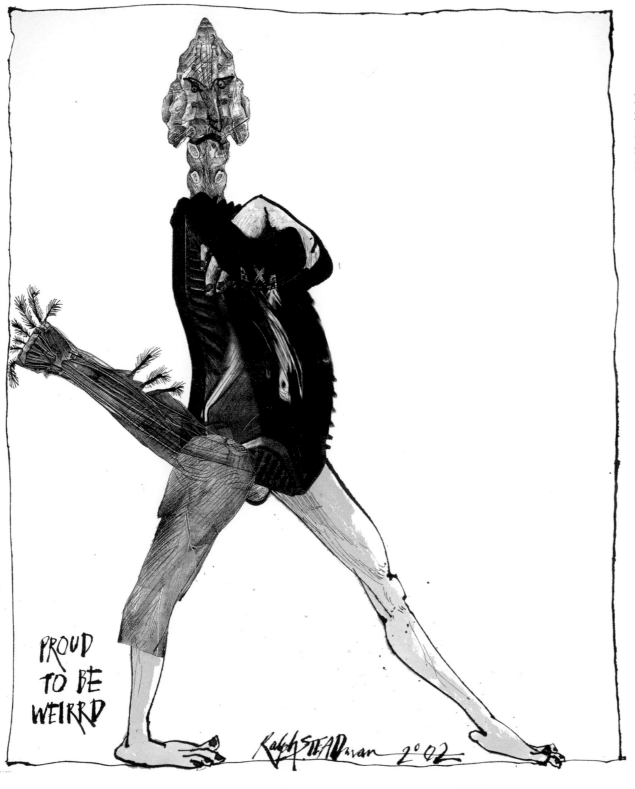

Proud to be Weird
2002
Indian ink, acrylic paint and collage on paper,
from *Animal Behaviourists*
Private collection

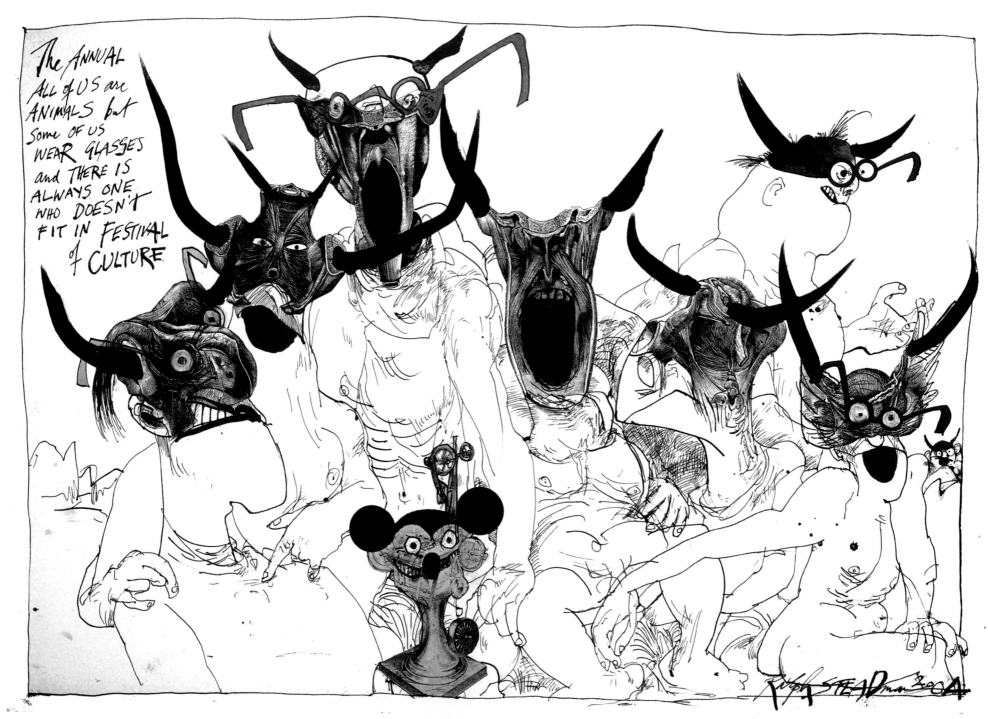

The ANNUAL
ALL of US are
ANIMALS but
Some OF US
WEAR GLASSES
and THERE IS
ALWAYS ONE
WHO DOESN'T
FIT IN FESTIVAL
of CULTURE

Special Thanks

opposite: **The Annual "All of Us are animals but some of us wear glasses and there is always one who doesn't fit in" Festival of Culture**
Indian ink, acrylic paint and collage on paper, 2004 from *Animal Behaviourists*
Private collection

**Many people have contributed to getting *Ralph Steadman: A Retrospective* on the road in the USA. We could not have done it without their belief in and support of the project.
Special thanks to:**

@Audible: Don Katz, Katja Kier, Chelsea Adams, Chris Harris for the development, guidance and creation of the Ralph Steadman Audio Guide and Michael Epstein for his incredible direction of the project.

@Flying Dog Brewery: Jim Caruso, Meghan Hessler, Erin Weston, Stephanie Betteker for their friendship and continuing support in marketing, design, special events and sponsoring the catalogue all the way through from the original exhibition at the Cartoon Museum, London to its current incarnation as it heads to San Francisco.

@United Therapeutics: Martine Rothblatt, Paul Mahon, Bill Rock for believing in the project from the start and providing invaluable advice and support and enduring friendship.

@Dietl: Andrea Megyes, Bill Eagan, William Sunstrum, Ila Forster, Megan Chunn for their incredible organizational skills, logistical management, safe storage and commitment in getting this and other exhibitions safely from A to B, come what may.

@Elsewhere: Anita O'Brien and Chris Miles for conceiving of the exhibition in the first place and researching and curating it piece by piece; Brian Chambers for his loyalty to the show and for introducing us to the incomparable Andrea Harris, who guides us forwards to each venue with a sure and experienced hand, encourages and listens and whose passion seeks out incredible spaces to showcase the artwork; the team at each venue who give us such support and whose dedication and commitment to creating a great show make each version a unique and immersive experience; Mark Denton for keeping tabs on our catalogues and making sure we do not run out; Simon Russell for putting up with the endless catalogue amendments; Tim Robbins for lending his dulcet tones to the Ralph Steadman Audio Guide; Trip and Laura Park for their friendship; Anna Steadman for her hospitality and forbearance with the constant deliveries and phone calls; Henry Steadman for designing the cover for the catalogue which has become our entire identifying vision; Chip Watkins for keeping the finances flowing; Andrew, Jean and Terry Williams for holding the fort and keeping the home fires burning; the Gonzo Trust for their support and trust in allowing us to show some of Hunter's letters in San Francisco; Johnny Depp, Anita Kunz and Carlo McCormick for contributing their words and thoughts to the catalogue; Dr Nick Hiley and Jane Newton for facilitating the loan of artwork from the British Cartoon Archive, University of Kent; Charlie and Lucy Paul and Sony Picture Classics for making accessible the fascinating documentary For No Good Reason (2012) in screenings and in the exhibition; Kate Owens and Alison Brown for providing curatorial support at the Cartoon Museum; Cheyenne Eastwood, Louisa Buck, Elena Burykh, Tony Rushton, Steve Marchant, Mark Stafford and Tony Quinn at Mag Forums for providing research material and help in tracing publication details; Sadie Williams, executive director of RSAC, for keeping going in the face of an almost insurmountable challenge and finally to Ralph Steadman whose good heart and good will have made all this possible in allowing access to his work, archives and memories and never wanting "to be a bother".

Johnny Depp

He is most assuredly a rare bird, dear Ralph… made up of many things, all of which beg to be found amongst the masterly demented brush strokes and very life's blood of splattered exclamation that comprise his essential oeuvre.

He is also a bitterly insightful bird, his moral compass fiercely accurate, sparing no one with his decimating and brutal wit. He has long, bravely wielded this unabashed, primal scythe in the face of planetary-sized adversity and yet, there lies a certain tenderness amongst the produce of his artful bristles, a warmth… always with the possibility of hope, a way out, a better way… not necessarily the easy way.

He is a hero for he is a survivor. But, more importantly, an uncompromised survivor. A dearly beloved compatriot on the eternal battlefield in the war against all things false and cruel. He is an icon, his topical, political renderings iconic, his mad jargon a paragon of artistic brilliance. And through the illustrated musings of his life and times, Ralph's bird will perpetually soar in the minds of those that follow, carrying the torch he once collected from all the dissidents that spewed their creative venom before him. Here is a man and artist of superior calibre. Look up. Watch him soar above us all. I've had the pleasure.

Now it's your turn.

opposite: from *I, Leonardo*, 1983

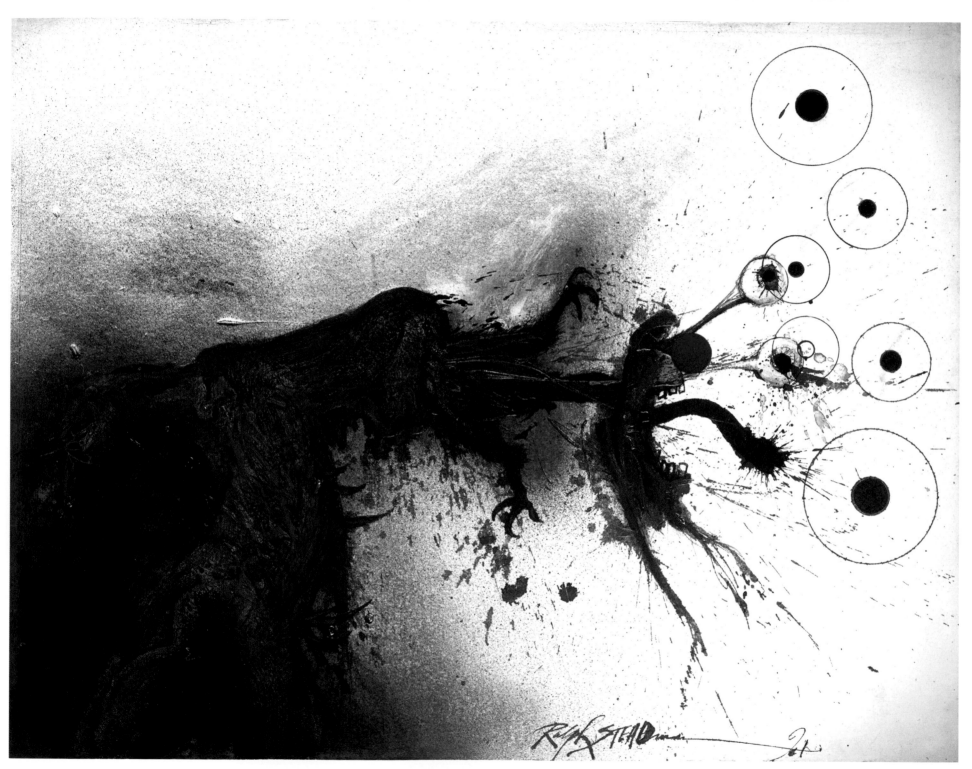

Red figure, 1991

Carlo McCormick

The pen is only mightier than the sword when it is wielded like a weapon. Ralph Steadman's pen is as sharp and ruthless as any other, brilliantly funny and deftly enlightening, you wouldn't want to get in its way.

Over his more than half-century tenure in the oft-compromised field of commercial representation, there's hardly the sense of Steadman as an illustrator, for his pictures don't try to explain so much as declaim. His is not some overarching voice of reason, rather those odd voices you might hear in your head on the way to madness, never a narrator but an unruly entertainer, spitting and sputtering, ranting like some visual Tourette's Syndrome, bespeaking an alternate truth, perhaps less evident but nonetheless real. He doesn't draw the line; he crosses it. And it's not pretty, it is downright messy, as if so driven by urgency, desperation and rage that it speaks to us in a gory assault of splattered ink and textual marginalia.

Anti-authoritarian and iconoclastic, Steadman's questioning and critique of consensus reality dances around the jagged edges of social distemper, where the smooth façade of politesse shatters along the fractious lines of hypocrisy and dissent. Like a smack in the face, Ralph reminds us that civilization is merely the false veneer of our baser animal being, like the grim smile a quarrelling couple might put on in public. He delivers all this in cartoon's most exaggerated terms, those radical distortions like dropped jaws, bulging eyes and smoking ears that cartoons use to express emotional extremes now rendered with such fierceness that his ink seems tinged with a mixture of acid and truth serum. In this he is heir to the lineage of caricature's satiric force, a legacy of caustic commentary and contempt from William Hogarth, Honoré Daumier and Thomas Nast, through George Grosz and John Heartfield.

Much like his collaborator in Gonzo journalism, Hunter S. Thompson, Ralph Steadman's work in editorial and book illustration has always been far more interested in delivering a highly subjective and emotionally heightened reading of life than fobbing off some dispassionate account of the truth. He's politically and socially engaged, but way more punk than hippie. Dystopian beyond any measure of idealism, Steadman's art is outrageous only in relation to his own sense of outrage, yet his wry humor and mordant cynicism harnessed into that supreme act of faith: creativity. And from the outset when he first began publishing his work in newspapers during the mid-fifties, through his move to humor magazines and eventually the most prestigious organs of youth culture, Ralph's always bumping against the inherent restrictions of the medium. His oeuvre, varied as it is in that time, is consistent in seeking out a more visceral expression and broader provocation against the passivity and complacency of his audience. Largely commissioned and existing in a commercial field, it is this frisson and discomfort which reminds us that Steadman is above all else an artist.

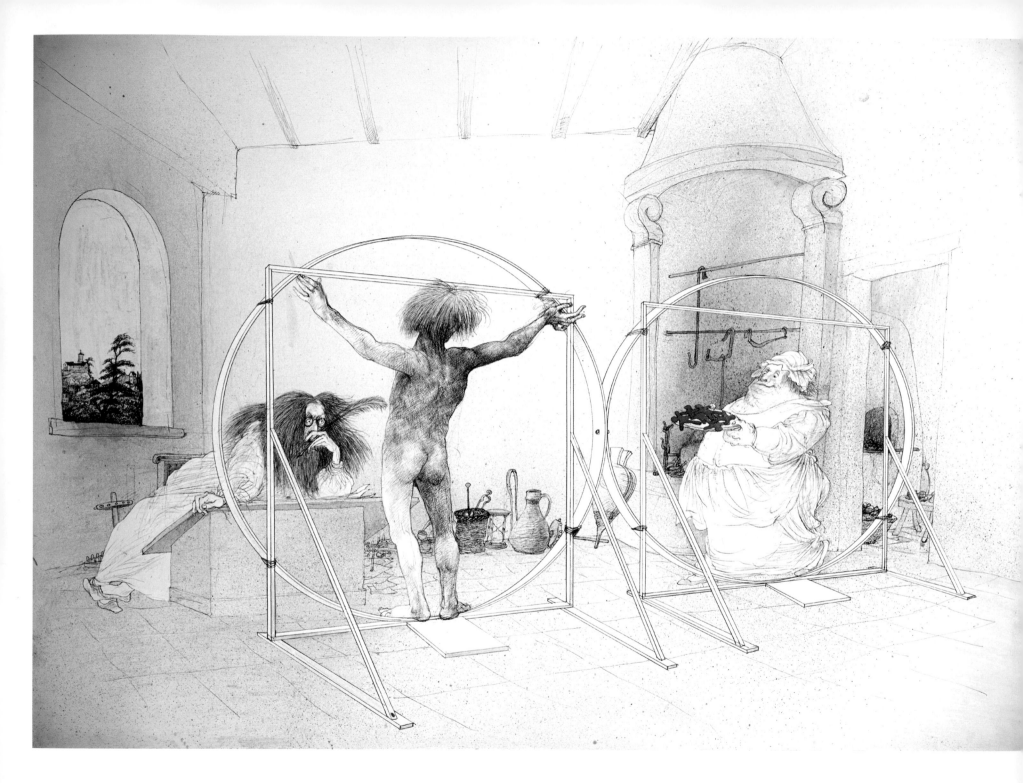

from *I, Leonardo*, 1983

12

Anita Kunz

He has been called a pictorial assassin. His fierce brush strokes and savage lines have visually described everything from the ravages of war to the entitlement of the rich, corporate wickedness and the lunacy of the class system to, more recently, the decline of the species and decimation of the planet.

He is as prolific as he has ever been and he has been lauded with many major awards. He is an icon in the truest sense of the word, and is well known worldwide, both for his collaboration with Hunter S. Thompson in the Fear and Loathing work, and also for his numerous projects dealing with more sobering topics.

To call him a cartoonist is to do him a disservice. He is far more than that. He is a writer, composer, poet, thinker, musician, and I think one of the greatest artists living today. Yet Ralph is a kind and gentle soul with a genuine concern for humanity and the frailty of our existence.

My first introduction to his genius was as a young art student. I discovered his lavishly illustrated books: *I, Leonardo, Alice in Wonderland, The Big I Am, Sigmund Freud, Animal Farm*. I marvelled at his poetic line work, his brilliant imagery and his remarkable ability to tell a story. His work was unlike anything I had ever seen, and it's no stretch to say I was very much influenced by his art.

I did have the chance to meet him while I was living in London in the early 1980s but declined because I was, frankly, far too intimidated. Fifteen years ago I got another chance. This time we were both, along with our spouses, invited to participate in judging an international cartoon competition in Istanbul. Ralph was there with his wonderful wife Anna (incidentally a terrific artist in her own right). We became fast friends, and that friendship has been and continues to be one of the high points of my life.

Uncompromising art is not always rewarded or appreciated in this culture. Challenging the status quo is not always tolerated or encouraged. So much art these days is decorative and shallow. And when art becomes a mere commodity it loses its power to encourage, challenge, subvert and even improve cultural norms. But Ralph has consistently taken the medium of illustration to higher levels with wit, energy, emotion and intelligence. He continues to hold a mirror up to our vanities and reminds us of our human folly.

He says, with regret, that he wanted to change the world. But I think he has.

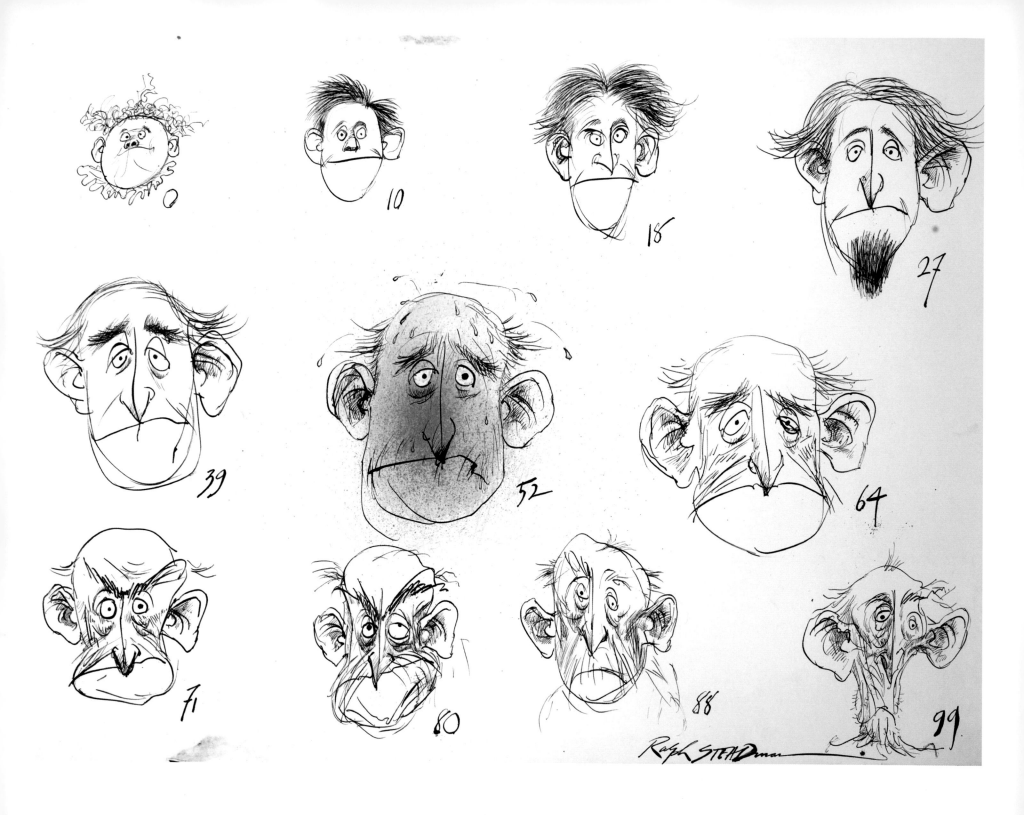

STEADman: A Biography

'I think the adrenaline you get from drawing is as good as any kind of drug you can get involved in. Somehow, I do love it when I get into it. That is, when a dialogue between me and the drawing begins.'[1]

Amongst the many paintings, prints, sculptures and embroideries which fill Ralph Steadman's home in Kent is an unassuming but significant little picture. Painted on a small panel, the landscape was the creation of his great-grandfather J. T. Steadman. Steadman knows little about this artistic ancestor other than he is believed to have worked at the Walker Art Gallery in Liverpool at the end of the nineteenth century. A few of his paintings are still to be found in the municipal art collections of Wolverhampton and Eastbourne. His great-grandson, on the other hand, will not slip so easily into obscurity. His vast output over the last fifty-plus years has been expressed in many forms: drawings, paintings, cartoons and cartoon strips, collage, photography, sculptures, sets and costume designs. The versatility and quality of his work has influenced several generations of artists and graphic designers around the world, and for many he is one of the most original visual creators of the last fifty years.

J. T. Steadman, c. 1900

Ralph Idris Steadman was born to Gwendoline and Lionel Raphael Steadman in Wallasey, Liverpool on 15 May 1936. From his Welsh mother he inherited the ancient Celtic name of Idris though, much to his regret, not her Welsh speaking skills. His father's passion was tinkering with cars, but the family regarded working as a mechanic as beneath him and instead he became a commercial traveller 'in women's coats and costumes – and ladies' knickers'. As a child Ralph shared his father's love of making things rather than drawing, but he recalls a visit to the home of a neighbouring boy whose 'mother allowed him to express himself all over the walls ... Scribble, scribble, scribble.'

In 1939 the outbreak of the Second World War brought a dramatic change to the family's life. Almost immediately Liverpool became the target of German bombers. As a major industrial centre and port the city played a crucial role in the war effort and after London was the most heavily bombed city in Britain with the loss of 4,000 lives. Later Steadman would recall the scream of the air-raid sirens and being quickly bundled under the bed by his mother or, if there was time, taken down to the family's Anderson shelter. Concerns for the safety of the family led Lionel to relocate the family to the safety of Abergele in north Wales where young Ralph and his sister Barbara continued their schooling.

In 1947 he moved on to Abergele Grammar School, where at first he was happy. But then the gentle old headmaster retired and was replaced by a 'hideous monster who carried a cane. From then on I loathed that kind of authority figure. Because I had been brought up to believe that there was good in the world.'[2] Though he did his best to 'be good', young Ralph lived 'in mortal fear of authority' and did all he could to avoid falling foul of the system. Homework was finished off at the earliest opportunity so that he could throw himself into his favourite pursuits, 'model building, photography, clockwork trains and chemistry'.[3] Ralph spent much of his time making model aeroplanes, initially from kits, later creating and building models of his own design. A fascination with flight and a love of making things have remained with him throughout his life and reappear in various forms throughout his work.

In 1952 the sixteen-year-old Steadman left school. His love of planes led him to his first job at the De Havilland Aircraft Company in Broughton, Chester, where he started as an apprentice aircraft engineer. His fantasies of immediately building aeroplanes came crashing down when he realised the tedious reality of factory life. He stuck it out for a few months,

long enough to pick up some skills in technical drawing. He found a new job at Woolworths in Colwyn Bay, but that ended a few months later following a clash with the manager. In 1954 McConnells Advertising Agency took him on as a tea-boy-cum-junior manager, where he was set designing trademarks and other small jobs. He had to leave later that year to begin his National Service with the RAF down in Hope Cove in Devon, where he worked as a radar operator forming part of Britain's 'first line of defence' against Communism. Here he continued to develop his skills in drafting and technical drawing.

Just as he was about to begin his National Service an advertisement in a magazine caught his eye: 'You too can learn to draw and earn £££s!' Percy V. Bradshaw's Press Arts School's cartooning course had been running for decades and counted some of the country's best cartoonists amongst its graduates and teachers, but by the mid-1950s it was rather old-fashioned. Steadman's mother paid the £17-6-0 fee, a not insignificant sum at a time when the average working man only earned about £20 a week.

During his National Service the budding artist practised his life drawing and got roped in to help produce designs for the unit's Christmas events. Soon he was sending off cartoons to newspapers like the *Sheffield Telegraph,* the *Leicester Mercury* and the *Manchester Evening Chronicle*, all signed with the pithy STEAD in capitals. His persistence paid off when in July 1956 the *Manchester Evening Chronicle* published his first cartoon about the Suez Crisis.

Shortly after, his National Service came to an end, and Steadman decided to try his luck in London. In 1959 he landed a job drawing for the Kemsley Group of Newspapers, whose stable included the *Manchester Evening Chronicle* and the *Aberdeen Press and Journal*, where he was expected to come up with at least ten ideas for joke and pocket cartoons every day, one of which he would work up as 'Smile with STEAD' as well as a strip 'Teeny'.

Though he was earning a living from cartooning, he was becoming increasingly frustrated, and yearned to immerse himself in 'the discipline of drawing' – a grounding he considers as 'imperative' for true creativity to emerge. 'I knew that I couldn't go on the rest

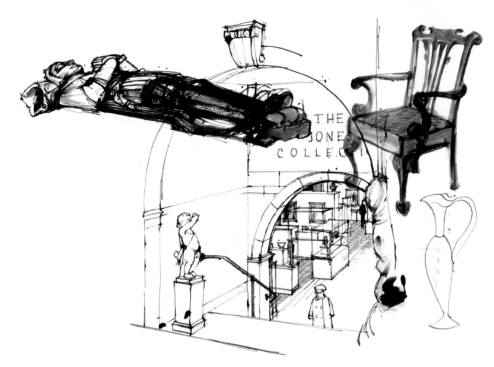

of my life drawing something which would just fill a space.'[4] In 1959 he enrolled as an art student at East Ham Technical College, London, where he studied, and later taught, until 1966. Shortly after he started at East Ham, he met Leslie Richardson, who taught life drawing in the evenings. Richardson became a major influence on his artistic development and a lifelong friend, introducing the younger man to a wide range of cultural influences. 'You'd take in photography, literature, philosophy and the history of art. He gave you an education.'[5]

For the next seven years he would finish his cartooning work by mid-afternoon, and then take life classes, or go to the large museums in South Kensington, where he would spend hours 'drawing from the antique' well into the evening. Sometimes he sketched with Gerald Scarfe, whom he had met at the inaugural meeting of the Cartoon Club of Great Britain in 1960. The two became friends, encouraging one another and influencing each other's early styles. Steadman introduced Scarfe to his teacher Leslie Richardson. In

1961, encouraged by Richardson, he also studied at the London College of Printing and Graphic Arts. It was around this time that he bought the complete contents of a printer's studio, including a printing press. The printing blocks and movable type soon began to feature in his work and have become a fundamental element in Steadman's iconography. He continues to use the press and lettering in his work to this day.

After more than three years of 'sorry, not quite' rejection slips he achieved another ambition when his first cartoon was published in *Punch* on 20 July 1960. By 1961 Steadman, now signed 'STEADman', was a regular contributor and had progressed to designing covers for the magazine. However, he was already finding that the demands of conventional cartooning cramped his style. 'Cartooning wasn't just making a little picture and putting a caption underneath. It's also something else – a vehicle for expression of some sort, protest, or it's actually a way of saying something which you can't necessarily say in words.'[6]

In 1961 he met Leslie Illingworth, the political cartoonist at the *Daily Mail*, and asked for some career advice. 'He said "Get the sack!", so I did and I haven't had a proper job since.'[7] Steadman took the bold step of going freelance. Soon afterwards he produced a complex double-page spread called 'Plastic People' and sent it to *Punch*, who rejected it: 'They weren't really interested in social comment, they wanted jokes.' He decided to try it on the editor at the newly-founded *Private Eye*. 'I got a letter from Richard Ingrams saying, 'Here's a fiver, more power to your elbow!' As far as Steadman was concerned this break was 'an act of divine intervention … *Private Eye* gave me a platform of great scope and freedom and even indulged my odder whims.'[8]

Private Eye was part of what later became known as 'The Satire Boom' of the early 1960s. Artists such as Steadman and Scarfe wielded their pens as rapiers, puncturing the pretensions of those in power. For the first time in over 130 years the provocative and the grotesque once more took centre stage. Steadman's art studies inspired him to experiment, and the substance and the style of his output became increasingly complex and political. He discovered the work of artists such as George Grosz, Otto Dix, Max Beckmann, Marcel Duchamp, Kurt Schwitters

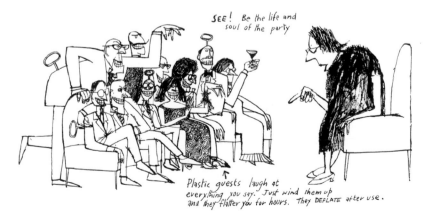

Detail from Steadman's first cartoon in *Private Eye*, issue 11, 18 May 1962.

and John Heartfield, all associated with 'the Dada movement, itself committed to a kind of political art, the art of rejection of all values. A declaration that any society that can promote wars such as the Great War must be corrupt,[9] therefore society's values must be corrupt.' Just as Grosz and Heartfield offered confrontational and unflinching critiques of Weimar Germany and the rise of Nazism, so Steadman's drawings and collages exposed the hypocrisy and corruption which lay behind the bright lights of the swinging sixties. 'When the 1960s got under way I felt pretty hopeful and even dared to imagine that each new drawing was a nail in the coffin of old values or rather old patterns of behaviour which were full of privilege and injustice. It's a strong feeling when you're young. You really believe that things will change. So I worked with conviction. It genuinely felt like a cause.'[10]

Other opportunities were also coming his way. In 1964 he was asked to illustrate *Fly Away Peter*, a children's book written by fellow cartoonist Frank Dickens. He also collaborated on several books with the Yugoslavian writer and publisher Dimitri Sidjanski [penname Mischa Damjan], including *The Big Squirrel and the Little Rhinoceros* (1965) and *The False Flamingoes* (1967). In 1967 *The Jelly Book* was the first of many children's books which he both wrote and illustrated. Throughout the 1960s Steadman's work appeared in numerous publications including *New Society*, *Radio Times*, *Town*, *New Musical Express*, the *Times Higher Educational Supplement*, the *Daily Telegraph*, and many others. His political cartoons became a prominent feature of the radical left-wing paper *The Black Dwarf* in 1968 and 1969.

In 1967 Steadman began his most important project to date. He had never read Lewis Carroll's *Alice's Adventures in Wonderland* as a child and discovered it at the age of thirty for the first time. He became totally absorbed by Carroll's Victorian characters and wondered how it would be if he recast them in a satire of the '60s scene. Steadman's *Alice* was very well received and would go on to win a Francis Williams Award in 1972.

In 1969 Steadman published *Still Life with Raspberry*, his first collection of cartoons, and in April 1970 set off to New York. Steadman's book had caught the eye of Englishman Donald Goddard, ex-foreign editor of *The New York Times*, who was working at the newly launched *Scanlan's Monthly*. The New York-based magazine was dedicated to maverick journalism and had commissioned the journalist Hunter S. Thompson to produce an article on the Kentucky Derby, to be accompanied by illustrations. Thompson explained to the co-founder and editor Warren Hinckle III that what they needed was 'somebody with a really peculiar sense of humour, because this is going to be a very twisted story. It'll require somebody

from **The Big Squirrel and the Little Rhinoceros**, 1965

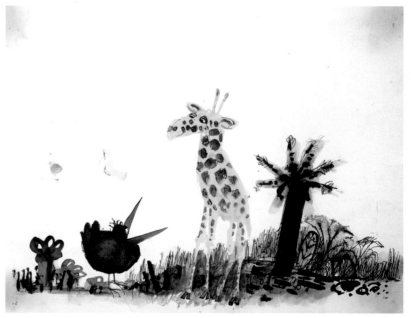

from **Fly Away Peter, 1964**

with a serious kink in his brain'.[11] Hinckle thought he knew just the person. The magazine's art director J. C. Suares tracked Steadman down in Long Island: 'How would you like to go to Kentucky and meet an ex-Hell's Angel who's just shaved his head?' Steadman took up the challenge and headed off to Louisville. When they met at the track Thompson told him that they weren't there for the horses, but to nail 'the real Kentucky face'.[12] Almost immediately Thompson realised that Steadman's 'filthy scribblings' and his dangerous tendency to share them with his American audience were a volatile mix with explosive potential. Yet from the beginning the two hit it off, and after Steadman's return to London, Thompson wrote to say he hoped they would work together again. When the article appeared in *Scanlan's* it was hailed by *Boston Globe* journalist Bill Cardoso as 'pure GONZO!' Thompson later defined 'Gonzo' as 'a style of "reporting" based on William Faulkner's idea that the best fiction is far more *true* than any kind of journalism – and the best journalists have always known this.'[13]

Before his American experience Steadman had already demonstrated his ability to confront the uglier side of human nature. However, he believes his work was missing a crucial element. 'It lacked bite; it lacked rawness; an edge.'[14] His love-hate relationship with America's brash lifestyle and Hunter's provocative influence gave him the jolt which thrust him into another dimension. Thompson would later say that Steadman worked best on the edge, 'when you put him in a situation where he's bordering on flipping out, but not quite, you know – when he can still function … When he's comfortable and not stunned or appalled at what he's seeing then he doesn't do his best stuff.'[15]

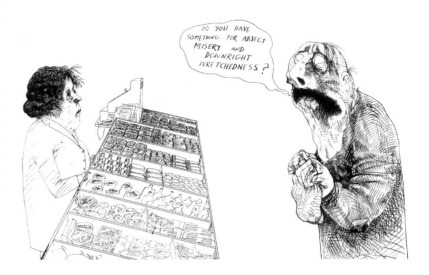

Steadman cites this drawing from the early 1960s as 'the birth of GONZO in my work'.

Steadman returned to Britain to cover the June 1970 general election for *The Times*. The paper gave him a couple of three-month contracts, but it was an uneasy partnership. Steadman's radical cartoons were never intended to be easy viewing. They generated complaints from readers and were regarded as 'dangerous and subversive' by the editor, William Rees-Mogg.[16] The paper fired him in January 1971, though his work would continue to appear in the *Sunday Times Magazine* throughout the 1970s.

Freed from the demands of *The Times* Steadman was now able to complete his drawings for Carroll's second *Alice* book. In 1970 he had been approached by the recently formed Lewis Carroll Society, who asked him to illustrate a new edition of *Through the Looking-Glass, and What Alice Found There* (1972). At the time he was living in a flat full of mirrors, which suggested an alternative way in which to approach the text. 'I split the pictures … I drew Alice going through [the looking-glass] but coming out at the same time to give some sort of animation without animating.'[17] Creating the drawings for the book was an intense but immensely satisfying experience. He felt he was 'pushing the boundaries' beyond anything he had done before. It remains one of his finest achievements.[18]

In September 1970 Steadman renewed his partnership with Hunter S. Thompson when the two headed off to Newport, Rhode Island to cover the classic boat race, the America's Cup. Their ensuing adventure became for the artist *the* quintessential Gonzo experience. Suffering from seasickness, Steadman noticed that Thompson was unaffected and asked if he could have one of the small pills which the writer was taking. What he actually took was the hallucinogen, psilocybin. Egged on by Thompson Steadman suggested they row out and spray 'Fuck the Pope!' on the hull of a racing yacht. However, the pair were rumbled and had to flee, narrowly avoiding capture by the police. As a diversion, Thompson set off a distress flare, which started a fire on a yacht. A strung-out, shoeless Steadman finally made it

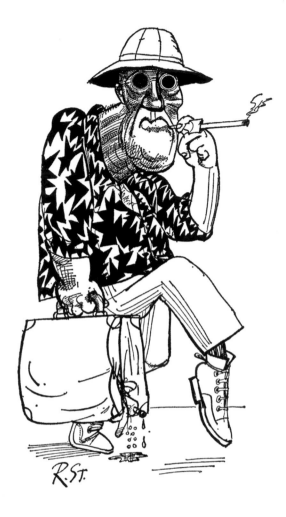

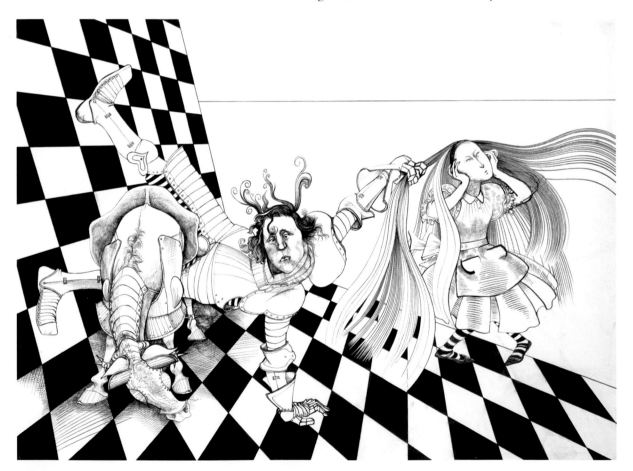

back to New York with barely the clothes on his back and his sketchbook.

Nine months later when he came to create his iconic images of gonzotic madness for Thompson's *Fear & Loathing in Las Vegas: A Savage Journey to the Heart of the American Dream*, he at last had the opportunity to exorcise the nightmarish experience of the year before. The story was commissioned but later rejected by *Sports Illustrated*, and appeared instead in the November 11 and 25 1971 issues of *Rolling Stone*. Although Steadman didn't make the trip with Hunter, he felt he 'already knew the story. I had been there. Not the same place, not the

same story, not even in the same skin, but a shock of recognition from a suppressed well of personal experience and personal dread'[19]

In the early '70s Steadman moved to Fulham, where he met and became friends with Bernard Stone, who ran the alternative Turret Bookshop in Kensington Church Walk. Steadman regularly dropped into the shop, meeting and collaborating with a number of poets and novelists. Later in the '70s Steadman and Stone would collaborate on a series of children's books, the first of which, *Emergency Mouse*, came out in 1978.

In 1972 and again in 1973 Steadman returned to America to cover a Democratic Convention in Miami and the Watergate hearings. Steadman's response to America's screaming lifestyle and venal politics was acute culture shock expressed in extreme images. In October 1974 Steadman and Thompson journeyed to Kinshasa in Zaire for the much hyped 'Rumble in the Jungle': a face-off between Muhammad Ali and George Foreman. Steadman met Foreman and produced the pictures, but Thompson sold the tickets to the fight, the story was never written, and the article never published.

For a period in the late 1970s Steadman drew a weekly cartoon for the *New Statesman*, and his work has continued to appear in the magazine on a regular basis. In 1977 he had his first major retrospective exhibition in the foyer of the National Theatre on London's South Bank. The same year he was approached to be filmed for a two-part documentary on drawing, *The Living Arts: Seeing through Drawing* (BBC 1978). The director, Michael Dibb, was so taken with Steadman's work that he produced a profile of the artist *Arena: Art & Design – Ralph Steadman* (BBC, 1977). Around the same time another BBC documentary crew explored the creative partnership at the heart of Gonzo, following Steadman on a visit to Thompson's home at Woody Creek, near Aspen, Colorado. The result was *Omnibus: Fear and Loathing on the Road to Hollywood* (1978), which would become one of Thompson's favourite films.

In 1976 Paddington Press approached Steadman and asked him if he would do a book based on Sigmund Freud's 1905 work *Jokes and Their Relation to the Unconscious*.

For three years the artist retraced Freud's footsteps all the way back to Vienna, fastidiously revisiting places that Freud frequented, even going so far as to stretch out on the floor in Freud's original consulting room to view the wallpaper just as the patients would have seen it. The book brought together events from the life of the father of psychoanalysis and Freud's elucidation of different joke techniques. In the course of his research for *Sigmund Freud* (1979) Steadman discovered that Freud had been interested in Leonardo da Vinci and came across the quote, 'Leonardo da Vinci was a man who woke up in the dark'.

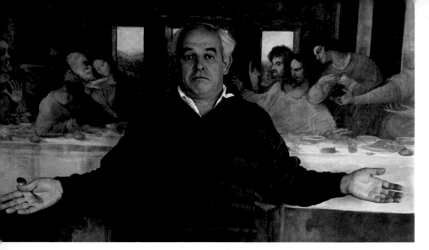

Photograph by Philip Sayer

The Renaissance polymath had fascinated Steadman since his teens, when he had discovered a copy of Leonardo's notebooks in the bargain basement of W.H. Smith in Rhyl, north Wales. In 1980 he decided he wanted to create a book on Leonardo but was unsure exactly how he could 'get inside the skin' of the artist. Then an idea came to him: he would write the book as if *he* were Leonardo, using many of the artist's own words. Not only that, but he decided he would 'have a go at painting Leonardo's *Last Supper*' in egg tempera on the wall of his bedroom, and build a gliding device inspired by a Leonardo design. For three years he read and researched, pondered and painted. His progress was followed in the Channel 4 documentary *Don't Tell Leonardo*, also directed by Michael Dibb, which coincided with the publication of *I, Leonardo* in 1983. An exhibition of his lustrous pictures followed at the Royal Festival Hall in London. The next year marked a major retrospective exhibition, again in London, and a book, both entitled *Between the Eyes*.

Since his days as an art student, Steadman has been fascinated by sequences of images and what can be revealed about an individual during a 'moment of expression – of transition'[20] In the early 1980s during a holiday to Turkey he stumbled across a new medium – the Polaroid photograph. By reworking the photograph's gelatinous layers he could create a new form of caricature: the 'Paranoid' was born. Over the next couple of years he created hundreds of 'Paranoids' of politicians, artists, writers, musicians, actors and directors for *The Observer Colour Magazine,* many of which were published in *Paranoids: from Socrates to Joan Collins* (1986).

Steadman had already tackled two of the most creative minds of Western Civilisation: Freud and Leonardo. In his next book, *The Big I Am* (1988) he grappled with the mysteries of the creative force itself: 'God and why he/she/it was such a vindictive old bastard and what the hell it could have to do with me.' His 1986 designs for a set of Royal Mail stamps to mark the 76-year passage of Halley's Comet, 'Maybe Twice in a Lifetime' also evoked the mysteries of the universe and went on to win a BBC Design Award in 1987. In the 1980s and '90s he also continued to write and illustrate acclaimed children's books including *That's My Dad* (1986), *No Room to Swing a Cat* (1989) and *Teddy! Where Are You?* (1994).

In December 1980 Steadman was reunited with Hunter S. Thompson when the two travelled to Hawaii to cover the Honolulu marathon for *Running* magazine. From the outset the project was beset by difficulties, but eventually Thompson finished the text and their final major collaboration *The Curse of Lono* was finally published in 1983. For the rest of the 1980s Steadman and Thompson were taken up with other projects, but in 1994 Steadman produced a series of elegant drawings for Thompson's *Polo is My Life, Part 1* for *Rolling Stone*.

from ***Teddy! Where Are You?***, 1994

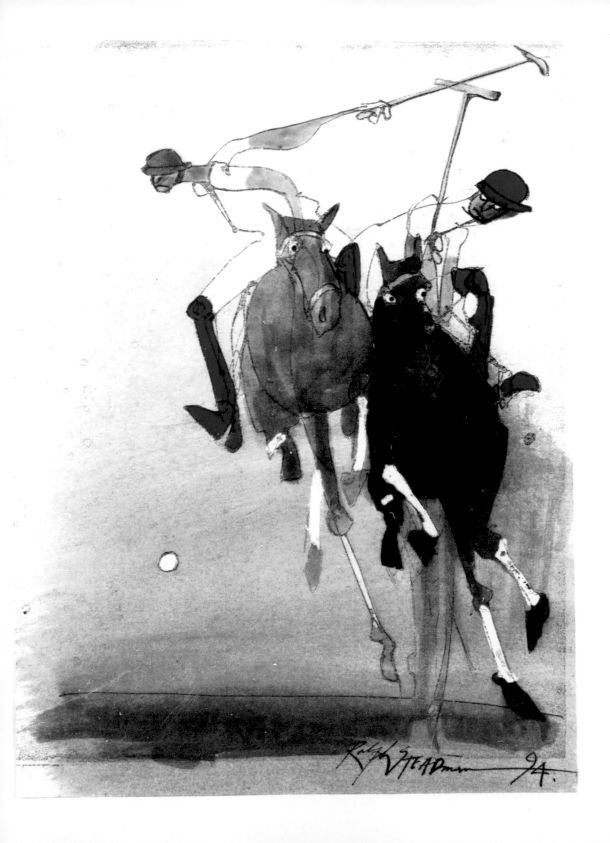

For centuries politicians have more often been flattered than insulted by political cartoons intended to wound them. In 1987 Steadman decided he would no longer be party to this game and resolved henceforth to only draw their legs. However, in recent years he has returned to the fray of political caricature. Also in 1987 he began a long and fruitful association – illustrating catalogues for Oddbins Wine Merchants. From 1987 to 2000 he travelled the world, visiting vineyards and distilleries, meeting the winemakers and whisky blenders and sampling their wares. The experience inspired him to plant vines in his garden in Kent, and for several years he produced his own vintage.

In 1989 Steadman received an invitation to become the Artist-in-Residence at Exeter Arts Festival. This in turn led to a commission to write the libretto and produce designs for an oratorio to be performed at Exeter Cathedral. The result was *Plague and the Moonflower* with music by Richard Harvey. Steadman's starting point was Margaret Mee's book *In Search of the Flowers of Amazon Forests* and explored humanity's relationship with and impact on the natural world. The oratorio was also performed at Canterbury and Salisbury cathedrals and broadcast by the BBC on New Year's Eve 1994.

Since childhood Steadman has always enjoyed making things, and in 1990 he collaborated with the artist and automata maker Keith Newstead to create the complex automaton *Mad God Universe* for an exhibition at Croydon Town Hall. In the early 1990s Steadman returned to an early love of his – printmaking. In 1993–4 he travelled to work at Peacock Visual Arts in Aberdeen, where he produced a series of etchings, mostly of writers. At around the same time he was approached by the American artist and printmaker Joe Petro III to create a series of silkscreen prints based on his *Fear and Loathing* work and other drawings. Exhibitions of the resulting prints followed soon afterwards in Aberdeen and Denver, Colorado. Steadman has always had an interest in the theatre, sketching actors in rehearsal and producing set designs and posters for a number of plays, particularly for work by friends such as Adrian Mitchell. In 1999 he was asked by The Royal Ballet to create costume and set designs for a new ballet based on Arthur Miller's *The Crucible* with music by Charles Ives, which premièred in April 2000.

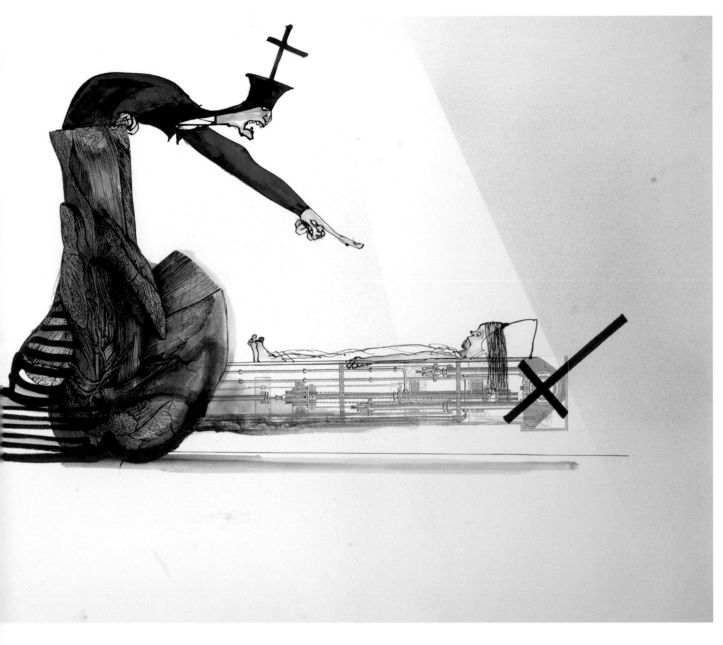

The 2000s brought two volumes of autobiographical writings. In 2002 he published *Doodaaa. The Balletic Art of Gavin Twinge: A Triography*, in which Steadman reveals the life and thoughts of his alter ego, the artist Gavin Twinge, as related to Ralphael Steed. On 20 February 2005 he was saddened, but not surprised, to learn that his old Gonzo partner Hunter S. Thompson, who had been suffering from health problems, had shot himself. Six months later in collaboration with Thompson's family and friends he helped realise the dramatic send-off which Thompson had first proposed in the 1978 BBC documentary *Fear and Loathing on the Road to Hollywood*. For nearly thirty-five years Thompson had been one of Steadman's best friends. A larger-than-life character in every sense, his absence left a huge gap. In *The Joke's Over. Bruised Memories: Gonzo, Hunter Thompson and Me* (2006) the artist recounted their close but at times fractious relationship, as well as touching on his own wider career.

From 2003 to 2008 Steadman formed a new creative partnership with Will Self, producing drawings to accompany Self's weekly *dérive* in *The Independent*, 'Psychogeography'. Over the years he has produced several books on both dogs and cats, both real and imagined. In 2011 he was contacted by the filmmaker Ceri Levy and asked if he would produce a drawing of an extinct bird for the *Ghosts of Gone Birds* show, which sought to draw attention to the plight of endangered birds. One bird soon became one hundred 'Boids' – some real but extinct, others wholly the product of Steadman's fertile imagination. The 'Boids' paintings became an exhibition and then in 2012 a book *Extinct Boids* co-written with Ceri Levy. Levy and Steadman continued their partnership with two further volumes on creatures that can still be saved. *Nextinction* (2015) features the 192 Critically Endangered birds on the International Union for Conservation of Nature Red List, while *Critical Critters* (2017) foregrounds animals facing the very real threat of extinction.

As Steadman enters his ninth decade, he is still as much in demand as ever, and still making waves. 2012 saw the release of the film documentary about Steadman *For No Good Reason*. For over a decade filmmaker Charlie Paul filmed and photographed Steadman at work and in conversation with friends such as the actor Johnny Depp. In 2014 he was the artist of choice for *Breaking Bad*'s writer and director Vince Gilligan and was asked to produce cover images of a new limited edition boxset of the series.

For nearly two decades Steadman has been producing provocative label designs for Flying Dog Brewery's beers. In 2009 his label for the brewery's 20th anniversary IPA beer, 'Raging Bitch', was deemed 'detrimental to the health, safety, and welfare of the general public' by the Michigan Liquor Control Commission and banned from sale. After Flying Dog sued in Federal Court, the Liquor Commission decided to lift its ban in June 2011.

Ralph Steadman continues to be 'led astray' by the flow of his prodigious imagination and shows no sign of running out of ideas. He admits that his attempts to change the world may have failed, but he remains convinced of the necessity of artists. His desire to create and to communicate his vision remains: 'We live in a time when the world needs a powerful injection of hope and personal achievement. Nothing cynical will serve our purpose now. Nothing smart-arsed or gross will do. It must seem real, weird and extraordinary, but within our reach.'[21]

Anita O'Brien
Director/Curator
Cartoon Museum

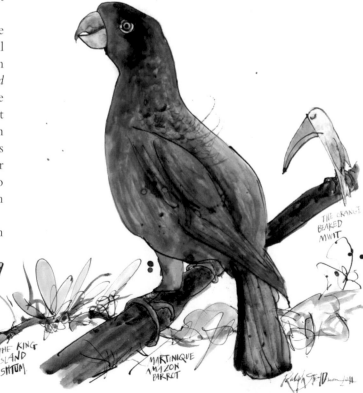

THE KING ISLAND SHTUM

MARTINIQUE AMAZON PARROT

THE ORANGE BEAKED MWIT

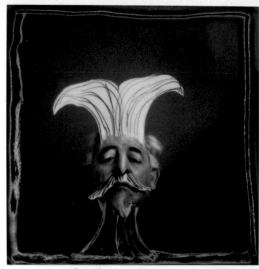

Self PORTRAIT ①

[1] *Living Arts: Seeing through Drawing*, BBC TV, 1978
[2] Robert Chalmers, 'Life in the old bird yet: Ralph Steadman on Hunter S. Thompson, Jack Nicholson's buns and his love for extinct 'boids', *Independent on Sunday*, 13 January 2013
[3] Steadman, *Between the Eyes*, 1984, p. 11
[4] *Seeing through Drawing*, BBC, 1978
[5] Chalmers, 2013
[6] *Arena: Art & Design – Ralph Steadman*, BBC TV, 1977
[7] 'The pen is mightier than the word', *The Observer*, 27 February 2000
[8] *Between the Eyes*, p. 13
[9] Ibid.
[10] Ibid., p. 142
[11] 'A Conversation on Ralph Steadman and His Book 'America' with Dr. Hunter S. Thompson', *America*, 1974
[12] Ralph Steadman, *The Joke's Over*, p. 13
[13] Hunter S. Thompson, *The Great Shark Hunt*, Picador, 1980
[14] Chalmers, 'Life in the old bird yet', 2013
[15] Thompson, 'A Conversation on Ralph Steadman and His Book', *America*
[16] *The Joke's Over*, p. 37
[17] *Arena: Art & Design*, 1977
[18] *The Joke's Over*, p. 41
[19] Ibid., p. 71
[20] Steadman, *Paranoids*, 1986, p. 6
[21] *Between the Eyes*, p. 236

THROUGH THE GLASS, VERY DARKLY —H.S.T

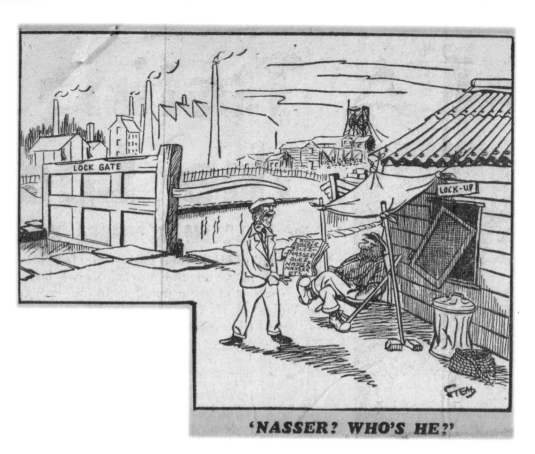

'NASSER? WHO'S HE?'

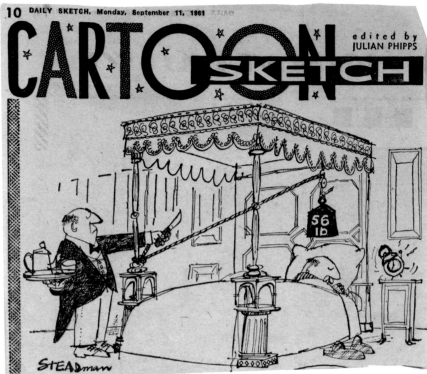

'Nasser? Who's he?'
Manchester Evening Chronicle, July 1956
Newspaper cutting
Private collection

On 13 June 1956 the last British troops left
Egypt. Eleven days later, Egyptian Prime
Minister Colonel Nasser was voted President
in a national plebiscite. One of his first
initiatives was to seek British and American
funding to build a dam at Aswan, but both
declined. Incensed, Nasser announced on 26
July that he was nationalising the Suez Canal.
The Suez Crisis culminated in an Anglo-
French-Israeli assault on Egypt in October–
November 1956.

This was Steadman's first published cartoon. It
was, he later acknowledged, 'a Giles in all but
name'.

CARTOON SKETCH
Daily Sketch, 11 September 1961
Newspaper cutting
Private collection

In the 1950s cartoonists had short punchy
names like 'Giles', 'Low', 'JAK' and 'Trog'.
So Steadman decided he should become
'STEAD'. 'It was my mother who wondered
if I was ashamed of my full name. I hadn't
given it a thought until then. I was merely
looking for an identity with a short sharp
name that everyone would remember.'
His mother's comment made him think again:
from autumn 1961 his cartoons were signed
'STEADman'.

Freedom of the Individual
c. 1960–1
Pen and Indian ink on paper
38.3 x 28.2 cm
Private collection

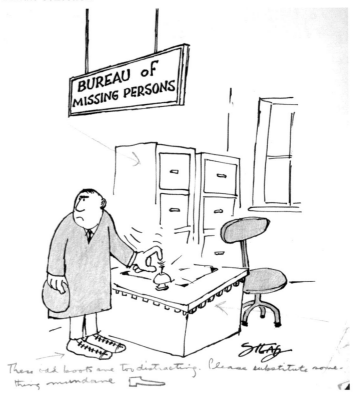

These old boots are too distracting. Please substitute something mundane ➡

Bureau of Missing Persons
Rough drawing for cartoon published in
Punch, 24 August 1960
Pen and ink and blue pencil on paper
23.3 x 19 cm
Private collection

Steadman started sending his cartoons to
Punch in 1957. For three years he received
a succession of rejection slips from the art
editor Bill Hewison. This rough drawing was
returned with the following note: 'I'm passing
the "Bureau" in spite of the boxing boots, but
I would stress the inadvisability of straining
for effect.' Some things were changed – the
chair and the desk became fancier – but the
boxing boots stayed.

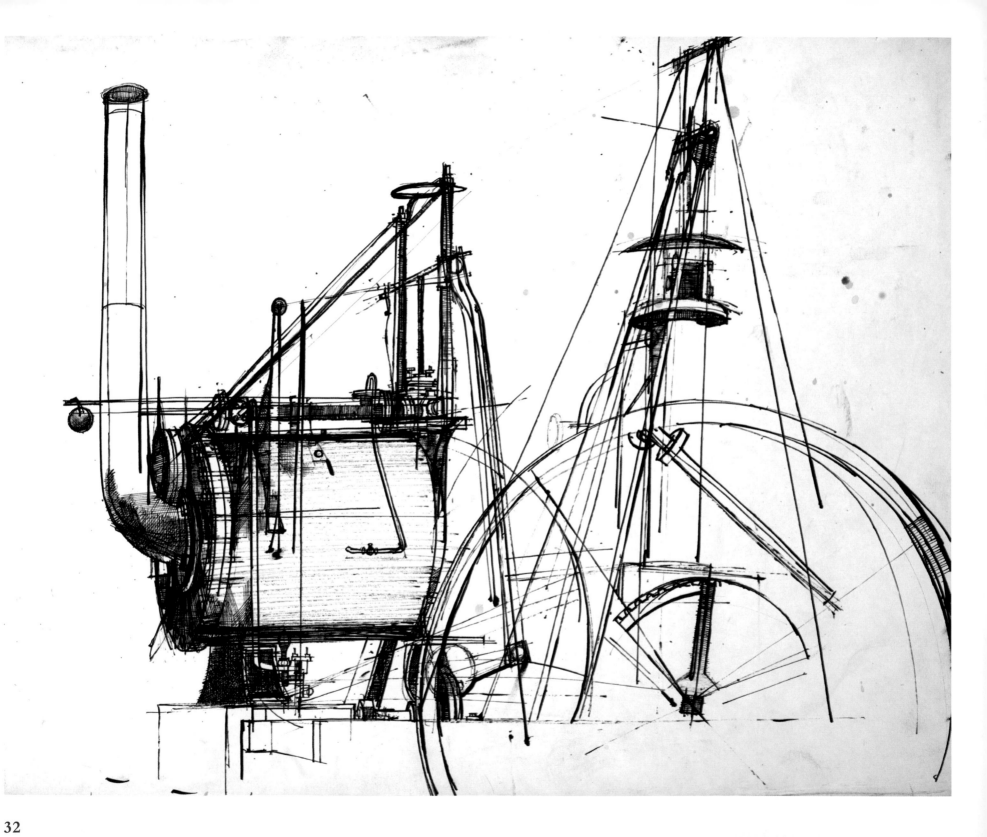

32

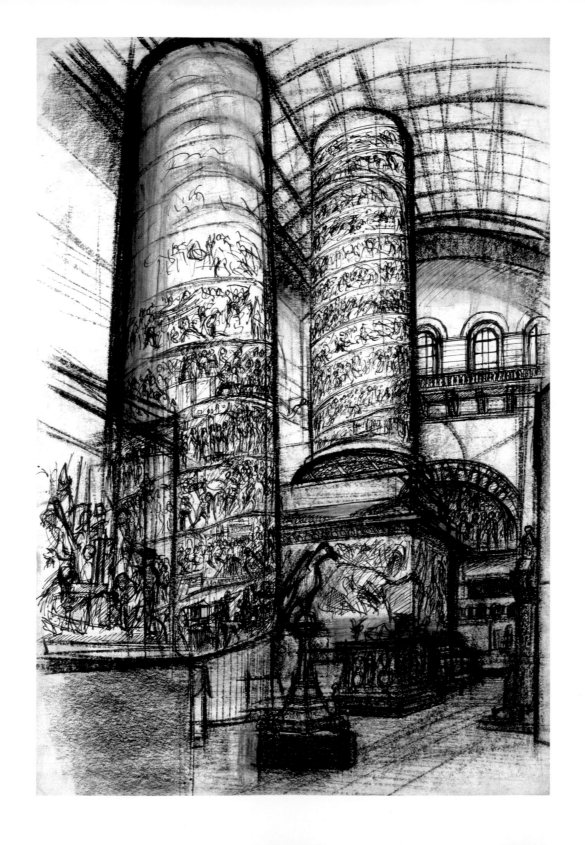

Engine at the Science Museum, London
early 1960s
Pen and ink on paper
38.2 x 56 cm
Private collection

Making things has always been a favourite activity of Steadman's. As a child he built model aeroplanes and when he left school at sixteen his first job was at the De Havilland aircraft factory. There he picked up the rudiments of technical drawing, which he later developed during his national service.

This sketch done at the Science Museum of the Trevithick high-pressure engine (c. 1806) reveals a very precise style of drawing which foreshadows the ruled lines and precisely described circles which would later become an intrinsic part of his style.

Cast room, Victoria and Albert Museum
Pen and ink, conté pencil on paper
56 x 37.8 cm
Private collection

From 1959 to 1966 Steadman devoted himself to mastering the 'discipline' of drawing, spending many afternoons and evenings sketching the exhibits at the great museums in South Kensington. The cast room at the V&A includes plaster casts of a number of classical architectural features, including sections of Trajan's Column in Rome.

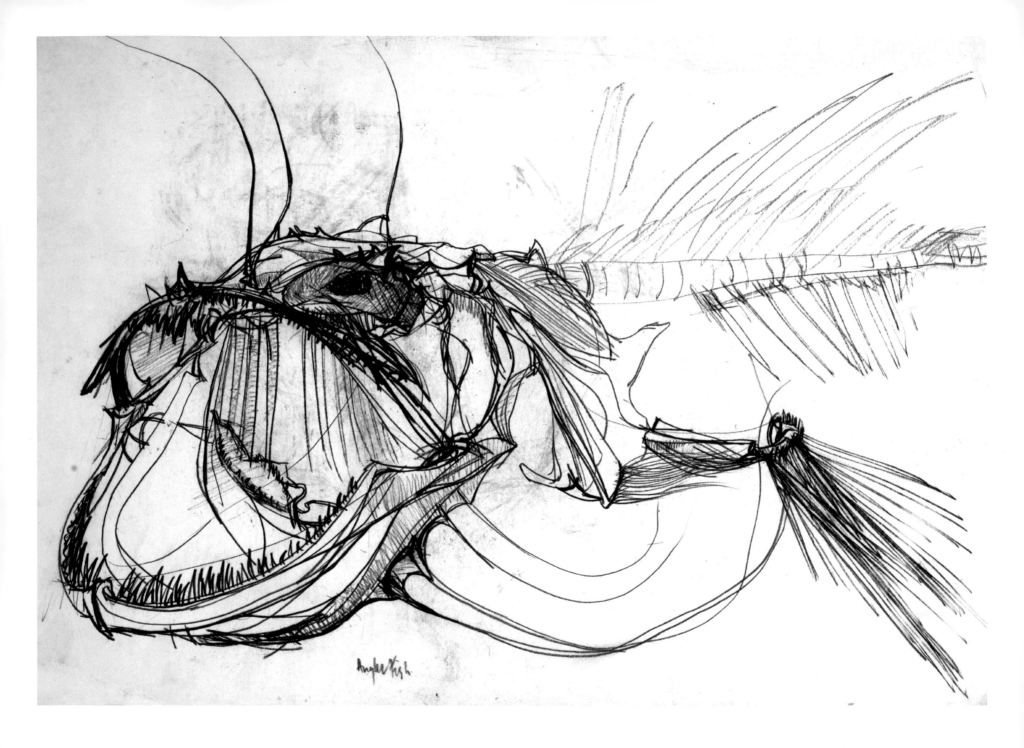

Angler Fish.

34

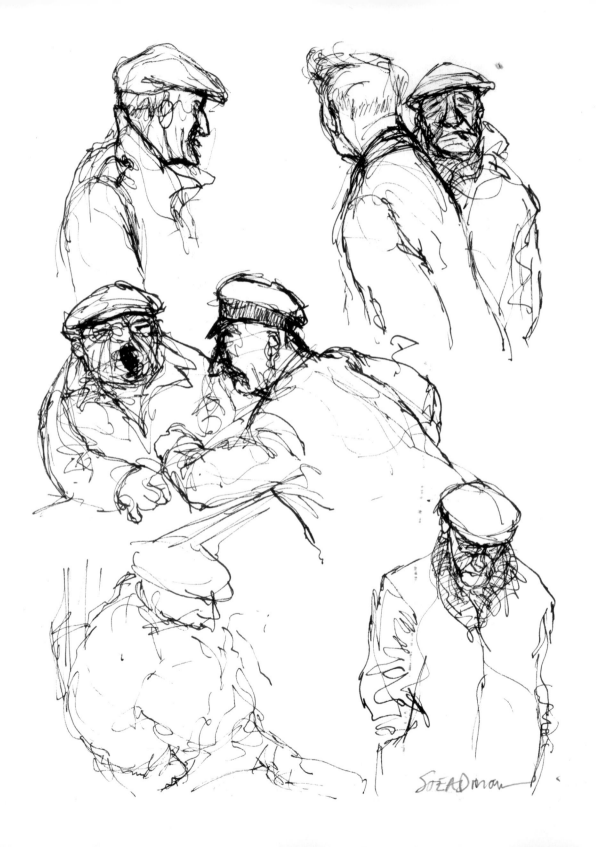

Angler Fish
Pencil on paper
38.2 x 56 cm
Private collection

Steadman also visited the Natural History
Museum, where he sketched this dramatic
specimen. In 2007 he was reunited with many
of his student drawings. They were returned
to him by Leslie Richardson, his former
tutor at East Ham Technical College and the
London College of Printing and Graphic Arts,
who had saved them for nearly fifty years. In
the early 1960s Richardson played a key role
in Steadman's artistic development.

Men in a London Pub
Pen and Indian ink on paper
35.4 x 25.3 cm
Private collection

When he was an art student, Steadman often
continued his life drawing outside of class: 'I
used to draw in pubs for a pint… And that
taught me a lot about character'. In his 2002
memoir twice removed, *Doodaaa. The Balletic
Art of Gavin Twinge*, Ralph's alter ego Twinge
remembers his days of apprenticeship:

> 'Drawing wasn't a gift for me, at first, but
> familiarity and practice are good bedfellows
> … You draw to see how many ways you
> can express a particular form, a shoulder in
> relation to the neck; the solar plexus and
> the wonderful change of direction of a
> leg coming towards you but not bending;
> describing space as it will. When I speak of
> form, I don't mean light and shade. Form
> is the dynamic surface tension of a figure.'
> [*Doodaaa*, 2002, p. 57]

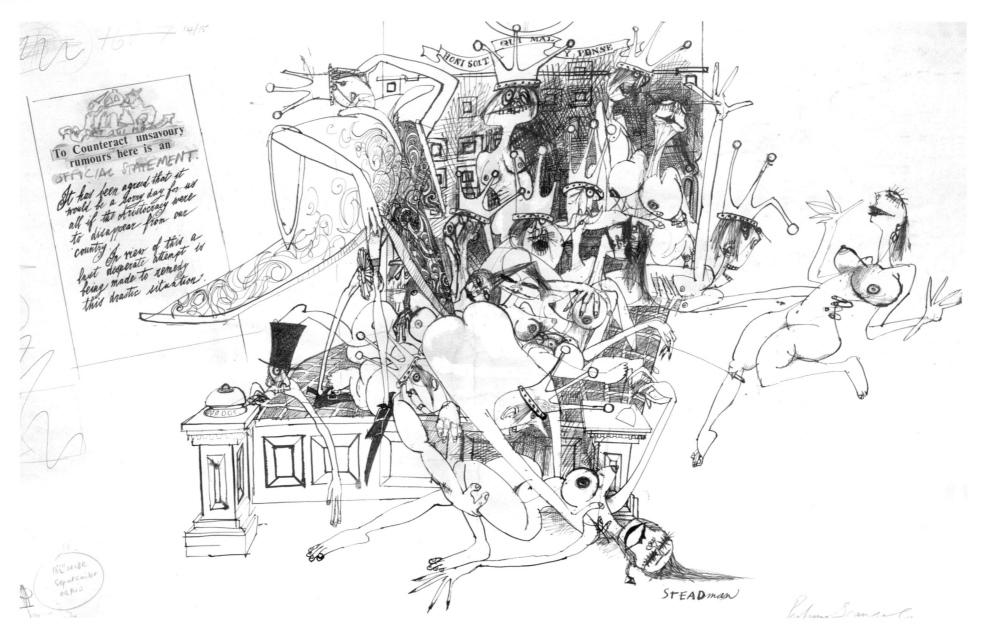

To Counteract unsavoury rumours here is an OFFICIAL STATEMENT
Private Eye, 26 July 1963
Pen and ink on paper
48 x 76.5 cm
British Cartoon Archive, University of Kent

The Peerage Act of July 1963 gave hereditary peers the right to disclaim their titles. The act allowed Sir Alec Douglas-Home, formerly the earl of Home, to succeed Harold Macmillan as prime minister in the Commons in October 1963. Sex was in the serious news as well as the scandal sheets in 1963. In June 1963 Secretary of State for War John Profumo resigned over his relationship with a call girl, Christine Keeler.

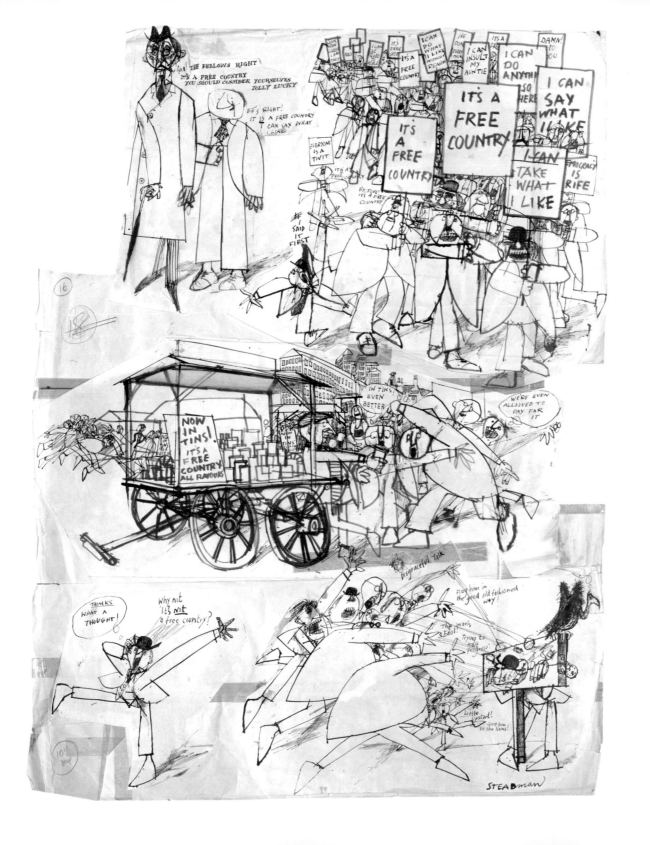

It's a Free Country
Private Eye No. 30, 18 February 1963
Pen and ink on pieces of paper
57 x 76 cm
British Cartoon Archive, University of Kent

This was one half of a double-page spread
in *Private Eye*.

Mr Punch
Unpublished, 1960s
Coloured chalks on paper
54.5 x 38.3 cm
Private collection

This study in Flash Flush and Teasing
Pink shows the influence of the French
cartoonist André François, one of the most
highly regarded cartoonists of the post-
war period and one whose line Steadman
greatly admired. In the late 1950s and '60s he
designed many covers for *Punch*. Steadman's
first cover design for the magazine appeared
on 5 April 1961.

Punch cover
Punch, 17 March 1965
Pen and ink with watercolour and printed collage
54.5 x 38.3 cm
Private collection

In 1961 Steadman began studying at the London College of Printing and Graphic Arts. In the early 1960s he purchased the complete contents of a printer's studio, including a printing press, for the princely sum of £75. Over the years he has made extensive use of the printing blocks and type, which occupy one whole room in his studio.

Hogarth '65
Marriage à la Mode: Breakfast Scene
Private Eye, 30 April 1965
Pen and ink, poster white on paper
45.5 x 64 cm
Private collection

In March 1965 Steadman created a series of
contemporary retellings of Hogarth prints
and paintings for *Private Eye* – 'Hogarth '65',
beginning with *Gin Lane* and *Beer Street*.

His *Marriage à la Mode* updates the
second plate of Hogarth's original suite
of 1745 engravings to the 1960s. Viscount
Squanderfield's drawing room has become
the breakfast room of 'Dingle Nook Guest
House' and the languid young Lord is now
a slouching biker. His heavily pregnant wife
has exchanged her silks for slacks. The violin
and music-book are now an electric guitar
and a 'fab' magazine with an article on Jagger
and the Rolling Stones. An electric fire with
flame effect has supplanted the ornate 18th
century original, and on the mantelpiece,
the Squanderfield's chinoiserie and antique
bust have made way for a Blackpool Tower
thermometer and a large glass cat.

The upright steward of the Squanderfield
household is now a slobbish landlord,
clutching, in lieu of a sheaf of unpaid bills, a
football pools coupon.

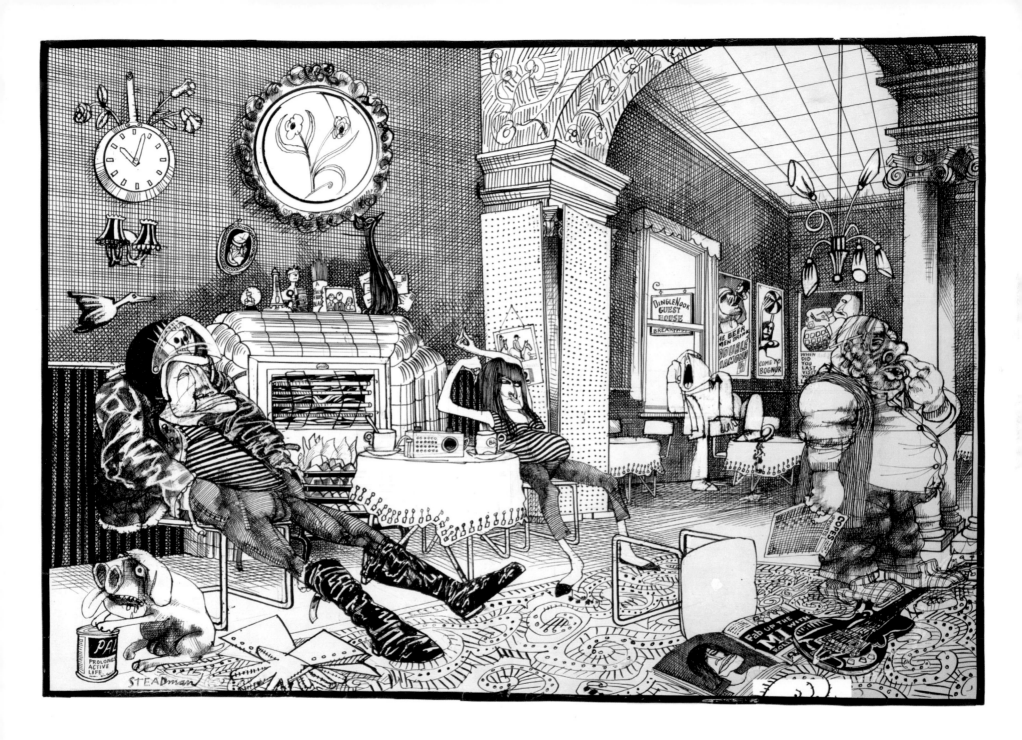

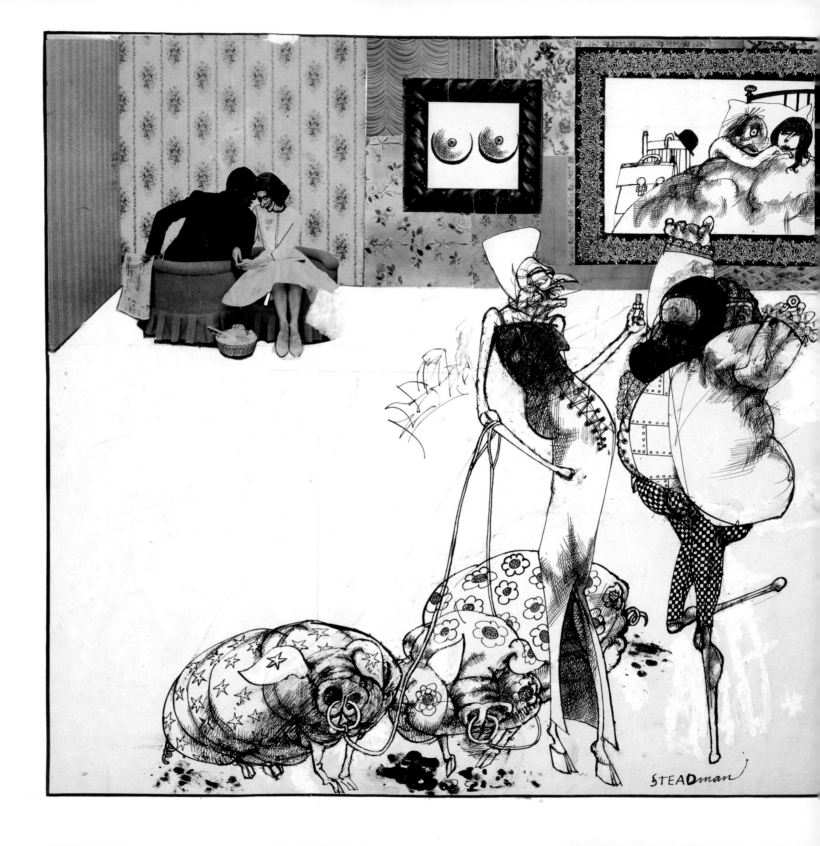

Hogarth '65: Taste in High Life 1

1965, in *Still Life with Raspberry*,
Rapp & Whiting, 1969
Collage, pen and ink, poster white on paper
50 x 71.7 cm
Private collection

In Hogarth's c.1742 painting, *Taste in High Life,* two niminy-piminy connoisseurs of modern taste rhapsodise about a tiny cup and saucer. Steadman's 1960s counterparts – she hoofed and trussed à la mode, he a bearded and befrilled Edward-Lear-look-alike, are in ecstasy over a bijou nut and bolt. Hogarth's monkey has been supplanted by a duo of fashionable piggy-wigs with rings at the end of their noses. The fire-screen has been replaced by a pedestal, on which is displayed the couple's latest curio.

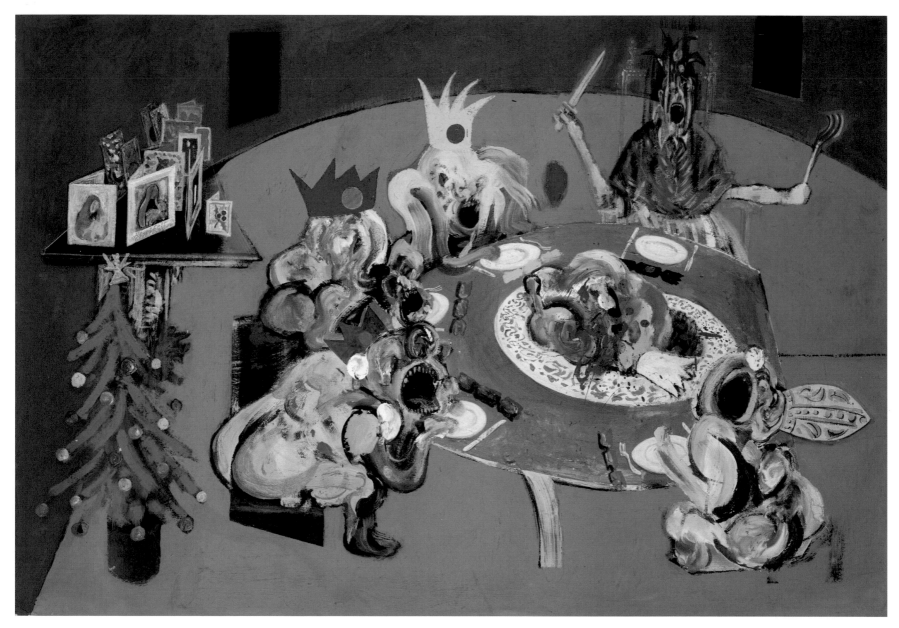

Francis Bacon's Christmas Party
c. 1966–8
Gouache on board
52.5 x 76.6 cm
Private collection

A Screaming Pope invites some Baconian biomorphs round for a spot of Xmas lunch.

In 1949 Francis Bacon created *Head VI*, the first of his series of paintings inspired by Velázquez's *Portrait of Innocent X* – the so-called 'Screaming Popes'.

In 1974 Hunter S. Thompson said of his friend: 'His view of reality is not entirely normal. Ralph sees through the glass very darkly.'

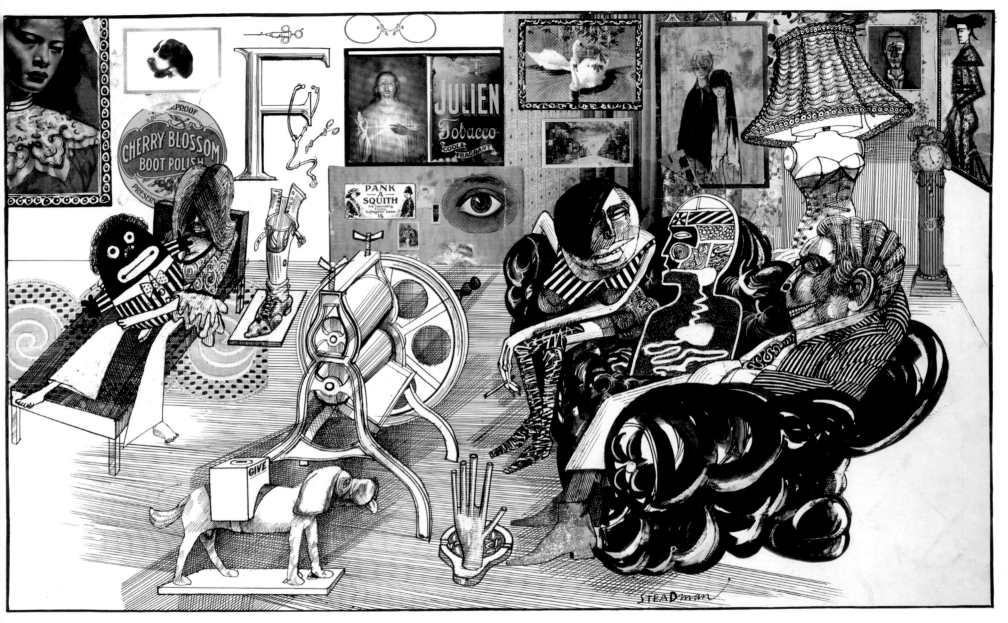

Hogarth '65: Taste in High Life 2
Private Eye, 6 April 1965
Reprinted in *Still Life with Raspberry,*
Rapp & Whiting, 1969
Pen and Indian ink and collage on paper
47 x 73 cm
Private collection

In his Hogarthian homage, *Taste of High Life 2* Steadman recycled some of the decade's most evocative mass-produced images, including Vladimir Tretchikoff's *Chinese Girl,* big-eyed waifs popularised in the 1960s by the American artist Margaret Keane, and the Sacred Heart. Steadman's gallimaufry satirises the new fashions in interior design, mixing antique and modern, good design and junk.

Steadman told Sue Lawley on *Desert Island Discs* in 1998: 'We've become saturated with imagery – we don't know what to do with it all. I recycle it. I actually put it in my drawings again – things that exist in magazines and newspapers and bits of print and bits of everything.'

**New London Cries
No. 1 'Non-Stop Strip!'**
Private Eye, 12 November 1965
Pen and ink, poster white on paper
51 x 28 cm
Private collection

At the end of 1965 Steadman began a new
series in the *Eye*: 'New London Cries'. The
pocket-sized reproductions in the magazine,
however, fail to do justice to his drawings.
Steadman's cries and London types follow
in the unsentimental tradition of the 18th
century 'London Cries' of Paul Sandby and
Thomas Rowlandson – pictures of hawkers,
street vendors and musicians – but without
the 'come buys' and folderol of the originals.
They punch you in the face.

 Steadman's discovery of the German
satirical artist George Grosz early in his
career profoundly shaped his style. His
observations of London life in the 1960s have
something of the brutal honesty of Grosz's
Berlin drawings of forty years earlier. 'What
interested me,' wrote Grosz in 1923, 'was the
work of committed outsiders and moralists
of painting: Hogarth, Goya, Daumier, and
their like. I drew and painted out of a spirit of
contradiction, and through my work I sought
to convince the world that it, the world, was
ugly, diseased and perfidious.'

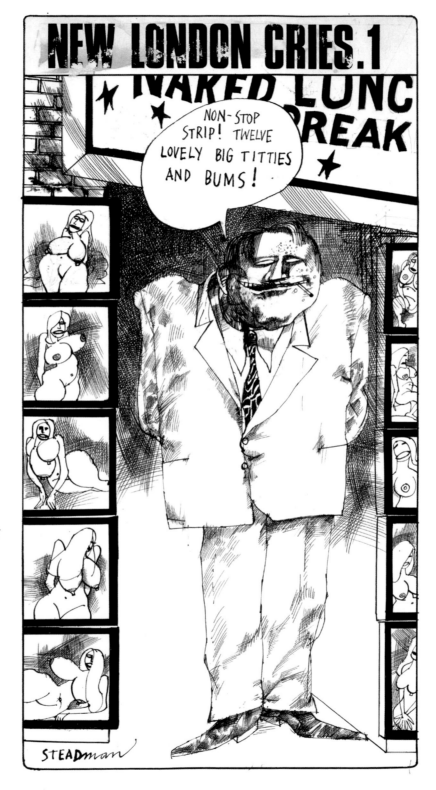

**New London Cries
No. 2 The Taxi Driver**
Private Eye, 26 November 1965
Pen and ink, poster white on paper
51.4 x 28 cm
Private collection

**New London Cries
No. 4 The Waiter**
Private Eye, 24 December 1965
Pen and ink, poster white on paper
51.7 x 28.5 cm
Private collection

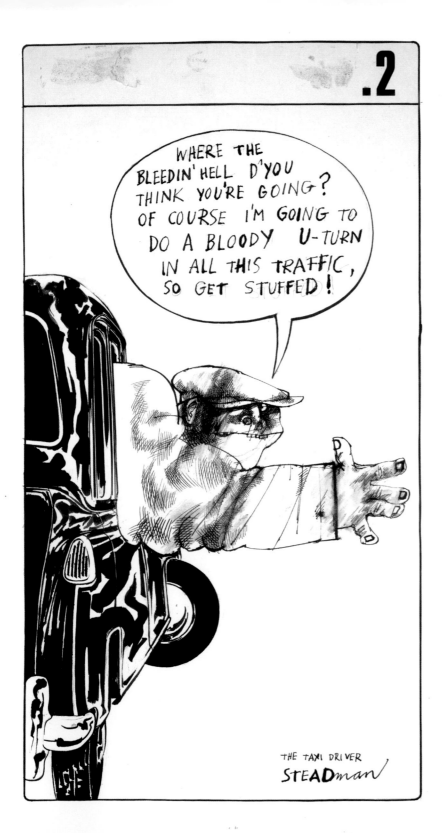

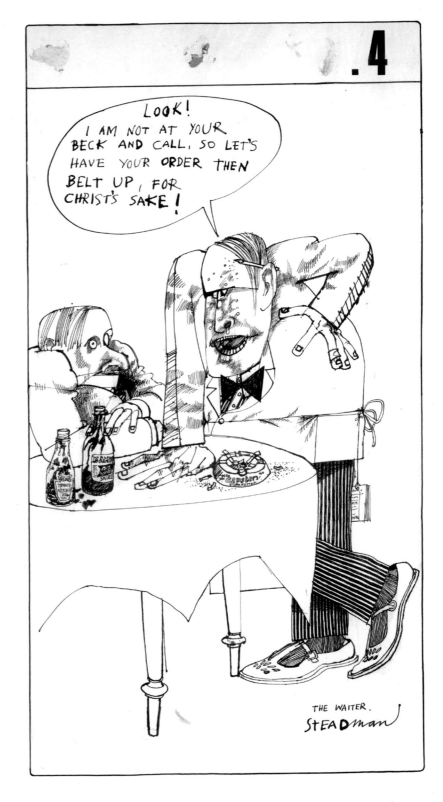

**New London Cries No. 6
'Don't 'e look queer?'**
Private Eye, 21 January 1966
Pen and Indian ink on paper
52 x 28.5 cm
Private collection

For a period in the 1960s swinging London
became the centre of the fashion world.
Mary Quant invented the mini-skirt and
hairdressers like Vidal Sassoon were setting
the trends for men as well as women. Trendy
boutiques on the King's Road and Carnaby
Street kitted out modern Dandies in satin
shirts and brocade jackets adorned with frills
and flounces that made them suspect in the
eyes of many.

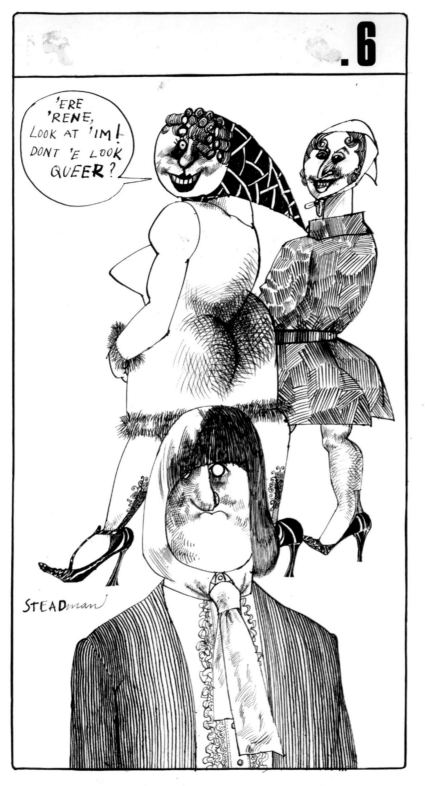

opposite: **Seventeen Years On …**
c. 1968
Pen and Indian ink on paper
51.5 x 73 cm
Private collection

In 1945 the Labour party won a landslide
victory in the general election. The Welfare
State opened up opportunities of free
secondary and third-level education to
many for the first time. Boys and girls from
working and lower-middle class backgrounds
could now go to grammar school and ascend
to the hallowed halls of universities. Their
subsequent questioning of the status quo
sometimes led to their estrangement from
the family circle.

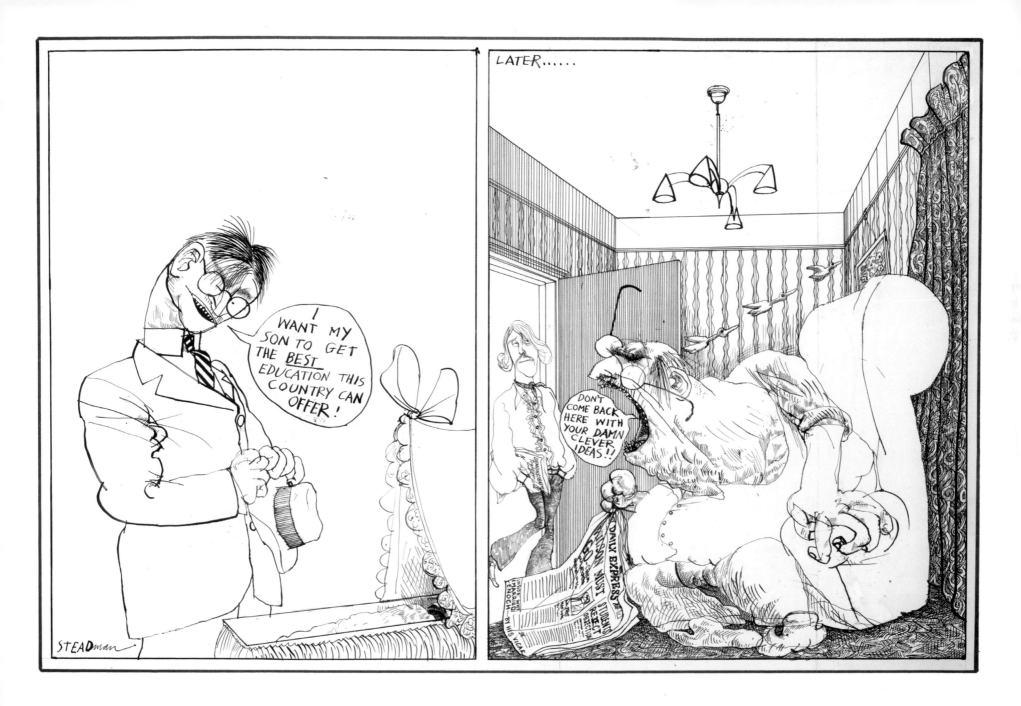

New London Cries
No. 9 'I'll Sue the Bastards!!'
Private Eye, 4 February 1966
Pen and ink, poster white on paper
51.9 x 28.1 cm
Private collection

Private Eye received its first libel writ in
November 1962. The first accusation of libel
against the *Eye* to go to court was brought
by Lord Russell of Liverpool in 1965. The
magazine lost and had to pay £8,000 in
damages and legal costs.

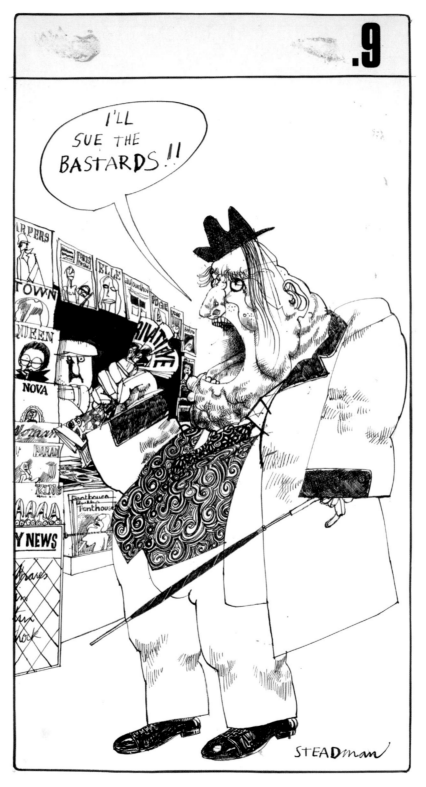

opposite:
Bedlam
1967
Ink with gesso on paper
66 x 66 cm
Private collection

It is not known what this ingeniously
labyrinthine guide to 1960s Britain was
produced for. Players enter the game through
a train carriage door and are taken on a
rollercoaster ride around the sixties social
scene. Among the destinations in this social
whirl are everything from an Art Gallery to a
Nudist Camp, a Ski Resort to a Betting Shop,
and everybody from a Psychiatrist to Guru
Brahmin – all represented in a gloriously
seedy style.

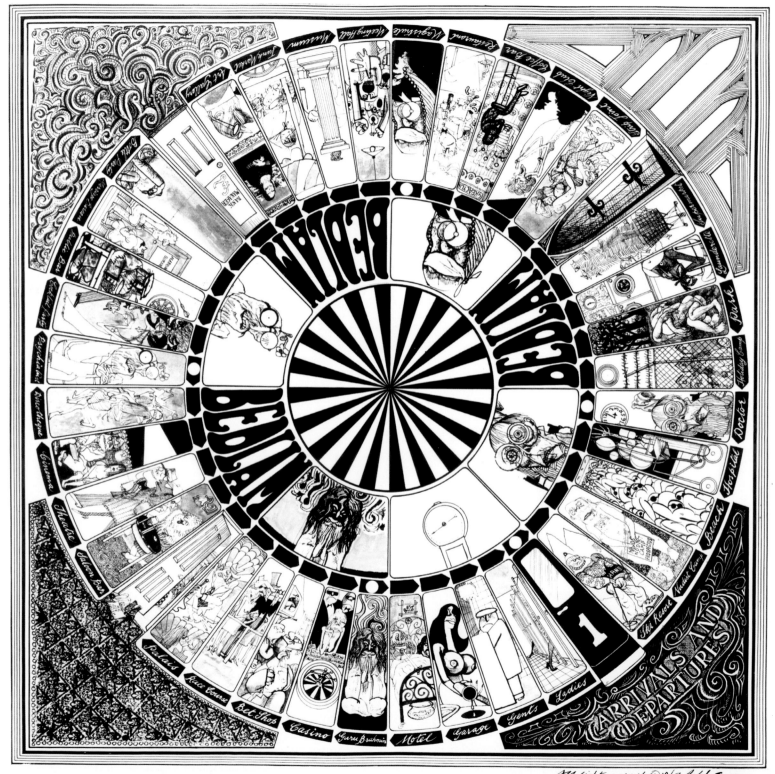

New Cries of London No. 18
'This Filthy Bleedin' Bunny Idea'
Private Eye, 8 July 1966
Pen and Indian ink on paper
56 x 38.5 cm
Private collection

On 29 June 1966 Playboy expanded its
operation, opening a London Playboy Club.
Described as the 'Gilded Hutch on Park Lane'
it was the first to offer a casino as well as
the usual dancing, drinking and dining with
the eye-catching Bunny Girls in attendance.
Bunnies were off limits to customers with no
touching or dating allowed.

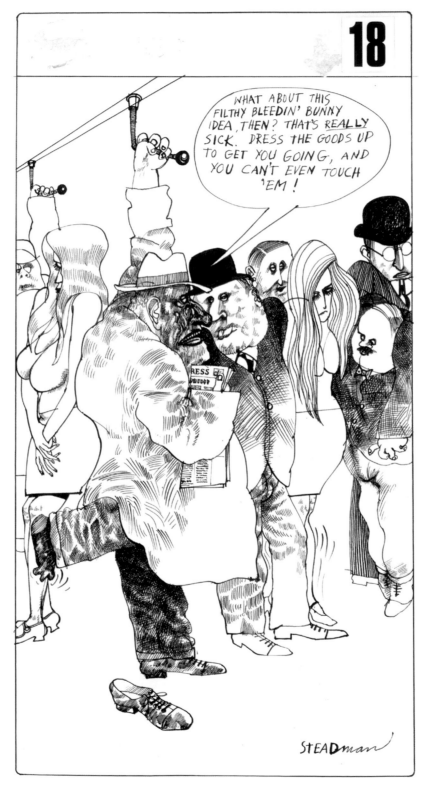

opposite: **The Man Who Touched a Bunny**
after H. M. Bateman
Private Eye, 17 February 1967
Pen and Indian ink and wash on paper
42.5 x 55.5 cm
Private collection

In the early 1960s Ralph Steadman visited the
retired cartoonist H. M. Bateman in his home
in Devon. The two chatted and sketched
each other, exchanging portraits. In the 1920s
Bateman's 'The Man Who …' drawings
captured the British obsession with class and
the horrors of the social *faux pas*.

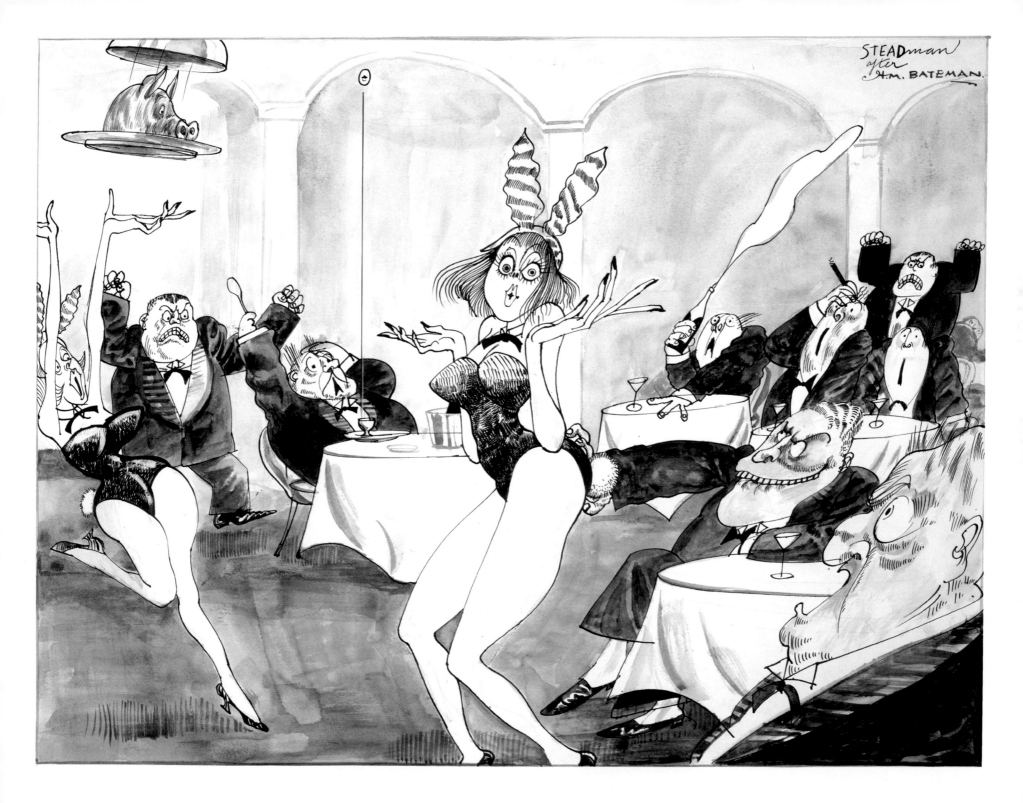

STEADman
after
H.M. BATEMAN.

53

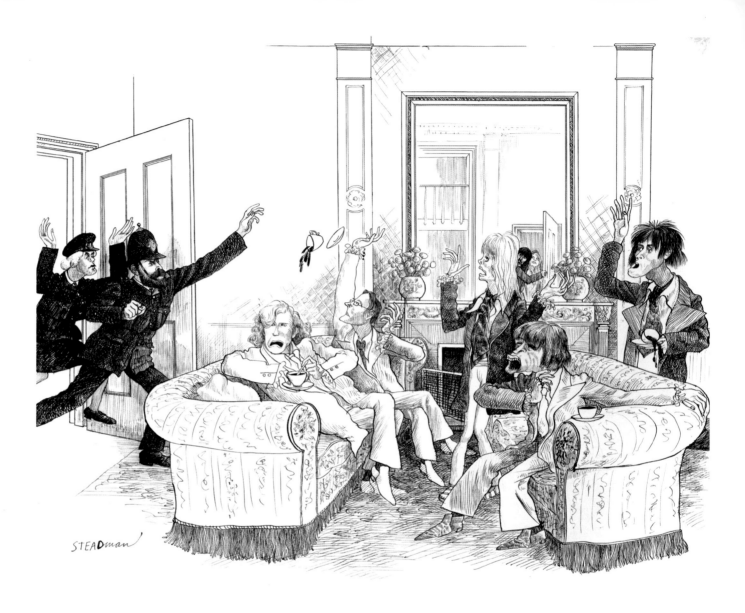

**Weekend at West Wittering
'Our visual reporter captures the dramatic moment when our gallant men in blue leap into the room and apprehend the miscreants.'**
Private Eye, 21 July 1967
Pen and ink, poster white on paper
47.3 x 52 cm
Private collection

On 12 February 1967 police raided a house-party at Redlands, Keith Richards' manor house at West Wittering, near Chichester, on a tip-off from the *News of the World*. The police took away some Ambre Solaire suntan lotion, a quantity of Earl Grey tea, joss sticks and a minute amount of cannabis resin.

In May 1967 Mick Jagger was charged with possession of two mild amphetamines (in fact, two travel sickness pills bought in Italy), Richards with permitting his house to be used for the smoking of cannabis, and a friend, the art dealer Robert Fraser, with the possession of heroin. (Fraser, in glasses, is shown sitting next to the antiques dealer and fellow dandy, Christopher Gibbs.) On 27 July all three were found guilty at Chichester Crown Court: Richards was sentenced to one year in jail, Fraser to six months and Jagger to three months. Jagger was later conditionally discharged and Richards' sentence was quashed on appeal.

Also present at Steadman's soirée is Jagger's girlfriend, Marianne Faithfull ('the girl in the fur rug'). George Harrison and Pattie Boyd can be spied in the mirror: the West Sussex constabulary discreetly waited for the Beatle to leave before they pounced.

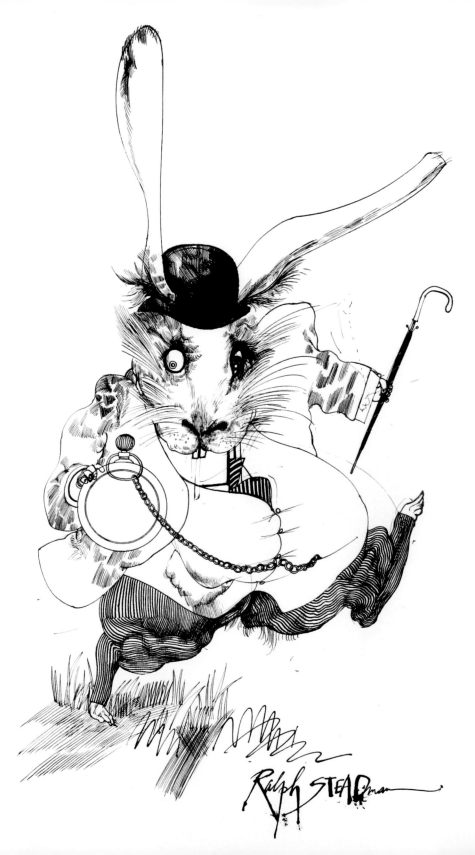

'...but, when the Rabbit actually *took a watch out of its waistcoat-pocket,* and looked at it, and then hurried on, Alice started to her feet, for it flashed across her mind that she had never before seen a rabbit with either a waistcoat-pocket, or a watch to take out of it, and, burning with curiosity, she ran across the field after it, and was just in time to see it pop down a large rabbit-hole under the hedge.'

from *Alice in Wonderland* by Lewis Carroll
Dennis Dobson, 1967

The White Rabbit
Pen and ink on paper
48.2 x 30.5 cm
Private collection

In 1967 Steadman noted of the White Rabbit: 'Worried by time, hurrying and scurrying. Sane within a routine, slightly insane but more engaging when the routine is upset. Today's commuter.'

Steadman admits to not having read Lewis Carroll's *Alice's Adventures in Wonderland* before he began to illustrate a new edition of the 1865 nonsense classic in 1967. 'It was all so familiar when I picked it up for the first time … Don't you ever get the strange sensation that what you are reading or watching is something you already know?'
　　Steadman's drawings for Carroll's *Alice* books proved to be a perfect match. Arguably, many surpass in their verve and interpretive wit and sensitivity John Tenniel's original illustrations. In 1972 his *Alice in Wonderland* drawings won the Francis Williams Award for the best illustrated book of the previous five years.

'The table was a large one, but the three were all crowded together at one corner of it. "No room!" they cried out when they saw Alice coming. "There's *plenty* of room!" said Alice indignantly, and she sat down in a large arm-chair at one end of the table.'

from *Alice in Wonderland*
Dennis Dobson, 1967

A Mad Tea Party
Pen and ink on paper
55.8 x 77.4 cm
Private collection

In 1978 Steadman told the documentary filmmaker, Michael Dibb that he had wanted to use the *Alice* books as 'some sort of catalyst' to express what he wanted to do. 'It was a perfect Victorian situation that could be transplanted to the sixties scene.'

'THE HATTER,' he wrote in 1967, 'represents the unpleasant sides of human nature. The unreasoned argument screams at you. The bully, the glib quiz game compère who rattles off endless reels of unanswerable riddles and asks you to come back next week and make a bloody fool of yourself again.

THE MARCH HARE is always standing close by. The 'egger-on' urging the banality to plumb greater depths. He always seems to be around to push someone into a fight.

THE DORMOUSE is always the dormouse. Harmless and nice. The man anyone in the office can take a rise out of. If you tread on his face he will smile right back at you.'

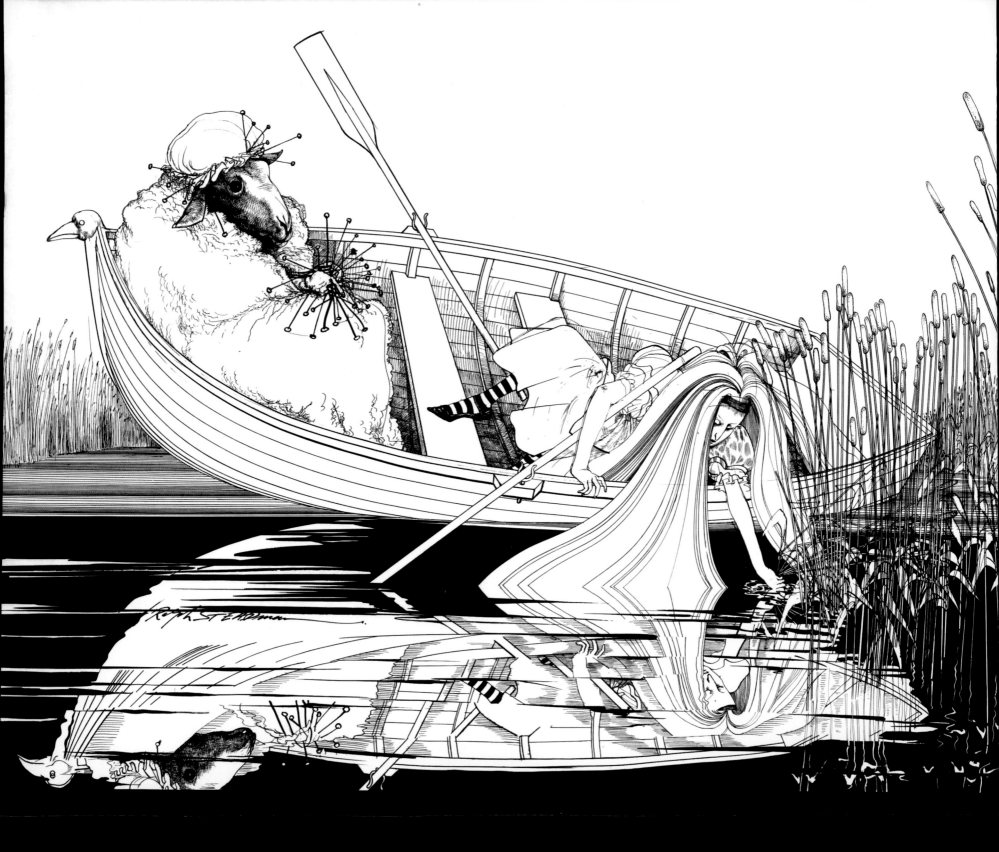

Wool and Water
Pen, brush and ink, poster white on paper
55.7 x 76.3 cm
Private collection

Following the success of the first *Alice* book,
Steadman was commissioned by the Lewis
Carroll Society to illustrate a centenary edition
of Carroll's 1871 sequel, *Through the Looking-
Glass*. At the time he was living in a flat full of
mirrors, 'which were having a strange effect
on my mind. Reflection became a strange
presence and suited my new project perfectly'.
His drawings for the second book became
even more conceptually and stylistically daring.
In one double-page image Alice is shown
climbing through the gutter of the book into
the looking-glass world. In *Wool and Water* the
specular play is on the horizontal rather than
the vertical plane: 'I drew this part with Alice
and the Sheep in the boat; then I traced it and
folded the tracing; and then rubbed it down on
to the bottom part of the picture in order to get
what I wanted here, which is the broken image'.

'This time it was a White Knight. He drew up at Alice's side, and tumbled off his horse just as the Red Knight had done; then he got on again, and the two Knights sat and looked at each other without speaking. Alice looked from one to the other in some bewilderment.'

from *Through the Looking-Glass, and What Alice Found There*
by Lewis Carroll
MacGibbon & Kee, 1972

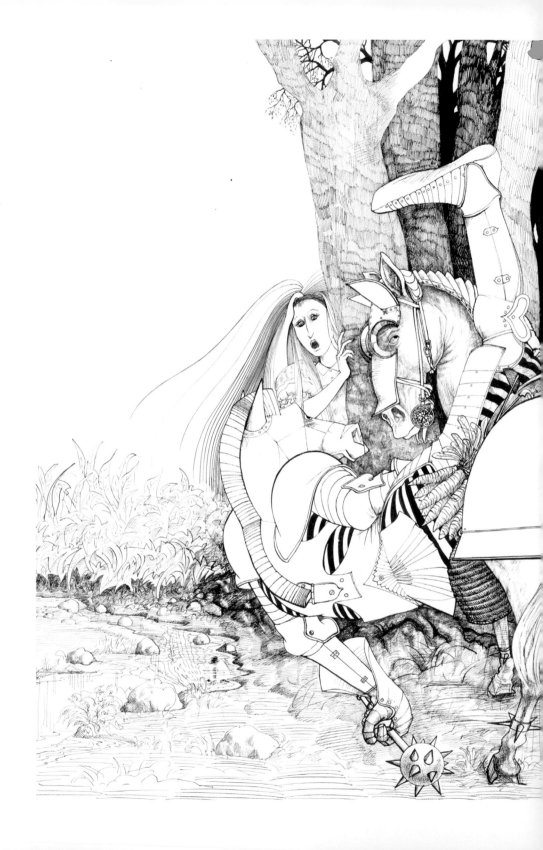

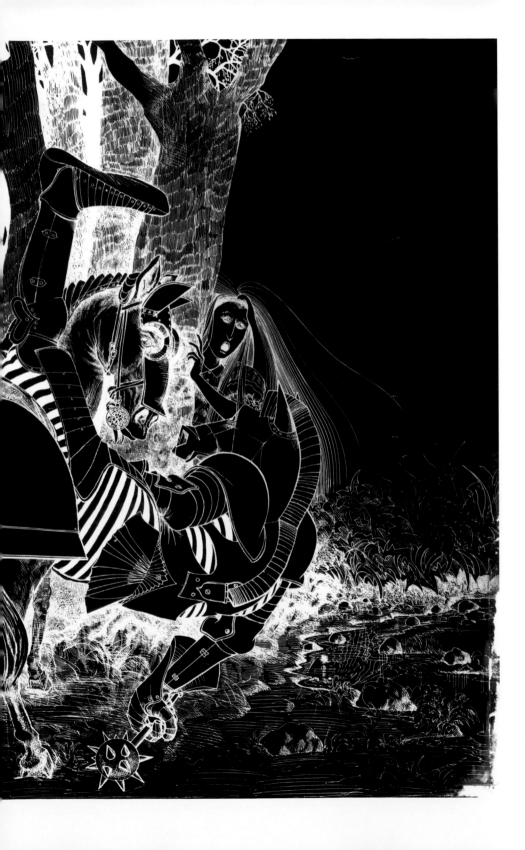

The White Knight and the Red Knight
Pen and ink, acrylic white,
photographic print on paper
55.7 x 76 cm
Private collection

Using the gutter as an axis of reflection,
Steadman conjures the Red Knight from
the White Knight through a negative
photographic print. The artist has selectively
removed the White Knight's bunches of
carrots, fire-irons, bee-hive and horse's anklets
from the Red Knight's trappings.

'Just the place for a Snark!' the Bellman cried,
 As he landed his crew with care;
Supporting each man on the top of the tide
 By a finger entwined in his hair.

'Just the place for a Snark! I have said it twice:
 That alone should encourage the crew.
Just the place for a Snark! I have said it thrice:
 What I tell you three times is true.'

from *The Hunting of the Snark* by Lewis Carroll
Michael Dempsey, 1975

The Landing
Pen, brush, ink and acrylic paint on paper
56 x 69 cm
Private collection

Lewis Carroll's 1876 tale of derring-do *The Hunting of the Snark: An Agony in Eight Fits* completed Steadman's cycle of the Rev. Dodgson's nonsense works. Among the intrepid crew in pursuit of the Snark (that *was* a Boojum) are, centre, the Bellman (captain of the ship) dandling the Boots; on board, above a bird figurehead, is the Billiard-marker, and below him are the Banker, the Broker, the Butcher, the Baker (wearing seven coats), the Barrister, the Beaver and the Bonnet-maker.

He came as a Butcher: but gravely declared,
 When the ship had been sailing a week,
He could only kill Beavers. The Bellman looked scared,
 And was almost too frightened to speak:

But at length he explained, in a tremulous tone,
 There was only one Beaver on board;
And that was a tame one he had of his own,
 Whose death would be deeply deplored ...

Yet still, ever after that sorrowful day,
 Whenever the Butcher was by,
The Beaver kept looking the opposite way,
 And appeared unaccountably shy.

from *The Hunting of the Snark* by Lewis Carroll
Michael Dempsey, 1975

The Butcher and the Beaver
Etching
28 x 26 cm
Private collection

The last to join the crew was the Butcher.

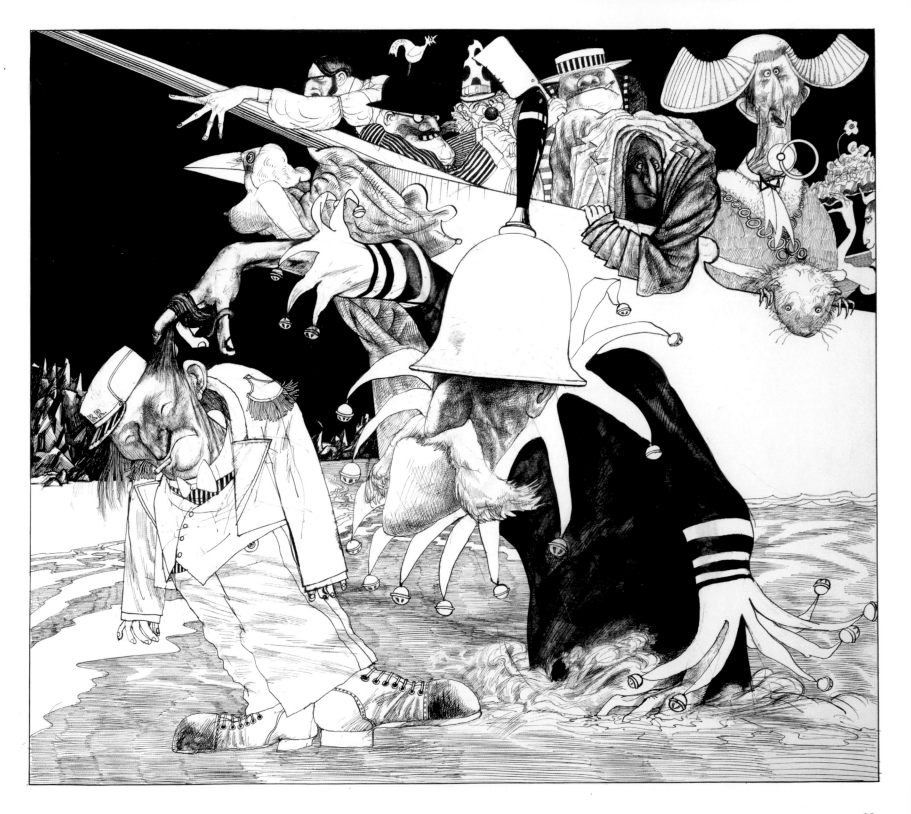

'Suddenly the doors opened and mice dressed as doctors and nurses wheeled out a lot of little beds and pushed them into rows. Henry couldn't believe his eyes – he leant over the edge of his bed to get a closer look.'

from *Emergency Mouse*
A Story by Bernard Stone
Andersen Press, 1978
Pen, brush, mouth atomiser and coloured inks on paper
30.4 x 48.1 cm
Private collection

It is midnight and everyone on the hospital ward is asleep except Henry, who sees a mouse hospital taking shape on the floor beneath his bed.

The story was written by Bernard Stone, the proprietor of the alternative Turret Bookshop in Kensington Church Walk, W8. Here Stone welcomed poets, novelists and artists, many of whom, including Steadman, became close friends. Stone and Steadman's *Emergency Mouse* was followed by *Inspector Mouse* (1980) and *Quasimodo Mouse* (1984).

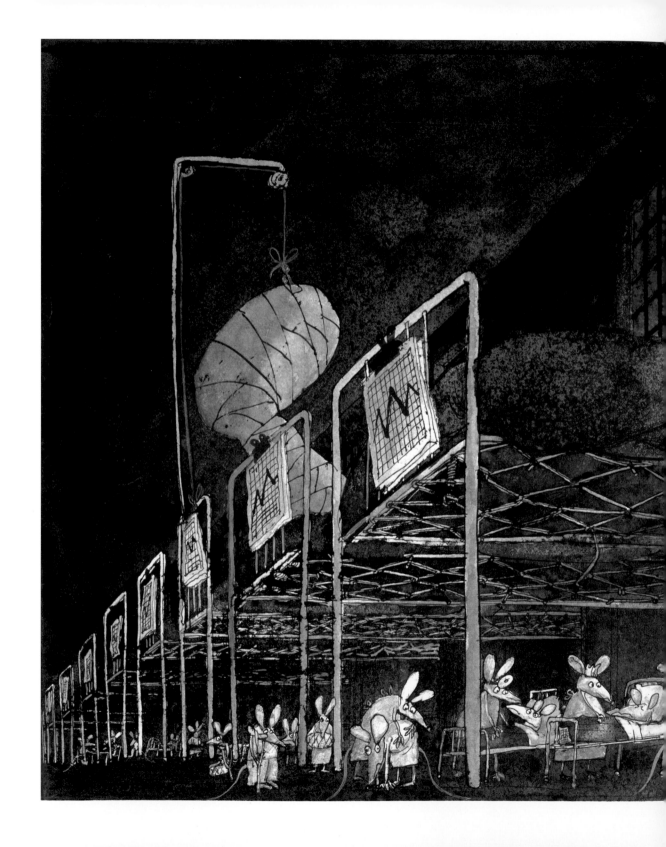

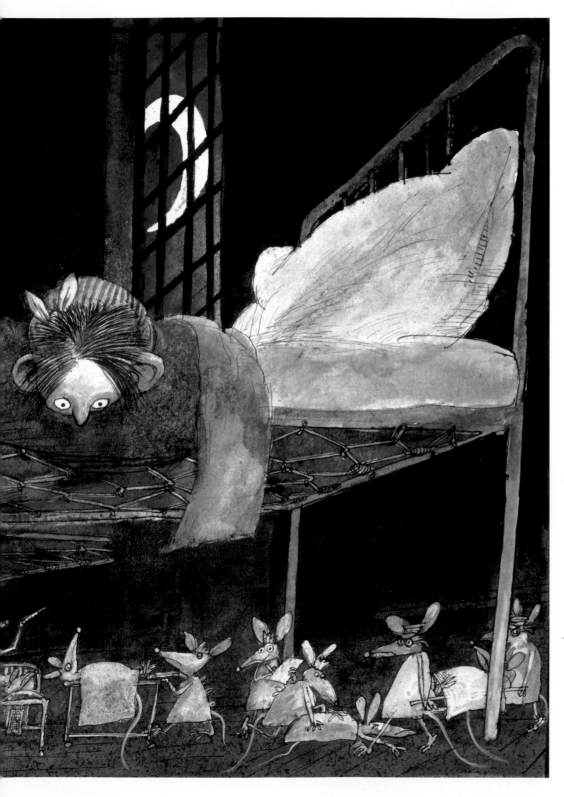

'"Emergency here! Get him to the operating theatre at once!" It was Surgeon Mouse speaking. Champion Mouse, the daredevil cheese-stealer, had been caught in the act at last and he was brought in with a mouse-trap firmly caught on his tail.'

from *Emergency Mouse*.
A Story by Bernard Stone
Andersen Press, 1978
Pen, brush, mouth atomiser and coloured inks on paper
48.6 x 35.8 cm
Private collection

'My room's too small,' said Tom. 'What d'you mean, love?' asked his mother.

from *No Room to Swing a Cat*
Andersen Press, 1989
Pen, brush, mouth atomiser and
acrylic ink on paper
59.4 x 84 cm
Private collection

Tom is fed up. He complains to his mother that his room is simply too small. Together they explore just how big it needs to be.

'My room's too small.
There's not even room to swing a cat.'

from *No Room to Swing a Cat*
Andersen Press, 1989
Pen, brush, mouth atomiser and
acrylic ink on paper
59.4 x 84 cm
Private collection

**'How big do you want it? …Big enough
to swing a donkey, then?' said his mother
'Nope,' said Tom.**

from *No Room to Swing a Cat*
Andersen Press, 1989
Pen, brush, mouth atomiser and
acrylic ink on paper
59.4 x 84 cm
Private collection

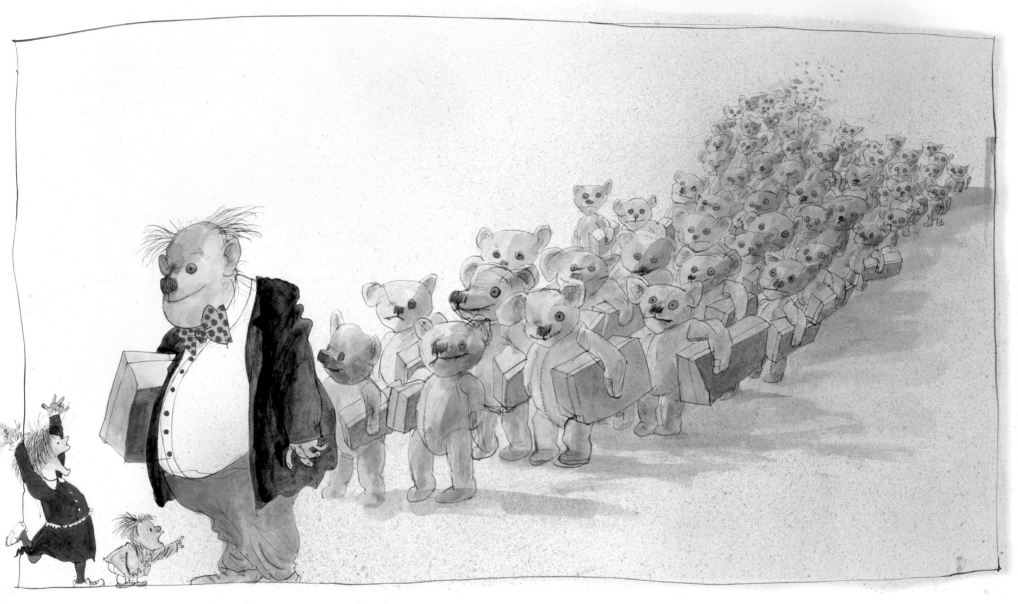

'So they all came. Grace and Rebecca Scarlett had never been so happy... and neither had the Teddy Bears.'

from *Teddy! Where Are You?*
Andersen Press, 1994
Pen, brush, mouth atomiser and
acrylic ink on paper
59.4 x 84 cm
Private collection

Inspired by the much-loved, well-worn, one-eyed Teddy Bear of the artist's wife, Anna, *Teddy! Where Are You?* follows Grace, Rebecca Scarlett and their grandfather Grumpy on their search for a worn out Teddy Bear 'that needs to be loved, and with only one eye'.

At a local toyshop they are very taken with the manager, who has 'a worn out face' and 'looked awfully unloved'. Grumpy decides to buy him and the children are overjoyed when he decides to bring along his many Teddy Bear friends – all of whom come with their own cardboard boxes.

An Afternoon on the Serpentine
after Georges Seurat

Town, October 1967
Pen and Indian ink on paper
45.6 x 66.7 cm
British Cartoon Archive, University of Kent

Town magazine headlined this picture
'Steadman's International Gallery – The first
in a series by Ralph Steadman'. In the 1880s
Seurat depicted the Parisian bourgeoisie
relaxing on the island of La Grande Jatte on
the Seine in *A Sunday Afternoon on the Island of
La Grande Jatte*. Steadman's exquisite pointillist
penmanship updates the promenading to
Hyde Park, London in the 1960s.

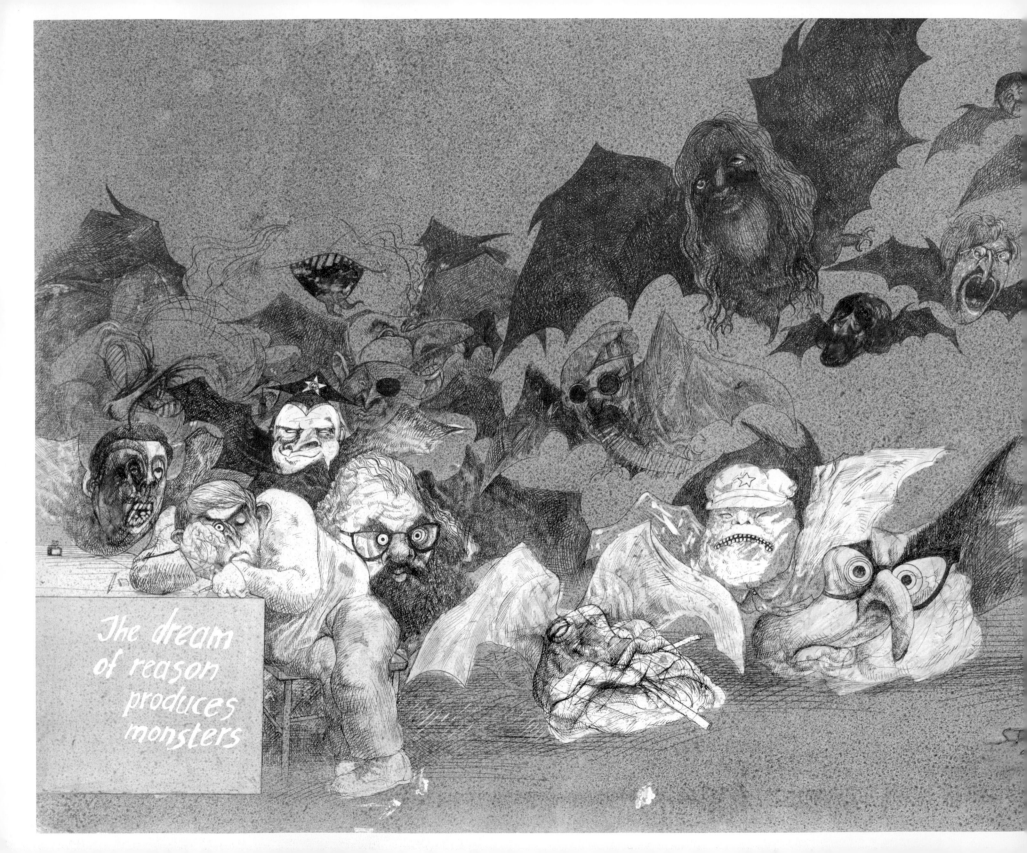

The dream of reason produces monsters.
Ralph Steadman dreams.
after Goya
Town, January 1968
Pen, ink and mouth atomiser on board
51.2 x 76.3 cm
British Cartoon Archive, University of Kent

1968 proved to be a turbulent year. Among Steadman's baleful progeny are from left to right: the Black Power activist Stokely Carmichael; US president Lyndon B. Johnson (grinning); Labour prime minister Harold Wilson (forked tongue flicking); communication theorist Marshall McLuhan (in academic cap); Israeli defence minister General Moshe Dayan (in eye patch) next to Egyptian president Gamal Abdel Nasser (two protagonists of the June 1967 Six Day War); Beat poet Allen Ginsberg (glasses and beard); 'Mercenary' (in beret and goggles); Mick Jagger (lips); 'Red Guard' (in Mao cap); Labour foreign secretary George Brown (biggest bat); and fluttering high above, the Maharishi Mahesh Yogi and his new recruits, George, John, Paul and Ringo.

Steadman adapts Goya's *El sueño de la razón produce monstruos*, No. 43 of Goya's 1799 cycle of prints, *Los Caprichos*. Whereas Goya used burnished aquatint and finely powdered rosin to create the eerie granular dusk of many of his etchings, Steadman achieves similar tonal effects through the use of breath, ink, a mouth atomiser and stopping-out.

Buttons and Dials

Illustration to Noam Chomsky,
'The Welfare/Warfare Intellectuals'
New Society, 3 July 1969
Pen and ink on paper
55.3 x 41.5 cm
Private collection

One of Steadman's characteristic principles of construction is the use of compass and straightedge, a legacy of his training in draughtsmanship. Concentric circles have become a signature motif in his work. Exactly described, Euclidean eyes give a manic-compulsive quality to a subject, or a hollowed-out deadness. A compass circle can become an abyssal mouth or a pendulous goitre. Tightly ruled verticals and recessive horizon lines define the cityscapes of his work in the 1970s. The artist is only able to achieve these effects, so powerful in reproduction, by working on large sheets of paper.

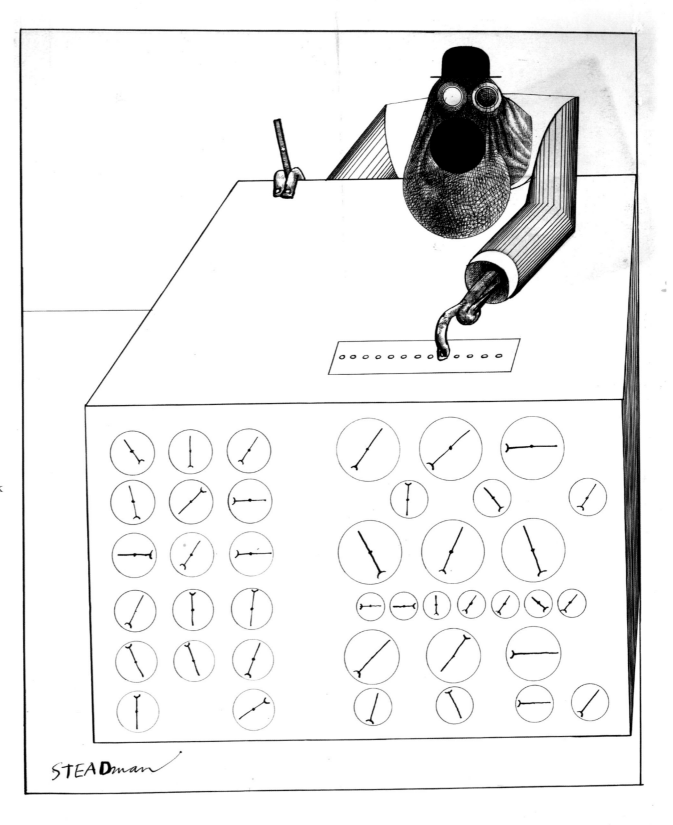

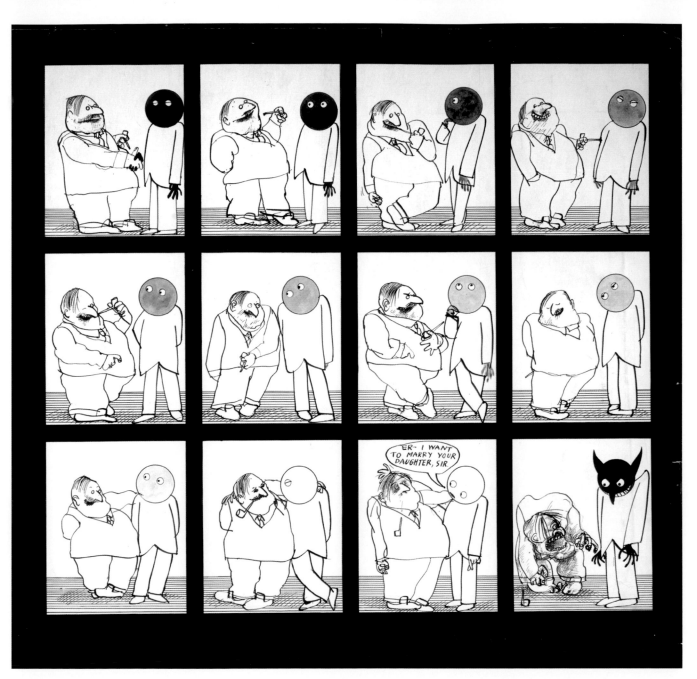

'Er, I want to marry your daughter, sir.'
c. 1968
Pen, brush and ink on paper
53.1 x 55.8
Private collection

In the late 1960s Steadman produced a series of 'Black Cartoons' satirising the racism – openly expressed and hypocritically concealed – endemic to British society at the time.

AUTHORITY IS THE MASK OF VIOLENCE (STEADman)

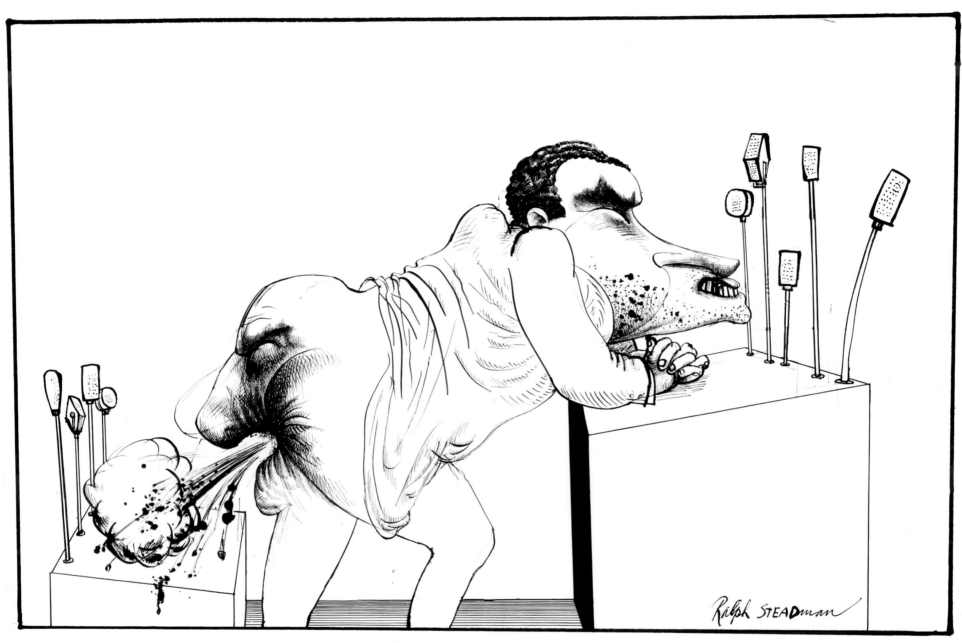

Richard Nixon and Spiro Agnew
first published in *Private Eye*,
5 December 1969
reprinted in *Rolling Stone*, 28 September 1972
Pen and ink on paper
55 x 76 cm
Private collection

Richard Nixon's Vice President Spiro Agnew was in Steadman's words, 'one of the most hated men in politics'. Agnew was Nixon's mouthpiece and chief hatchet man. Scourge of the liberal establishment (the 'radic-libs', as he liked to call them), his rhetorical venom was regularly spat at opponents of the Vietnam War ('impudent snobs') and critics of Nixon's administration.

In November 1969, after critical voices were raised in the media following Nixon's speech on his Vietnam policy, Agnew used a televised address to blast America's TV networks, dismissing them as 'a tiny closed fraternity of privileged men'. Just a few days later the investigative journalist Seymour Hersh reported the cover-up of a massacre in March 1968 of more than 500 unarmed Vietnamese men, women and children by American soldiers at My Lai.

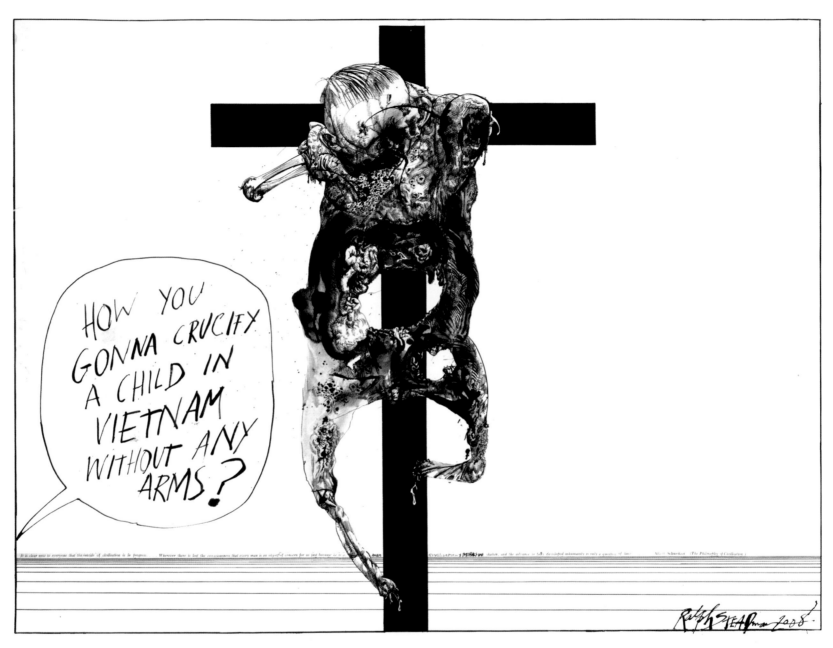

How you gonna crucify a child in Vietnam without any arms?
c. 1969, redated 2008
Pen, brush and ink and collage on paper
54.4 x 71.7 cm
Private collection

'It is clear to everyone that the suicide of civilisation is in progress … Wherever there is lost the consciousness that every man is an object of concern for us just because he is a man, civilisation and morals are shaken, and the advance to truly developed inhumanity is only a question of time.' Albert Schweitzer, *The Philosophy of Civilisation* (1923)

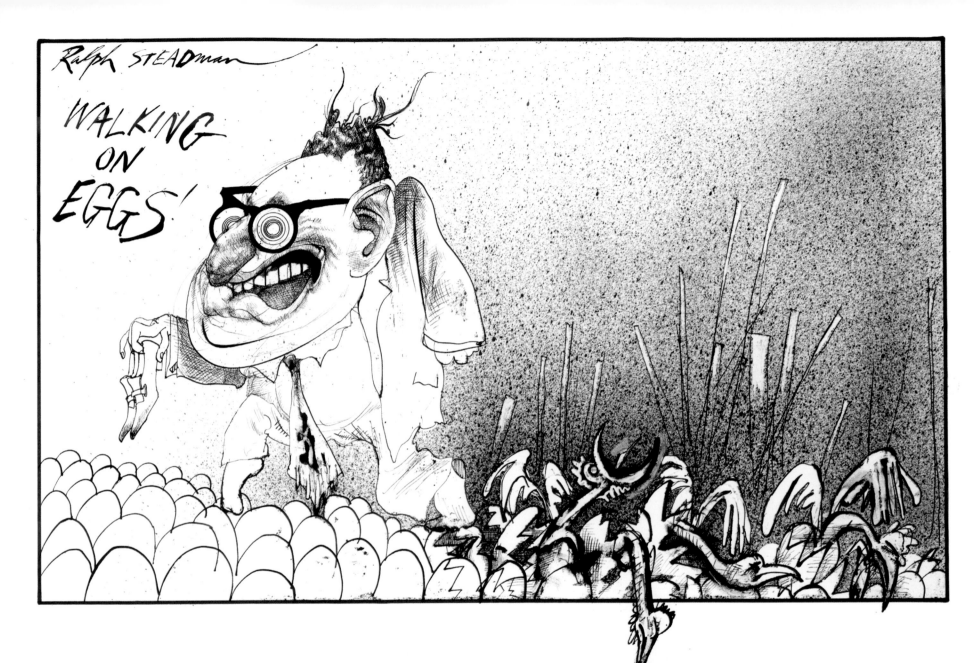

Walking on Eggs!
published in *Rolling Stone*, 28 August 1975
Pen, mouth atomiser and ink,
poster white on paper
55.8 x 76 cm
Private collection

Henry Kissinger was appointed Richard Nixon's national security adviser in December 1968 and became his secretary of state in September 1973. He is remembered today for his role in brokering détente with the Soviet Union and China and for his 'shuttle diplomacy' in the Middle East under both Nixon and Ford. He also helped to sabotage Vietnam peace plans before the 1968 presidential election; escalated the war in Vietnam; ordered secret and illegal air strikes against Cambodia in 1969 and the carpet bombing of Laos the next year, killing hundreds of thousands of civilians; connived at genocide in Bangladesh in 1971; supported a brutal right-wing coup in Chile in 1973; and twice put the US on nuclear alert.

He was awarded the Nobel Peace Prize in October 1973.

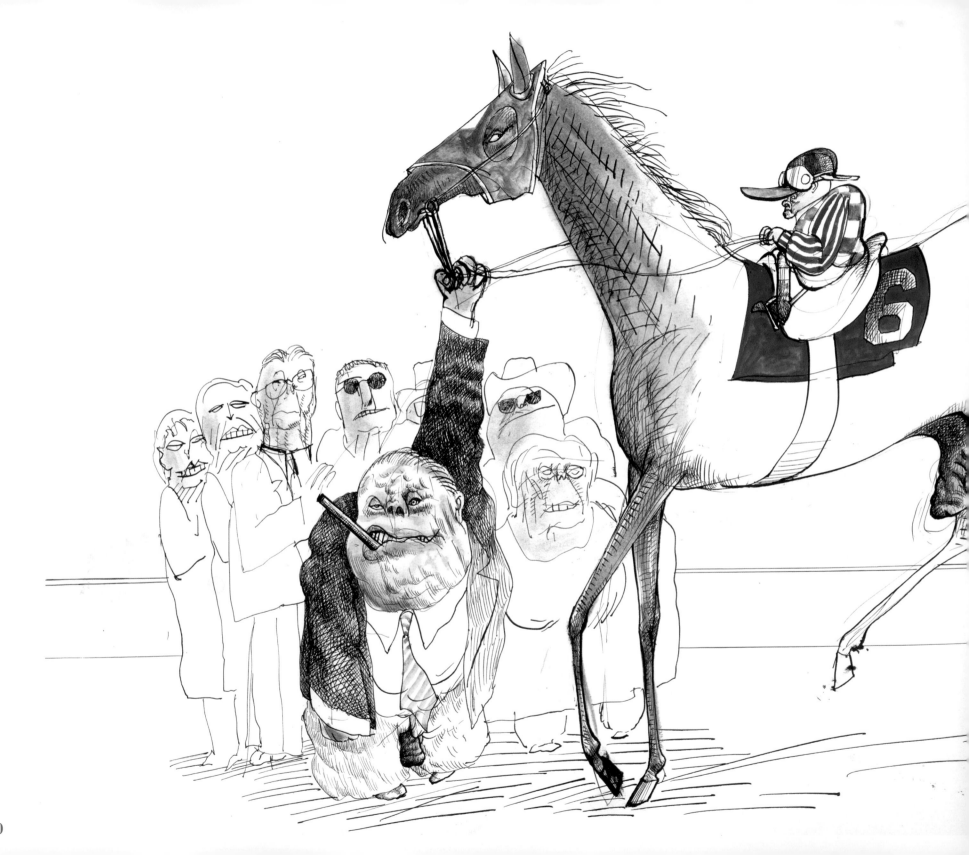

Ralph STEADman

'The Kentucky Derby Is Decadent and Depraved'

Scanlan's Monthly, June 1970
Pen, brush and ink and watercolour on paper
Private collection

The Kentucky Derby of May 1970 was Steadman and Hunter S. Thompson's first assignment together and inspired the first genuine piece of 'Gonzo' journalism. Armed with a few felt-tip pens and some borrowed Revlon lipsticks and eyebrow pencil – he had left his inks and colours in the taxi on the way to the airport – the artist was dispatched by *Scanlan's Monthly* from New York to Louisville, Thompson's old home town. Thompson met Steadman in the press box and explained that their focus was not on the horses but the Kentucky people. As soon as the race began the artist turned away from the course to sketch the excited faces in the crowd. 'Turn around, you hairy freak!' bawled a voice from somewhere in the boxes.

Steadman returned to New York and dropped off his drawings, only to be awoken by the co-founder/editor of *Scanlan's,* Warren Hinckle III, who wanted to know why none of the drawings featured horses. Steadman told him a horse was on its way. Unlike the other *Kentucky Derby* pictures this one was drawn with proper ink and watercolour.

A few weeks later the artist returned to London, his drawings having been taken to San Francisco by the publisher 'for safety'. For more than thirty-five years he mourned their loss, until this picture was returned to him by an American collector a few years ago.

'We were somewhere around Barstow on the edge of the desert when the drugs began to take hold. I remember saying something like "I feel a bit lightheaded; maybe you should drive…"'

from **Fear and Loathing in Las Vegas by Raoul Duke,** Part I
Hunter S. Thompson, *Rolling Stone*, issue no. 95, 11 November 1971

Journey to Las Vegas
Print
59.7 x 79.7 cm
Private collection

Ralph did not accompany Raoul Duke (Hunter's alter ego) and his 'Samoan' attorney, Dr Gonzo (in fact, Chicano lawyer and human rights activist Oscar Acosta) on their chemically assisted journey to the Heart of the American Dream. Thompson, however, told his editor at Random House that Steadman was 'the only illustrator I know of who understands the Gonzo journalism concept; he has lived thru it twice, and he'll catch the style & tone of this Vegas thing instantly'. The artist spent the summer of 1971 working on the 24 drawings to *Fear and Loathing in Las Vegas*, parts I and II, in the living room of his flat in Fulham:

'I dipped my steel pen – now a lethal weapon – into a blood-black cauldron of bile and began, accompanied by beer and brandy chasers, the therapeutic exercise of expunging from my mind all those trapped demons that lay in wait for their mark of recognition, so that they might emerge blinking and grimacing into the harsh daylight of reality.'

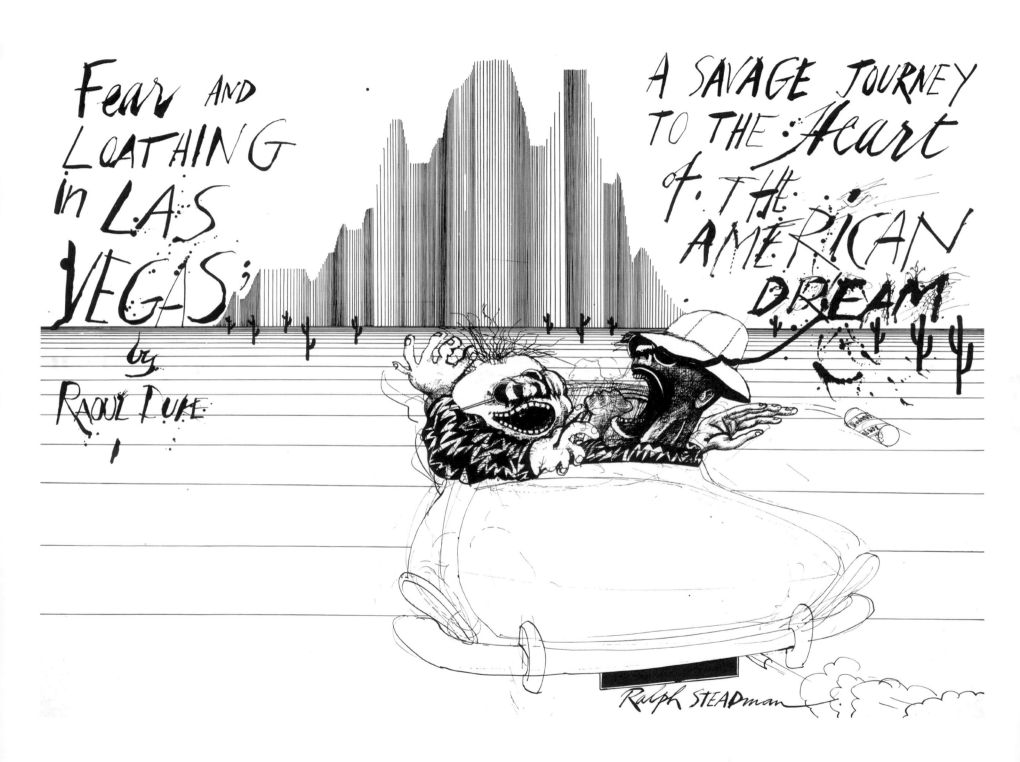

Lizard Lounge
from **Fear and Loathing in Las Vegas by Raoul Duke,** Part I
Hunter S. Thompson, *Rolling Stone*,
issue no. 95, 11 November 1971
Print
54.4 x 84 cm
Private collection

The bar of the Mint Hotel, Las Vegas

'Terrible things were happening all around us. Right next to me a huge reptile was gnawing on a woman's neck, the carpet was a blood-soaked sponge – impossible to walk on it, no footing at all. "Order some golf shoes," I whispered. "Otherwise, we'll never get out of this place alive. You notice these lizards don't have any trouble moving around in this muck – that's because they have claws on their feet."'

Steadman's agent persuaded him to sell all twenty-four of his *Fear and Loathing* drawings to *Rolling Stone* editor Jann Wenner 'for the princely sum of sixty dollars per drawing,' a decision he now bitterly regrets.

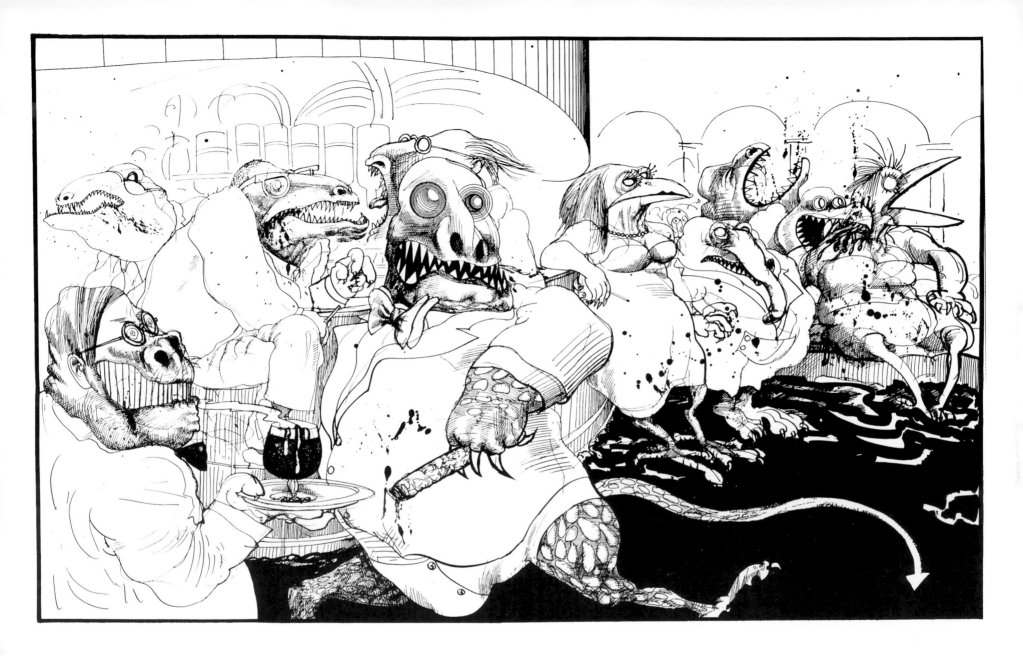

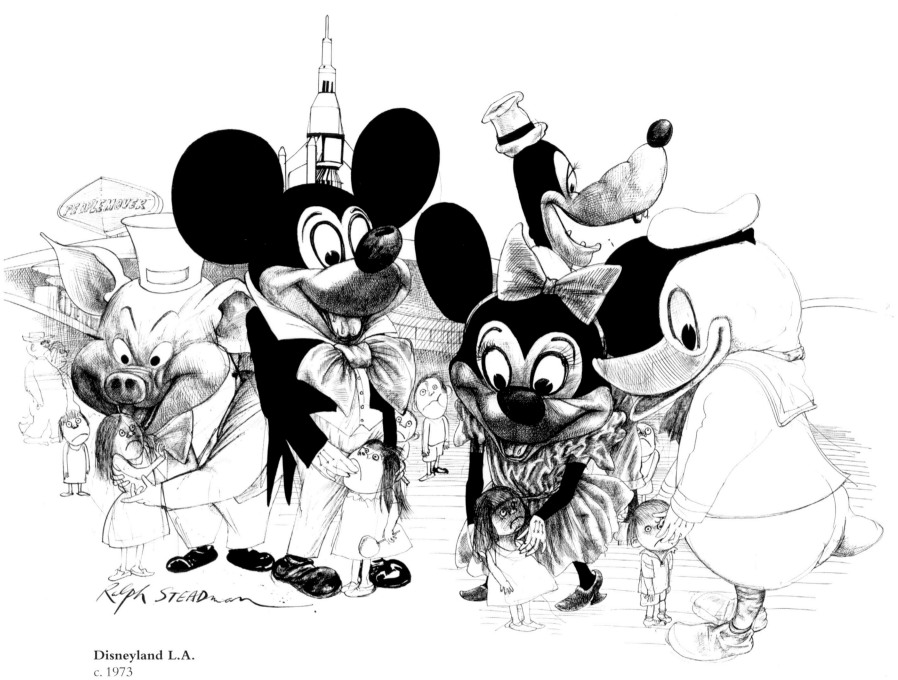

Disneyland L.A.
c. 1973
Print
47.5 x 67.5 cm
Private collection

'Alight here for the land of screaming kids
and tired feet.'

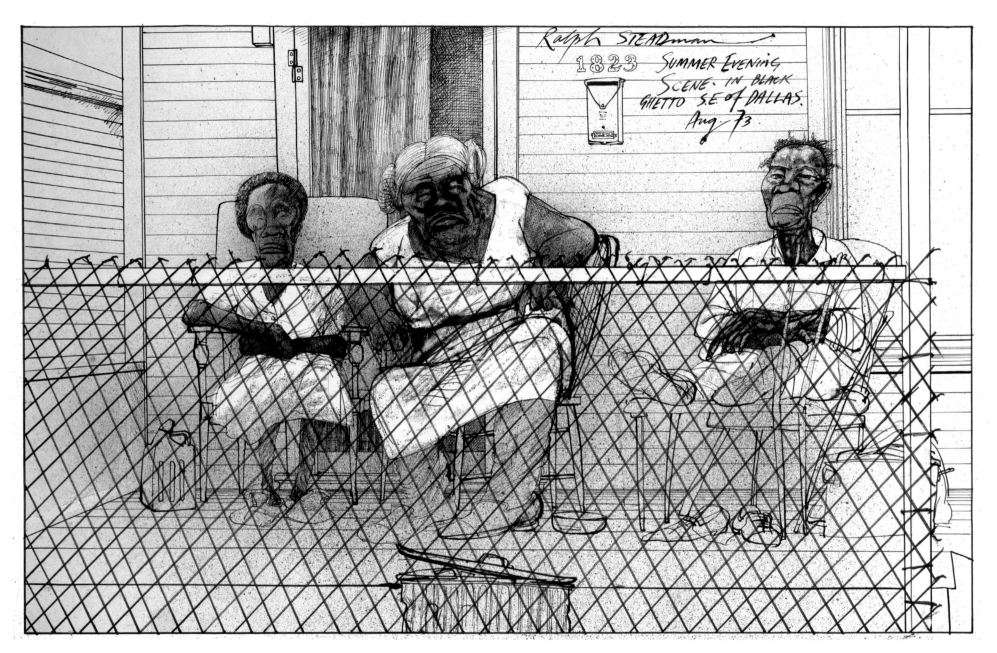

**Summer Evening Scene in Black Ghetto
S. E. of Dallas. Aug. 1973**
Rolling Stone, 6 December 1973
Pen, mouth atomiser and ink,
poster white on paper
55.7 x 76 cm
Private collection

'And there was the other crowd out of town –
although I couldn't help noticing the old Cadillac
(maybe not this year's model) hard up against some
of the front porches we passed.'

In the summer of 1973 Steadman was in the States for the
Watergate hearings. He took a trip to Dallas, Texas, and
recorded his visit in pictures and words for *Rolling Stone*.

Richard Nixon

c. 1974
Pen and ink on paper
55.7 x 76.4 cm
Private collection

From the start of his second term in office
in 1972 Richard Nixon was dogged by
allegations of a cover-up over the Watergate
affair. A break-in at the Democratic National
Committee headquarters at the Watergate
complex in Washington, D.C. in June 1972 was
traced to the committee for the re-election of
the president and some of his closest advisers.
In March 1974 Nixon was secretly named by
a federal grand jury as a co-conspirator in the
cover-up. After the House Judiciary Committee
moved to impeach the president for obstructing
the course of justice, Nixon chose to resign on
9 August 1974.

In the summer of 1973 Steadman attended
the Watergate hearings in Washington and
sketched many of the leading protagonists of
the drama:

'If we could ever hold a court where
the underdog puts the powers of authority
on trial, most of us would be sickened by
the crimes that are committed in our name.
That was what we were witnessing in that
Watergate hearing, except that it was still
authority trying authority … These thoughts
were passing through my mind as I watched
the likes of Ehrlichman and Haldeman's
whispered conversations with their defending
lawyers. "Authority is the mask of violence."
Who said that? I don't know but it occurred
to me and I wrote it down.'

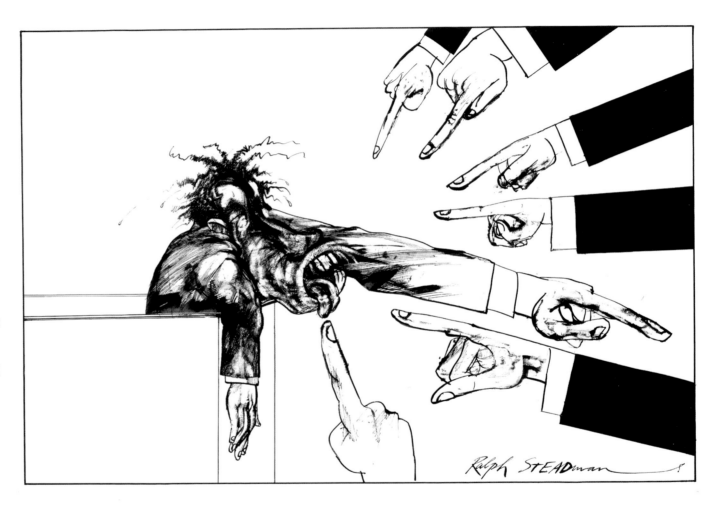

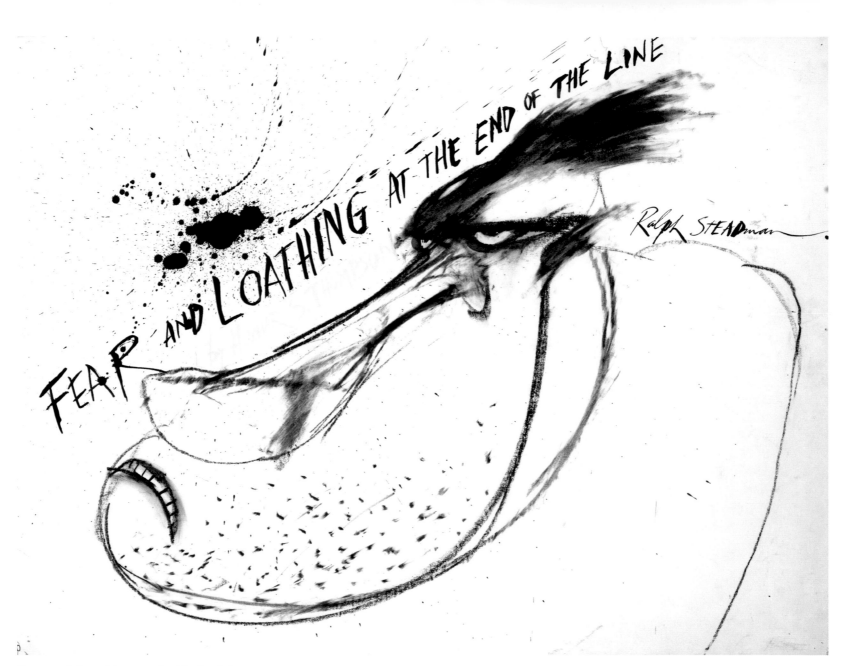

Fear and Loathing at the End of the Line
Rolling Stone, no. 144, 27 September 1973
Conté crayon, pen and ink on paper
54.3 x 71.7 cm
Private collection

In his 1987 book of America drawings, *Scar Strangled Banger* Steadman pays tribute to Tricky Dicky:

'Without a shadow of doubt, Richard Milhous Nixon was a satirist's dream. Someone to really get your teeth into. As a subject for drawing he has no equal. Those dark jowls. The eyes displaying a volatile and hazardous nature. The hangdog look of a creature made for the cut and thrust of dirty infighting. The look of a man, guilty from the cradle, rounding his shoulders into a curse. The sweep of his nose was the last thing I thought about. I only thought of the darker things.'

Good Time Crucifix
1979
Collage, pen and ink, mouth atomiser on paper
59.4 x 84 cm
Private collection

A striking study of the recklessness and precariousness of consumer capitalism. Steadman writes in *Gonzo – The Art*, 'If you look at a sunset in Beverly Hills you will see the orange smog of self-indulgence hanging above the city.'

Collage, 'drawing with lumps of the thing', continues to be one of the artist's favourite techniques, inspired by Dadaists such as Kurt Schwitters, Hans Arp and the pioneer of photomontage John Heartfield.

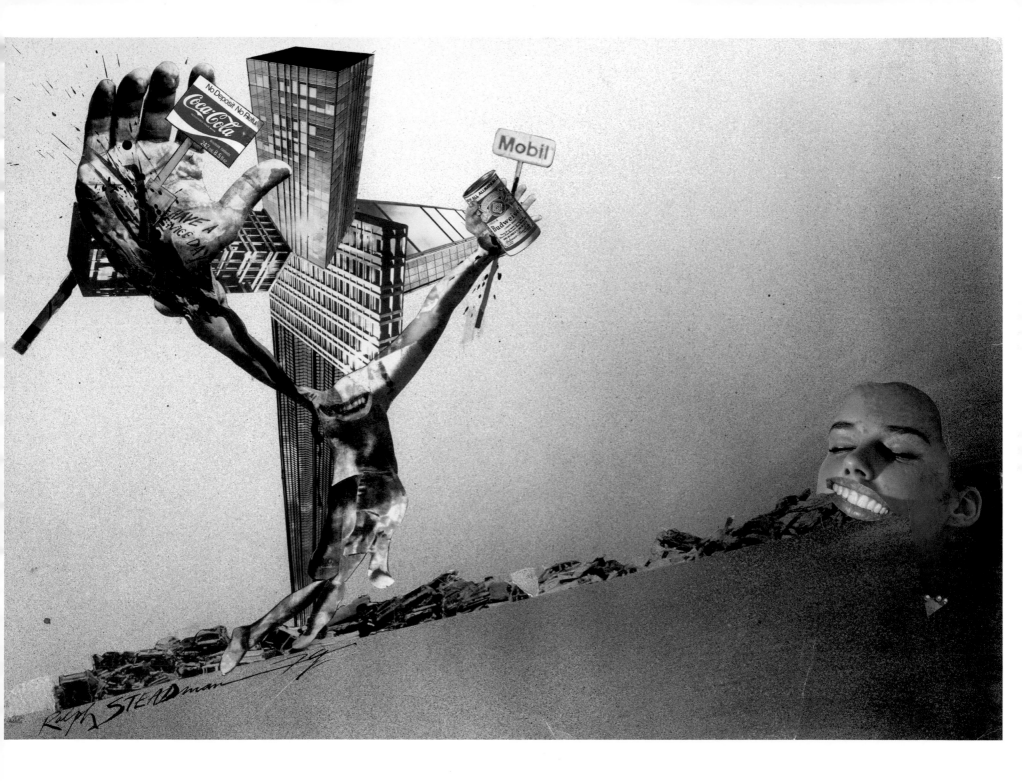

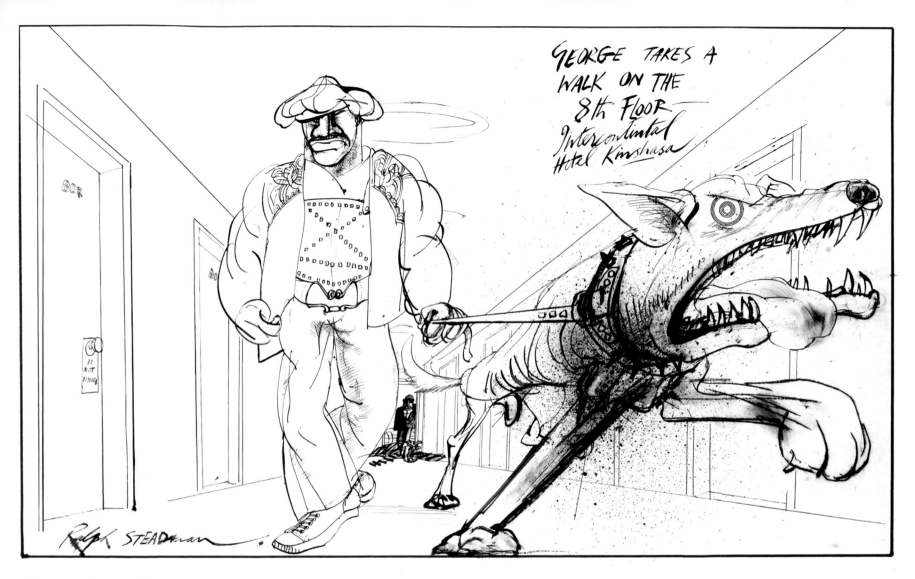

George Takes a Walk on the 8th Floor Intercontinental Hotel Kinshasa

George Takes a Walk
1974
Pen and ink on paper
50.5 x 76 cm
Private collection

In October 1974 Steadman and Thompson were sent by *Rolling Stone* to join the international media circus covering the historic Muhammad Ali-George Foreman fight in Kinshasa, Zaire – the 'Rumble in the Jungle'. Hunter found it hard to get a handle on the story and quickly lost interest in the fight: 'Nothing approaches the hideous disorganization and goddamn venal madness of this,' he informed Ralph. They didn't get to see Ali's training camp, but Steadman did get a 'scoop'– a talk with George Foreman:

'In the dead of night, at four in the morning, a party of George Foreman's protection posse paced George through the corridors on the eighth floor of the Intercontinental Hotel, Kinshasa. At that point no one dared to interrupt the champ's routine with something as banal as an interview or even a few enquiries delivered while running along beside him, but I fell in step with him just to ask a simple question: "Whotcha gonna do when this is all over and you are the champ and …er…you'll have a lot of time on your hands? Nobody fights forever."

"Yo're right man. Yo' the foist to ask me dat. I'm goin' inta da dough business … I'm gonna be a baker."'
[from *The Joke's Over*, 2006]

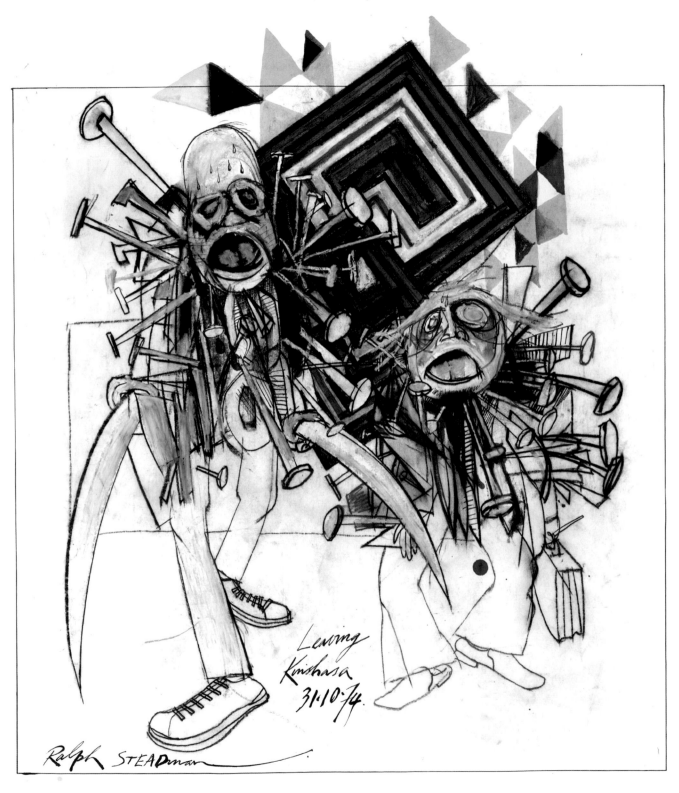

Leaving
Kinshasa
31·10·74.

Ralph STEADman

Leaving Kinshasa, 31 October 1974
1974
Pen, brush and ink, conté chalk,
acrylic ink on paper
76 x 56 cm
Private collection

Steadman and Thompson didn't get to see the Ali-Foreman fight after all. Thompson sold their tickets and went to the pool with an ice bucket, a Heineken, a bottle of Glenfiddich and a bag of grass. 'This is it, Ralph. An aesthetic experience. Fuck the fight!'

Steadman drew the pictures, but Thompson never wrote up the story. 'The biggest fucked-up story in the history of journalism' ended with the journalists leaving Kinshasa voodooed and empty-handed, apart from two elephant tusks Hunter had secreted in his luggage. The tusks still hang above his fireplace at Owl Farm, Woody Creek.

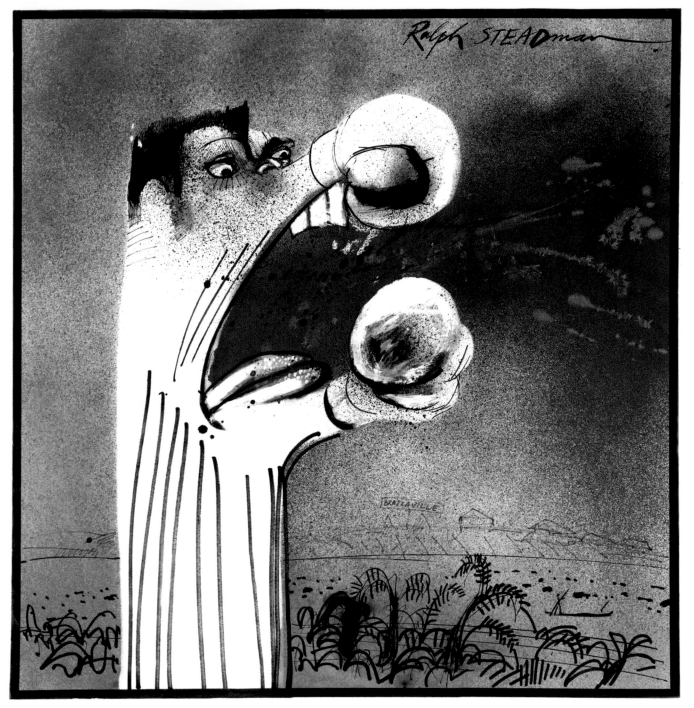

The Lost Artwork

Permanent marker and ink on paper
70 x 50 cm approx
Private collection

In 2018 one *Rumble in the Jungle* original was discovered in the collection of Norman Scott and on his passing a friend of his inherited the piece and contacted RSAC about it. We were proud to be able to present this piece for the first time at Moogfest 2018. What we know about it is...

1974: Ralph Steadman and Hunter S Thompson fly to Kinshasa for *Rolling Stone* to cover "The Rumble in the Jungle."

- Ralph produces drawings of his impression of Kinshasa and the circus surrounding the event from sketches he made while watching the fight on the hotel room TV, Hunter having sold their tickets for a large bag of weed. Hunter never writes the story up, and the collection is stored away

1974–1980: THE LOST YEARS

1980–1983: Artwork is discovered in a pile of posters about to be thrown away by Norman Scott who was interning at the time for Fantasy Records. Upon spotting the Steadman, he asks if he can take it home and is given permission.

1983–2017: The artwork remains in Norman Scott's possession until his death in 2017 at which time his girlfriend asks an artist friend if she would like to have it and some other items of work.

2018: Ralph Steadman Art Collection buys the piece for inclusion in the Moogfest Exhibition and then as an addition to the Ralph Steadman Retrospective, currently touring the USA.

Bill Murray in
Where the Buffalo Roam
1979
Pen, mouth atomiser and ink on paper
59.4 x 84 cm
Private collection

Bill Murray was the first actor to portray Hunter Thompson on the big screen in Art Linson's 1980 comedy *Where the Buffalo Roam*. The film also featured Peter Boyle in the role of Thompson's Gonzo compadre, Oscar Zeta Acosta. The story is loosely based on Hunter's tribute to Acosta, *The Banshee Screams for Buffalo Meat* written three years after the Chicano lawyer's mysterious disappearance in 1974.

Art Linson asked Steadman to make a series of drawings of the filming of *Where the Buffalo Roam* at Universal City, Hollywood. Bill Murray stayed with Hunter for a while and studied closely the man's distinctive tics and comportment: 'I talked to him about my impressions and observations of Hunter,' wrote Steadman in *Rolling Stone* in 1979, 'especially his mannerisms – a combination of a forward swaying lurch, nervous, rearing twitch and grimacing clumsiness, with a dignified monotone voice that lent the whole thing a certain nobility.'

Here Hunter is framed by his signature bats and is having his Wild Turkey 101% proof bourbon administered intravenously. In 1998 Thompson's TarGard cigarette filter passed to Johnny Depp in Terry Gilliam's *Fear and Loathing in Las Vegas*.

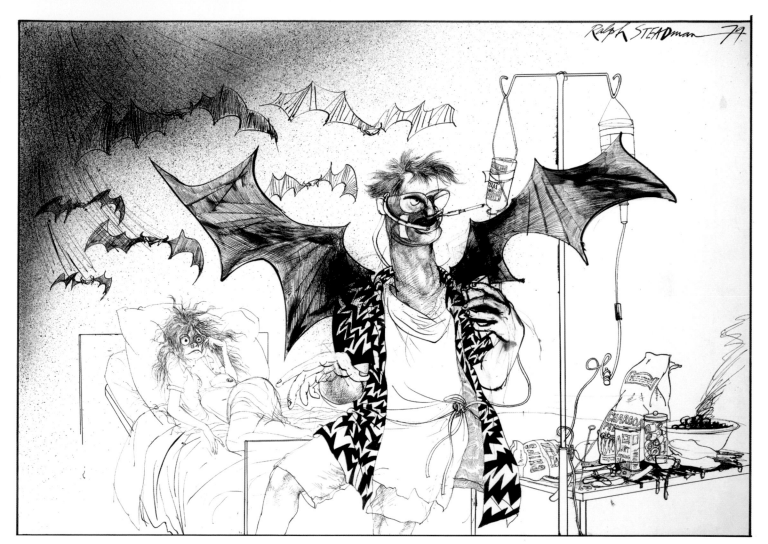

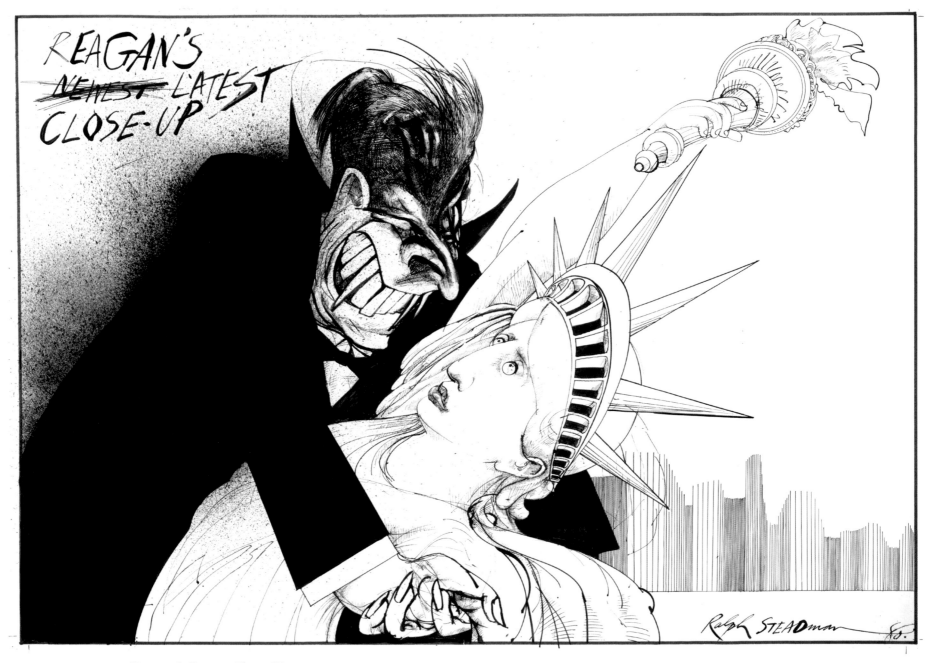

Reagan's Latest Close-Up
New Statesman, 7 March 1980
Pen and Indian ink on paper
59.4 x 84 cm
Private collection

In March 1980 the erstwhile B-movie star and governor of California, Ronald Reagan was the frontrunner in the Republican Party's presidential primaries. One of a new breed of Republican neo-conservatives, the 68-year-old Reagan announced his candidacy in November 1979, promising to restore America to its rightful place in the world. 'A troubled and afflicted mankind looks to us, pleading for us to keep our rendezvous with destiny; that we will uphold the principles of self-reliance, self-discipline, morality, and – above all – responsible liberty for every individual, that we will become that shining city on a hill.'

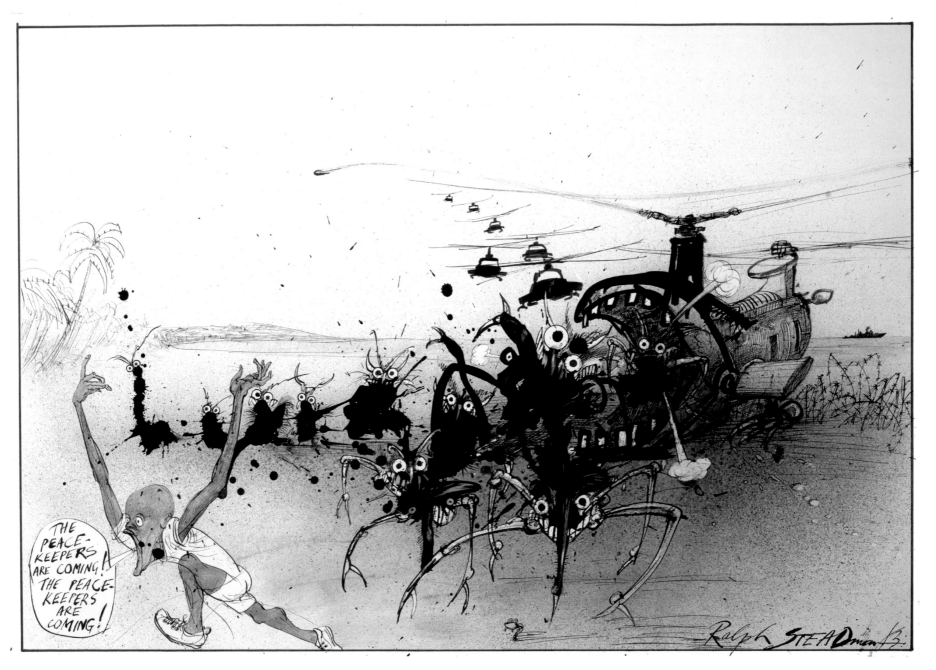

**'The Peacekeepers Are Coming!
The Peacekeepers Are Coming!'**
1983
Pen, mouth atomiser and ink on paper
59.4 x 84 cm
Private collection

In October 1983 thousands of US troops and helicopter gunships invaded the tiny Caribbean island of Grenada after a left-wing coup. Reagan's incursion into Grenada, a Commonwealth country, was the only occasion on which Margaret Thatcher and the US president had a serious falling out.

Steadman shows how new forms can spring from a few gouts of ink.

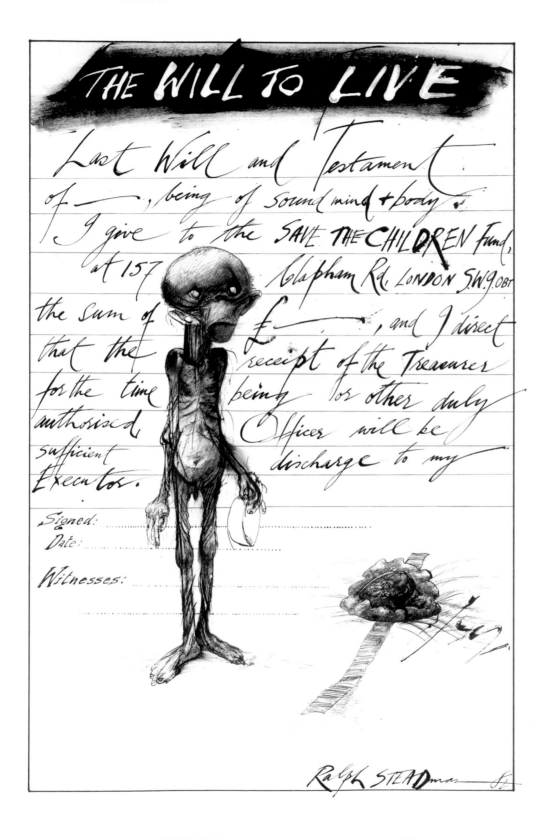

The Will to Live
1982
Pen and ink on paper
76 x 55.8 cm
Private collection

During the early 1980s Steadman created artwork for several charities, including the 'Stop Polio Campaign'. This was one of several drawings created for the charity *Save the Children*.

Free John McCarthy Campaign
1990
Pen, brush, mouth atomiser and ink on paper
59.4 x 84 cm
Private collection

On 5 April 1986 American planes dropped bombs on Libya. Twelve days later British journalist John McCarthy was taken hostage by Islamic Jihad while on his way to Beirut airport. The campaign to secure McCarthy's release was spearheaded by his girlfriend Jill Morrell, who formed The Friends of John McCarthy.

This picture was produced for a limited edition of signed posters which were sold in aid of the campaign. Bound and encased within an impenetrable border, Steadman's prisoner is reduced to an anguished cry.

On 8 August 1991 McCarthy was finally released, the longest-held British hostage, having endured 1,943 days in captivity.

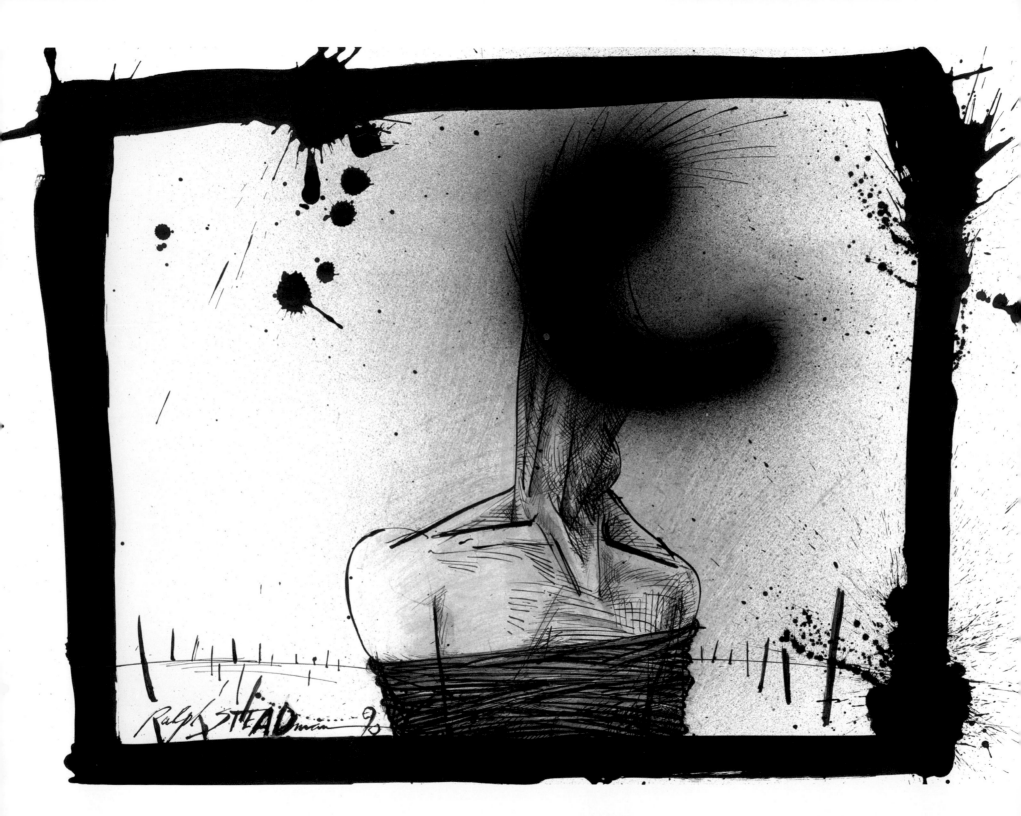

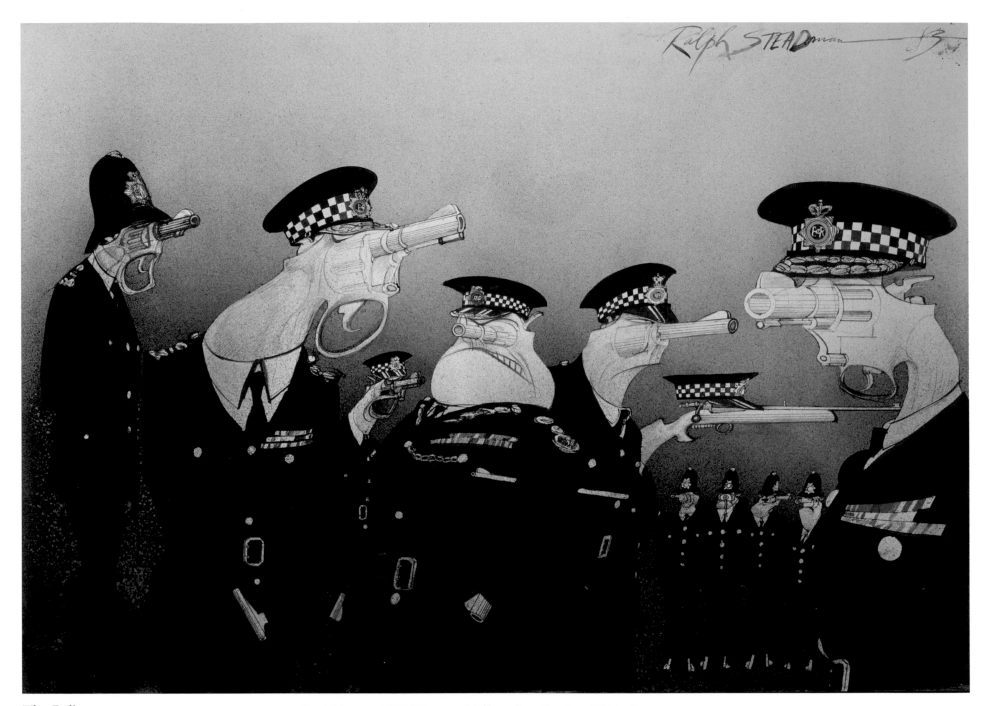

The Police
1983
Pen, brush, mouth atomiser and ink on paper
59.4 x 84 cm
Private collection

On 14 January 1983 26-year-old film editor Stephen Waldorf was mistakenly shot five times in the head and body by the Metropolitan Police in Earls Court, west London. The police thought he was an escaped prisoner, David Martin. In 1983 two officers were put on trial for attempted murder; they were both acquitted.

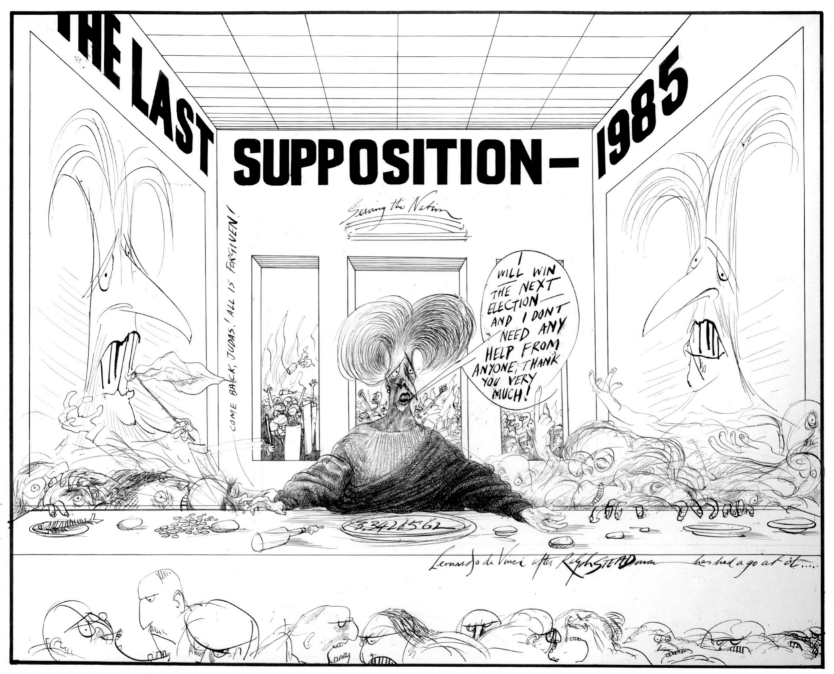

Margaret Thatcher. The Last Supposition – 1985
Leonardo da Vinci after Ralph Steadman has had a go at it…
New Statesman, 11 October 1985
Pen and ink on paper
59.4 x 84 cm
Private collection

After riots in Tottenham and Handsworth, record unemployment figures and growing scepticism among Tory voters, an unrepentant Margaret Thatcher told the Conservative Party conference in October 1985 that there could be no turning back to the bad old days before her arrival in May 1979.

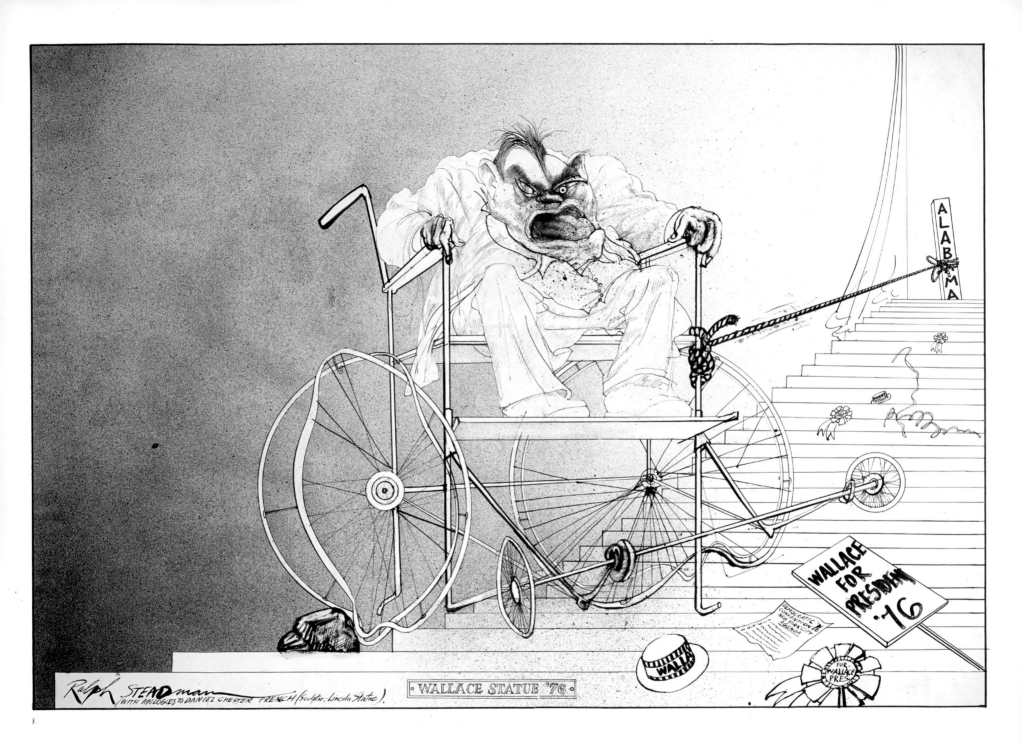

WALLACE STATUE '76

Ralph STEADman (WITH APOLOGIES TO DANIEL CHESTER FRENCH (Sculptor: Lincoln Statue).

ALABMA

WALLACE FOR PRESIDENT '16

102

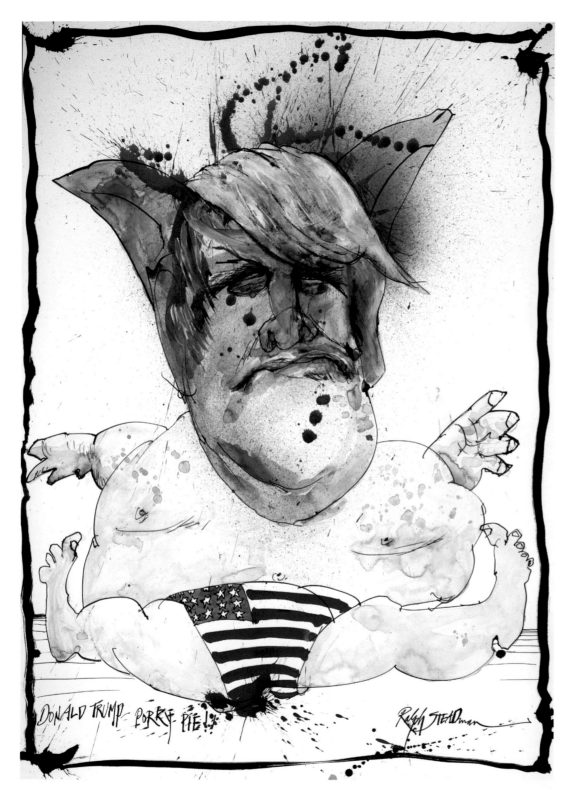

Donald Trump – Porky Pie!!

New Statesman, 17 December 2015
Pen, brush, mouth atomiser, acrylic and
gesso on paper
84 x 59.4 cm
Private collection

This porcine portrait of the real estate billionaire, reality TV game-show host and presidential hopeful Donald J. Trump accompanied an article by Laurie Penny, 'There is nothing funny about a Donald Trump rally'. 'By lying through his teeth,' she writes, 'he has managed to persuade thousands of people that he is the one truth-teller in American politics… Trump is selling fascism with a cartoon face'.

In November 2015, the mayor of Jersey City accused Trump of 'shameful politicising' after the Republican made unsubstantiated claims that in 2001 he watched on TV 'thousands and thousands' of Arab Americans in New Jersey cheering the attacks on the World Trade Center.

'Porky pie', or 'porky', is Cockney rhyming slang for 'lie'.

opposite: **Wallace Statue '76**
With apologies to Daniel Chester French
(Sculptor: Lincoln Statue)
c. July 1976
Pen and ink
56.9 x 81.5 cm
Private collection

At the end of the 1976 Democratic National Convention in New York, Governor George C. Wallace of Alabama was hoisted up onto the platform to deliver a diatribe against 'monster bureaucracy'. Wallace's third bid for the presidency had ended the month before, when he passed his 168 delegates over to Jimmy Carter. In 1972, the energetic and confrontational Wallace was shot and paralysed from the waist down while campaigning for the Democratic presidential nomination in Maryland. He spent the rest of his life confined to a wheelchair.

By the early 1960s, fierce political ambition had turned the liberal young judge from Alabama into a racist demagogue and hard-line segregationist. In his inaugural speech of 1963, the newly elected governor demanded 'segregation now, segregation tomorrow and segregation forever'. Wallace became a tribune of white 'backlash politics', only modifying his extreme views towards the end of his political career.

BY INDISTINCT THINGS THE MIND IS STIMULATED TO NEW INVENTIONS — Leonardo

**The secret of dreams is revealed to
Sigmund Freud**
from *Sigmund Freud*
Paddington Press, 1979
Pen, brush, mouth atomiser and ink on paper
59.4 x 84 cm
Private collection

In *Sigmund Freud* Steadman recounts the life
of the founder of psychoanalysis through
his 1905 work, *Jokes and Their Relation
to the Unconscious*. The artist uses various
scenes and incidents – real and fanciful – to
illustrate Freud's different 'joke techniques':
unification and displacement, double entendre
and allusion, jokes smutty, tendentious and
innocent. The book took Steadman three
years to research and includes over fifty large
black-and-white drawings and numerous
vignettes, by turns elegant, exuberant and
inkily crepuscular.

On 24 July 1895 Freud carried out the
first detailed interpretation of one of his own
dreams – known as 'Irma's Injection' – at
Schloss Bellevue, near Vienna. Half in jest he
confided to his friend Wilhelm Fliess that
perhaps one day a marble tablet at the site
might bear the inscription, 'Here the secret
of dreams was revealed to Dr Sigm. Freud
on 24 July 1895'. While Freud reflects on his
Boschian dream-content, his little daughter,
Anna watches her father through the window.

'**Freud looks up and says: "Anna, my
love, what are you thinking?"**

**Anna replies: "The fly on your head
has been there an awfully long time."**

**"Probably," says her father smiling,
"but not as long as the fly inside my
head."**

**"Then that must be the same one,
Daddy, because it came out of your ear."'**

Joke technique: 'representation by something
small or very small'.

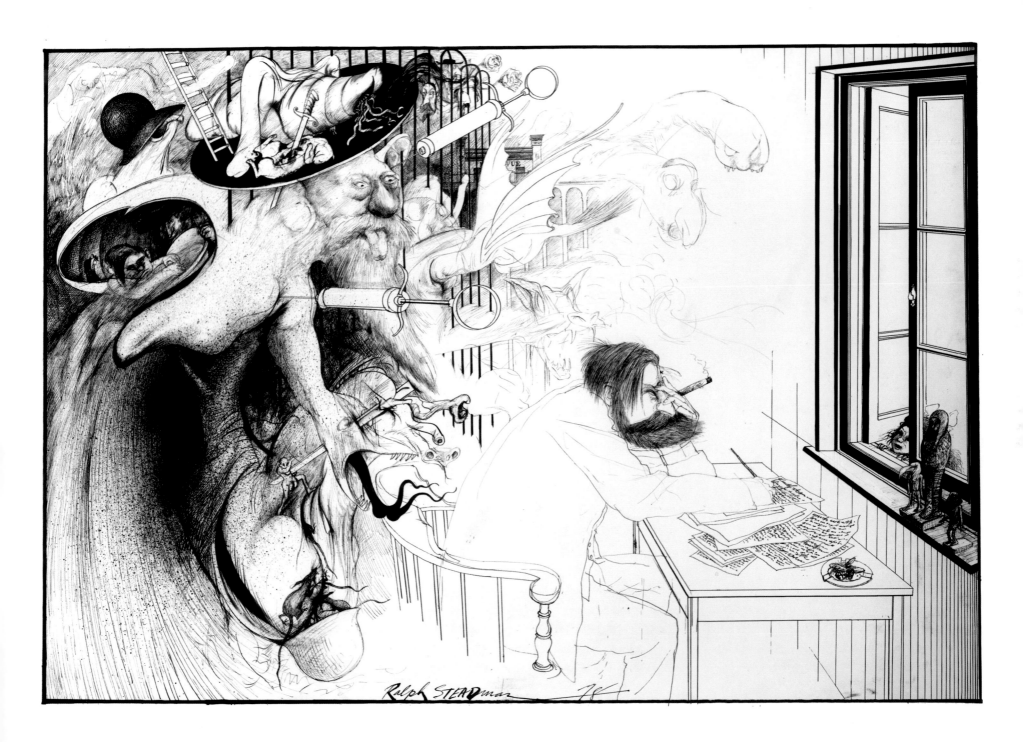

Overcoat
from *Sigmund Freud*
Paddington Press, 1979
Pen, brush, mouth atomiser and ink on paper
59.4 x 84 cm
Private collection

In the years following the First World War
life was tough in Vienna. Rampant inflation
cut into Freud's earnings from a diminishing
number of patients. Soon all his savings were
spent. Long hours in an unheated, dimly-lit
consulting room severely tested his powers of
endurance and concentration.

**'Freud had to face up to the fact that
local patients could no longer afford to
pay for psychoanalysis, no matter how
mad they might be. Now even cigars,
Freud's favourite vice, were in short
supply, and throughout the two bitter
winters immediately following the
war he had to work dressed in a heavy
overcoat.'**

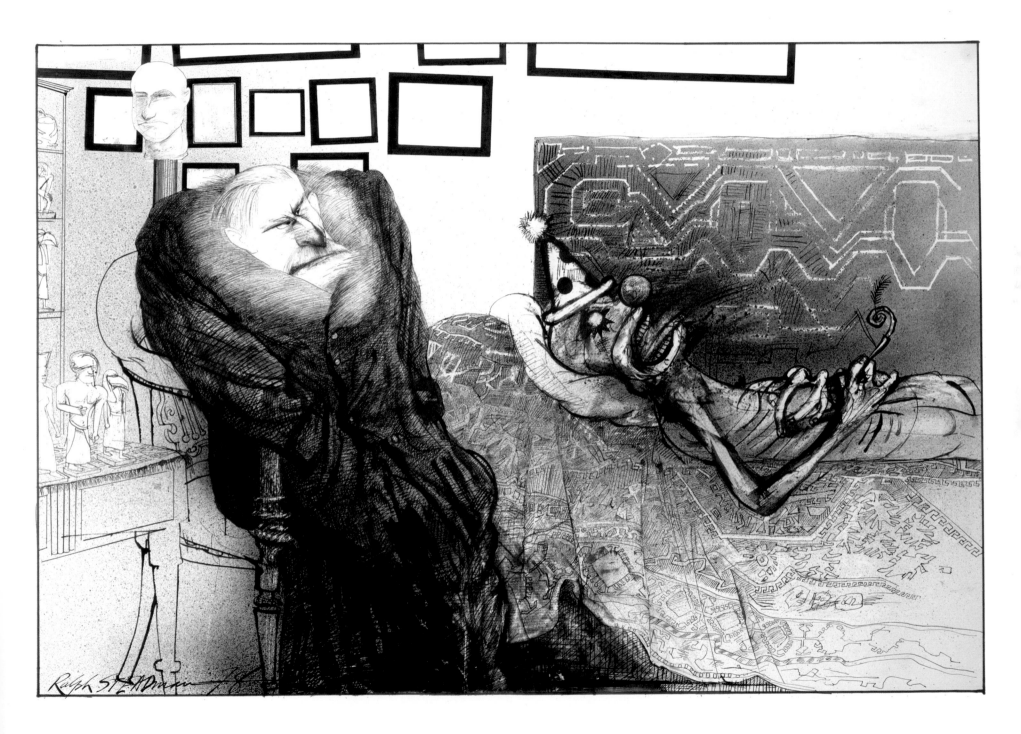

'My dream is to be a great bird. I want to feel the exhilaration of floating out beyond the edge of solid ground into a void I know will not consume me...
I have made many attempts to fly like a bird. I watch birds constantly and observe their methods of controlling their flight. In the event that I become weightless and fly I will know exactly what to do. I will fly with eagles, and they fly with me.'

from *I, Leonardo*
Jonathan Cape, 1983

'My dream is to be a great bird'
Pen, brush, mouth atomiser and ink on paper
64.1 x 90.2 cm
Private collection

'Leonardo da Vinci was a man who woke up in the dark.' A quote from Sigmund Freud's 1910 study of Leonardo drew Steadman to peer deep into the life and works of that model of the Renaissance *uomo universale* – revolutionary artist, inspired questioner of authority and ingenious practitioner of knowledge through experience and experiment.

In Steadman's quest to fathom his subject, he decided he had to *become* Leonardo and write an illustrated biography in the first person, 'through his eyes'. In a three-year project he went through 50 books on the man; recreated the *Last Supper* on his bedroom wall in Kent; and travelled to Florence and Milan to experience at first hand the sites and sources that had formed this most inscrutable of geniuses.

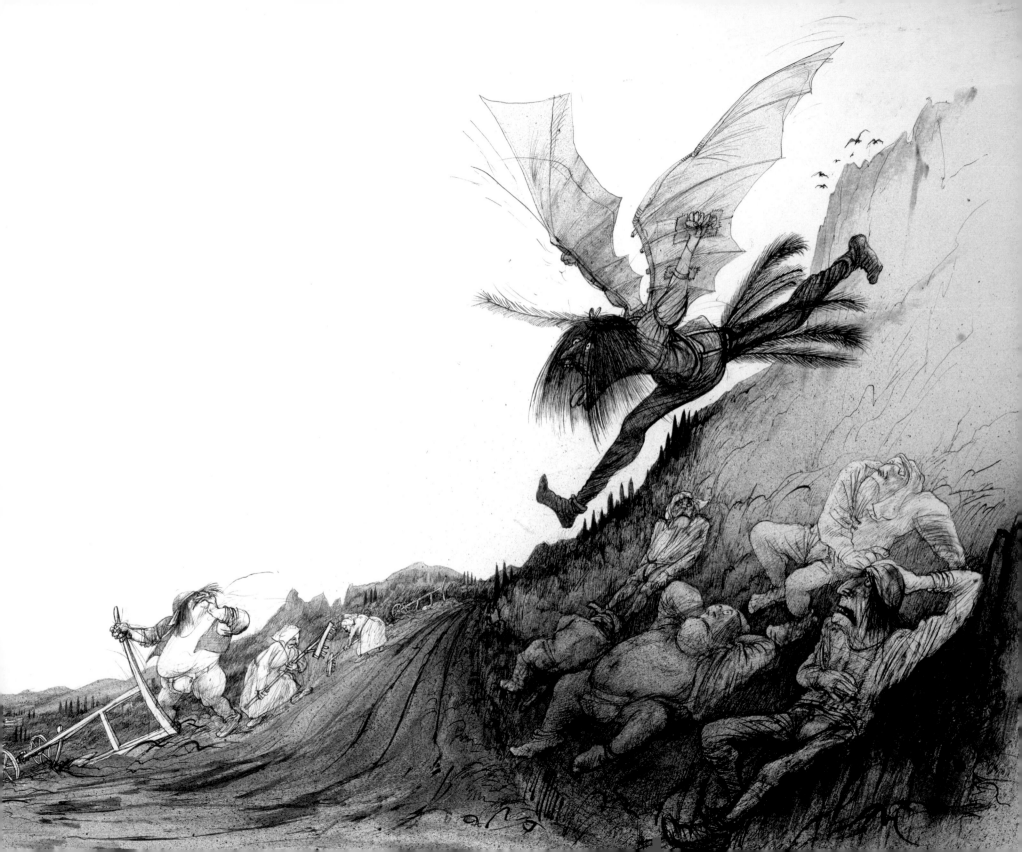

'Wondrous Shapes'
from *I, Leonardo*
Jonathan Cape, 1983
Pen, brush, mouth atomiser, coloured inks on paper
59.4 x 84 cm
Private collection

'I talked at length to Luca Pacioli, a mathematical professor in the employ of my patron ... He was at pains to write a book describing things that I held in high regard – that proportion is divine and part of everything we see in nature.

He gave me much and I in turn drew for him such wondrous shapes as geometry can describe. They thrilled my mind till I became intoxicated.'

The drawings of polyhedra in Luca Pacioli's geometrical treatise of 1498, *De divina proportione* (Of Divine Proportion), were the only Leonardo illustrations published in his lifetime. It's very likely that Leonardo built three-dimensional 'skeletal' models in wood as a basis for his drawings of the bodies – the five regular 'Platonic' solids and the more complex 'Archimedean' and other semi-regular solids, such as the '*Septuagintaduarum Basium Vacuum*' (a hebdomicontadissaedron with 72 open faces) at the centre of Steadman's picture. Steadman says of his affinity with the artist: 'I quite like making things, and I think he did, too.'

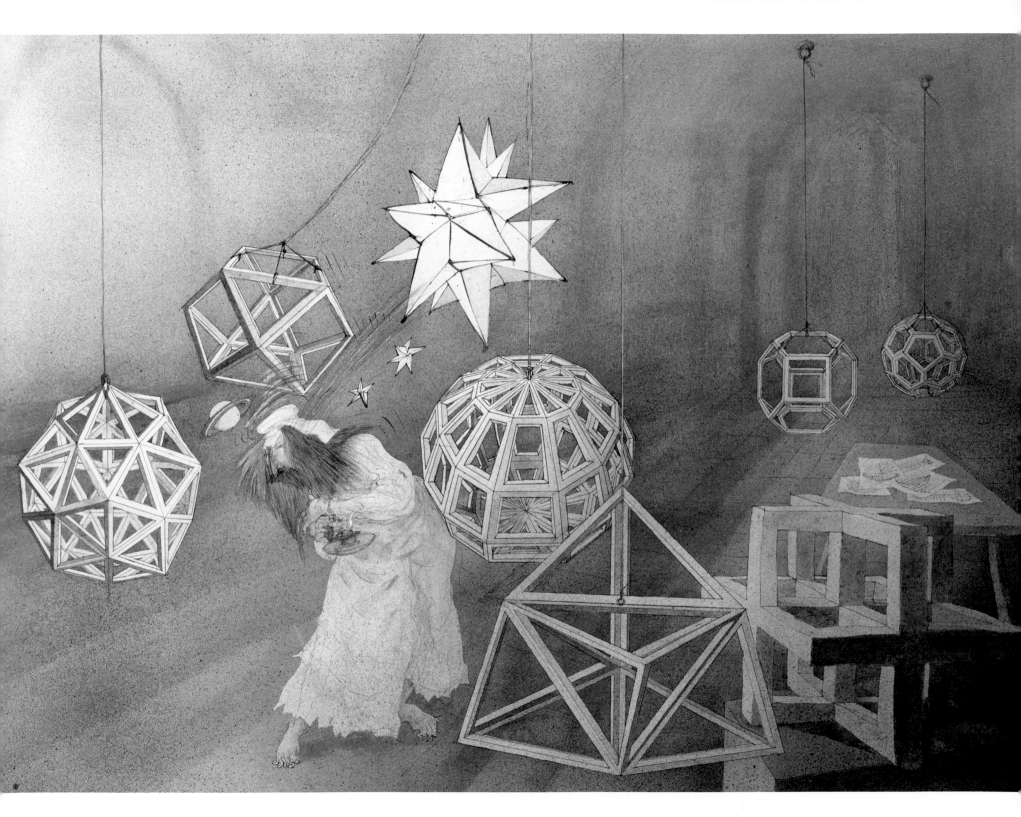

'Jibes and contemptuous declarations came my way from Michelangelo. He was now a man obsessed by confirmations of his genius... I had hoped to do the whole chamber myself but now the Signoria were powerless in the face of such a man and he was granted this commission – enough to vex me well beyond my patience ...

This was the spectacle that truly won the attention of the populace who daily came to be observers of our work.

I fear we came to speak of one another in a derogatory fashion urged on by those who would regard us as two starving dogs out on the street who fought upon a bone.'

from *I, Leonardo*
Jonathan Cape, 1983

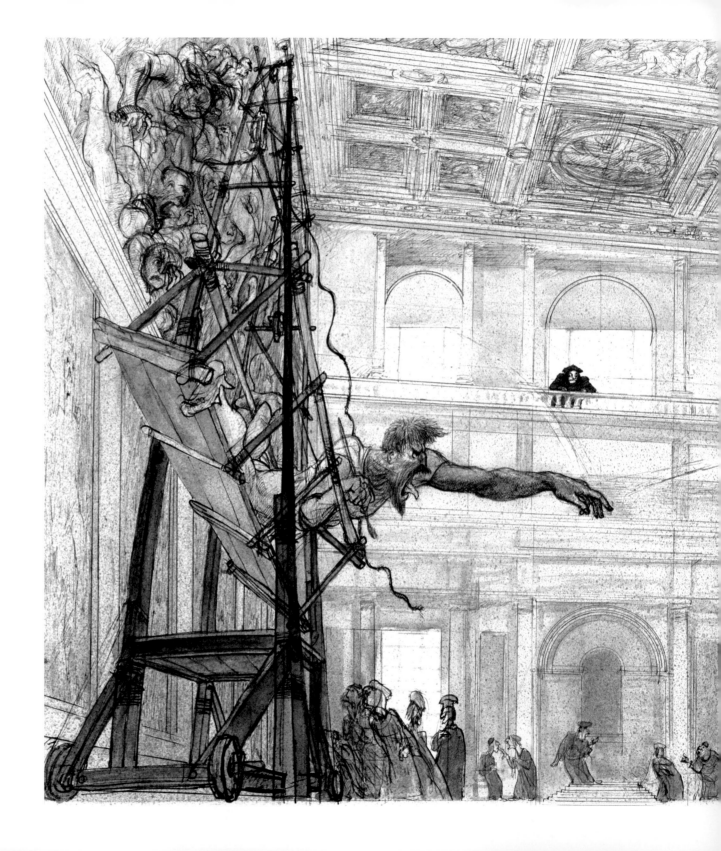

Michelangelo and Leonardo
Pen, brush, mouth atomiser,
coloured inks and wash on paper
59.4 x 84 cm
Private collection

In 1503 Leonardo and his young rival Michelangelo were commissioned by the government of Florence to paint two large frescoes on opposite walls of the new Sala del Maggior Consiglio [the Great Council Hall] in the Palazzo Vecchio. Neither Michelangelo's *Battle of Cascina* nor Leonardo's *Battle of Anghiari* has survived, though sketches and copies of the works give an inkling of what might have been.

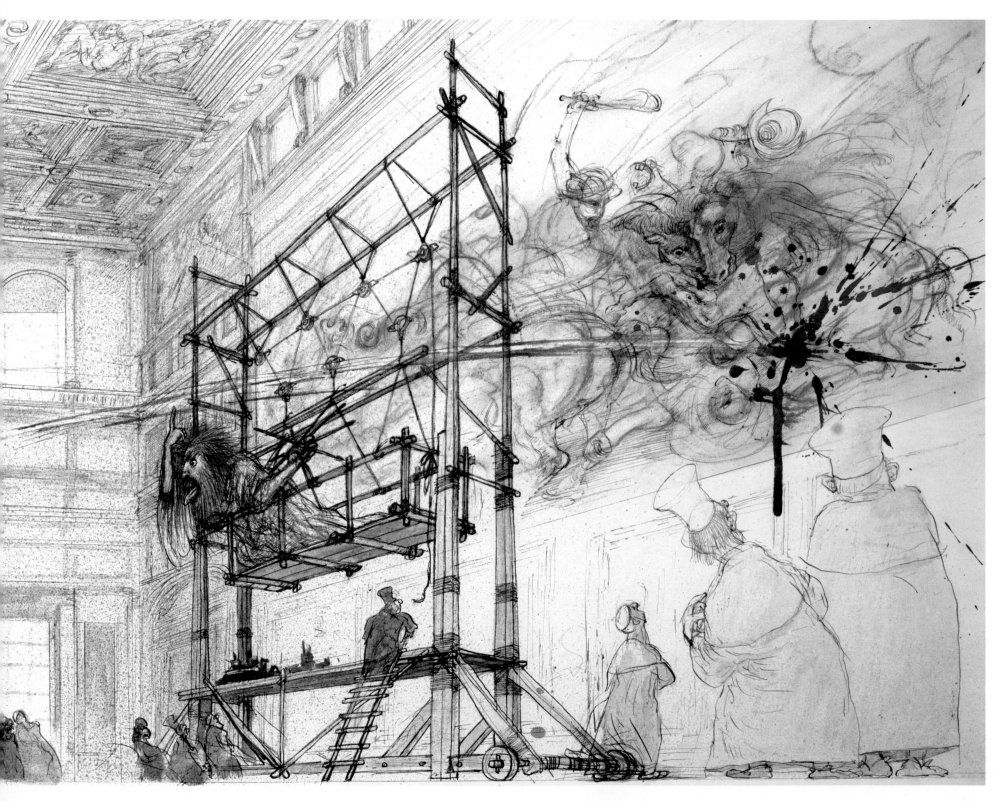

115

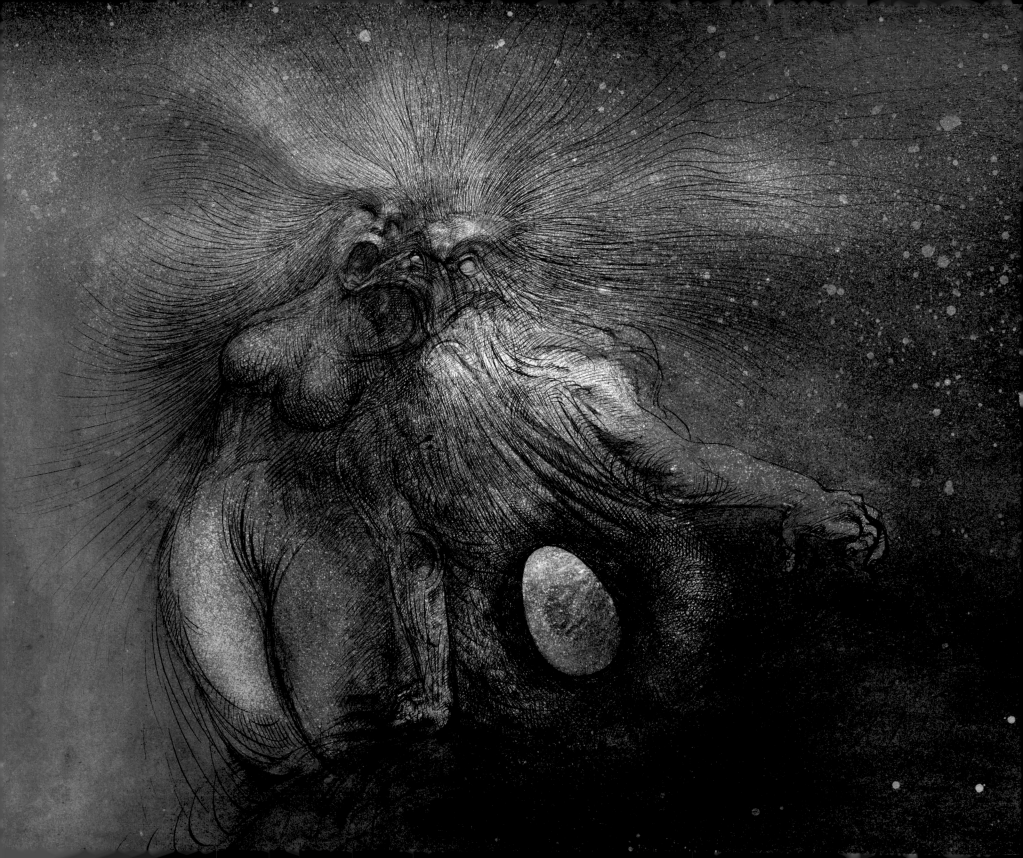

'Before the beginning there was me;
there was always me, but there was
someone else as well, but she, yes, she's
dead ...'

'We doubted our immortality because
of it. Before then we had not thought
of movement – or time. Time did not
exist. Now it does – the moment we
thought of our immortality. The inside
grew bigger, yes actually grew inside us,
swelled ... Deep inside that silence, that
hollow that swelled, there was a cry that
sent a shock wave through our thought
and found its form in sound.'

from *The Big I Am*
Jonathan Cape, 1988

God and His wife
Pen, mouth atomiser, brush and
coloured inks on paper
58.8 x 83.5 cm
Private collection

After taking the persona of Leonardo da
Vinci in *I, Leonardo*, Steadman turned to
soliloquising the Maker of makers for his next
big project. *The Big I Am* is God's apologia for
divine vindictiveness and cosmic indifference,
a lament for lost love and 'dark perfection',
and a document of human folly and fear.

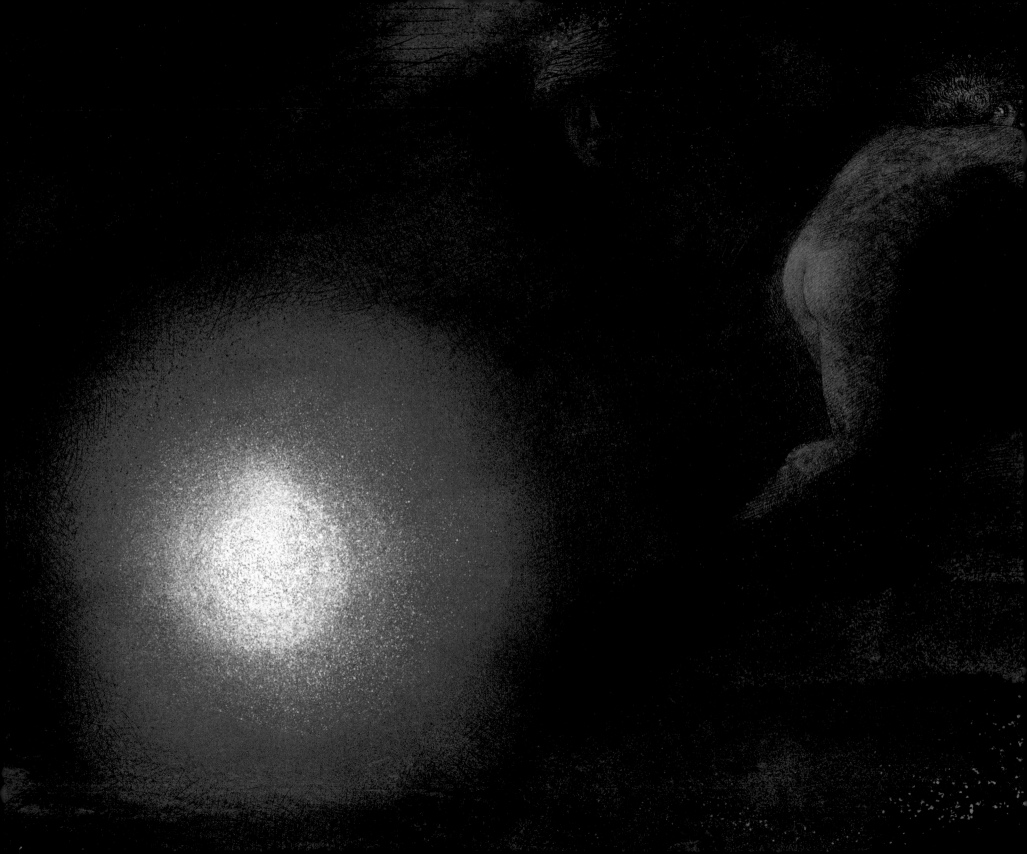

Before the birth of the EARTH, the
SUN is born to God and His wife and
its brilliance, stillborn though life-
giving, throws GOD into confusion as
the startling glow burns its presence into
the heavens and lights up the futility
of their fertility, as it were, their acts of
creation.

'The boredom drove the movement
onwards towards something hot,
something burned inside us and its heat
scorched the boredom and the sadness.'

from *The Big I Am*
Jonathan Cape, 1988

The Sun
Pen, mouth atomiser, brush and
coloured inks on paper
58.8 x 83.5 cm
Private collection

'As the human beings approached the farm buildings, Snowball launched his first attack. All the pigeons, to the number of thirty-five, flew to and fro over the men's heads and dropped their dung on them from mid-air ... Snowball now gave the signal for the charge. He himself dashed straight for Jones. Jones saw him coming, raised his gun and fired. The pellets scored bloody streaks along Snowball's back, and a sheep dropped dead...But the most terrifying spectacle of all was Boxer, rearing up on his hind legs and striking out with his great iron-shod hoofs like a stallion...'

from *Animal Farm: A Fairy Story*
by George Orwell
Secker & Warburg, 1995

The Revolution
Pen, brush, mouth atomiser and coloured
inks on paper
59.4 x 84 cm
Private collection

Steadman was asked to illustrate an edition of George Orwell's *Animal Farm* for the book's 50th anniversary in 1995.

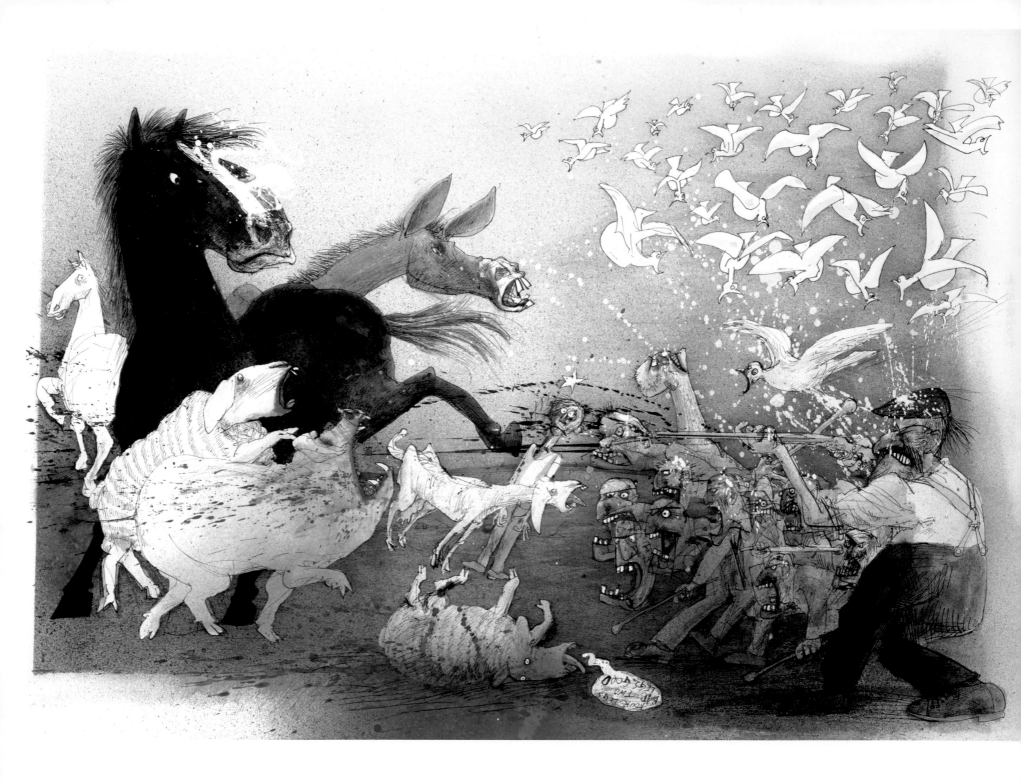

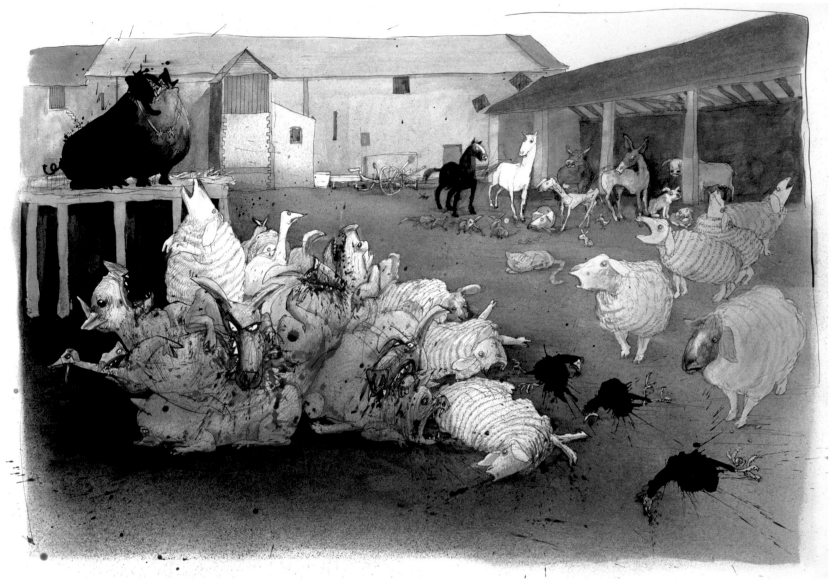

'Napoleon stood sternly surveying his audience; then he uttered a high-pitched whimper. Immediately the dogs bounded forward, seized four of the pigs by the ear and dragged them, squealing with pain and terror, to Napoleon's feet. The pigs' ears were bleeding, the dogs had tasted blood, and for a few moments they appeared to go quite mad...

Presently the tumult died down. The four pigs waited, trembling, with guilt written on every line of their countenances. Napoleon now called upon them to confess their crimes.'

from *Animal Farm: A Fairy Story* by George Orwell
Secker & Warburg, 1995

The Trial
Pen, brush, mouth atomiser and coloured inks on paper
59.4 x 84 cm
Private collection

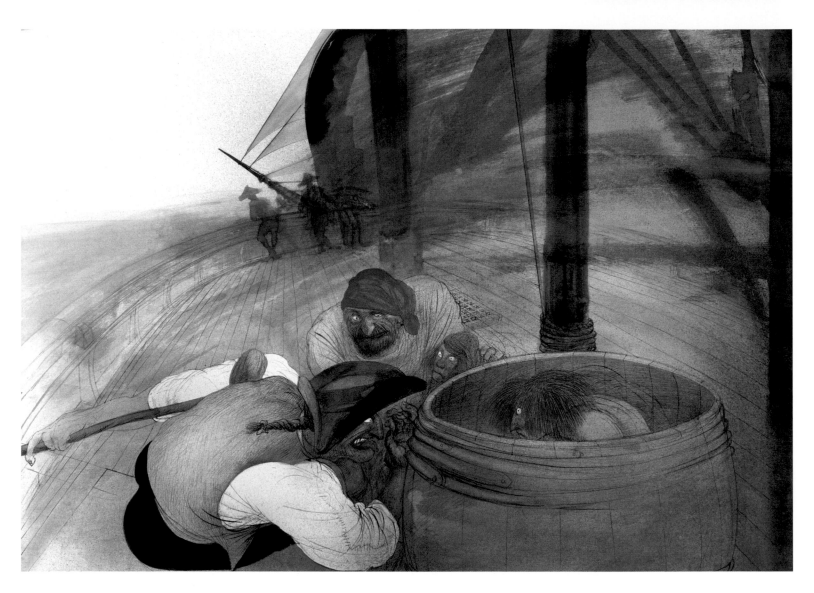

'In I got bodily into the apple barrel, and found there was scarce an apple left; but sitting down there in the dark, what with the sound of the waters and the rocking movement of the ship, I had either fallen asleep, or was on the point of doing so, when a heavy man sat down with a clash close by. The barrel shook as he leaned his shoulders against it, and I was just about to jump up when the man began to speak. It was Silver's voice, and, before I had heard a dozen words, I would not have shown myself for all the world, but lay there, trembling, and listening, in the extreme of fear and curiosity; for from these dozen words I understood that the lives of all the honest men aboard depended on me alone.'

from *Treasure Island* by Robert Louis Stevenson
Harrap, 1985

What I Heard in the Apple Barrel
Pen, brush, mouth atomiser, acrylic ink on paper
59.4 x 84 cm
Private collection

Steadman says of Stevenson's classic 1883 tale of 'gentlemen of fortune': 'There are no paragons in this story…So I didn't go out of my way to look for honour in the faces of the characters.'

123

Ralph I. Steadman

Photographs mounted on card, poster white with printed sticker on plastic cover

42.3 x 36.6 cm

British Cartoon Archive, University of Kent

Steadman has been an avid photographer since childhood. Some of the Steadman mug shots are marked with 'F.B.I.' numbers, and a sticker bears the cryptic message:

'I AM NOURISHING
PLACE ME
BETWEEN
TWO SLICES OF BREAD
AND
SWALLOW'

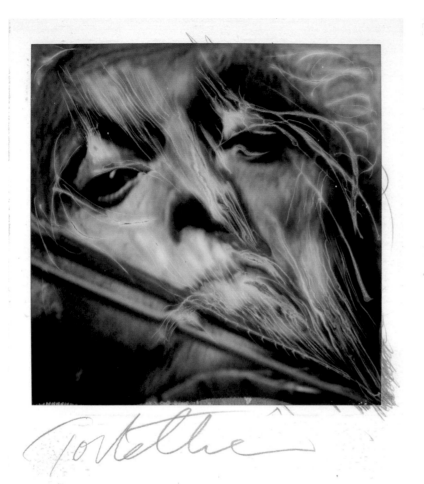

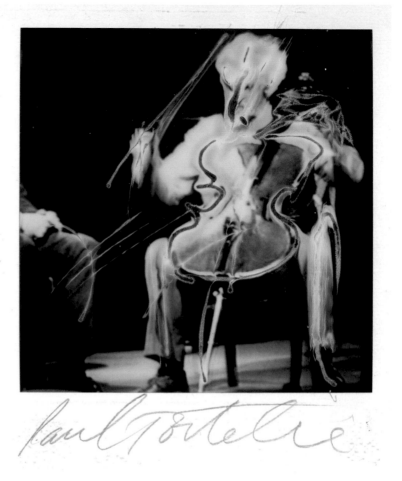

Paul Tortelier
from *Paranoids*, Harrap, 1986
Reworked Polaroid photograph
10.8 x 9 cm
Private collection

Paul Tortelier
from *Paranoids*, Harrap, 1986
Reworked Polaroid photograph
10.8 x 9 cm
Private collection

'It's that point of change that one tries to capture in photography…
When you draw a caricature … it's the moment between that you
realise you're actually capturing… the moment of expression –
of transition; they're making the full use of their face to express
themselves – their inner emotion.'

In the early 1980s Steadman discovered a new medium. By pushing
around the middle layers of emulsion of a Polaroid photograph with a
pencil, while it was still warm and gooey, he could stretch the images
into another dimension. Many of his 'Paranoids' were published in the
Observer Magazine.

Music has always exerted a powerful influence on Steadman. These
two Paranoids are from a series of five which Steadman created
while watching a performance on TV given by the French cellist
Paul Tortelier (1914–1990). In this Paranoid he set out to capture the
expression not just of the face but the whole body.

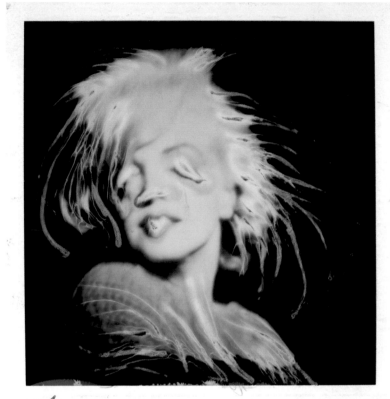

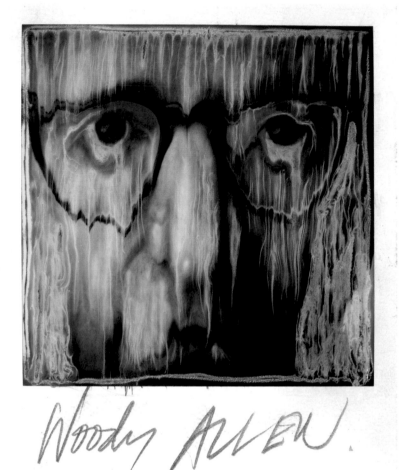

Marilyn
from *Paranoids*, Harrap, 1986
Reworked Polaroid photograph
10.8 x 9 cm
Private collection

The special nature of the Paranoid meant
that Steadman could work from any image
of an individual, in person, on television
or even from a photograph or a book. He
could produce images of individuals he could
never hope to get close to, or who were
inconveniently dead.

Woody Allen
from *Paranoids*, Harrap, 1986
Reworked Polaroid photograph
10.8 x 9 cm
Private collection

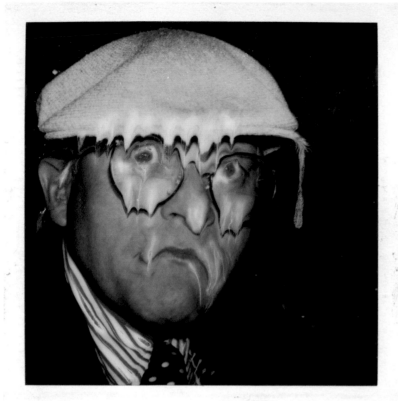

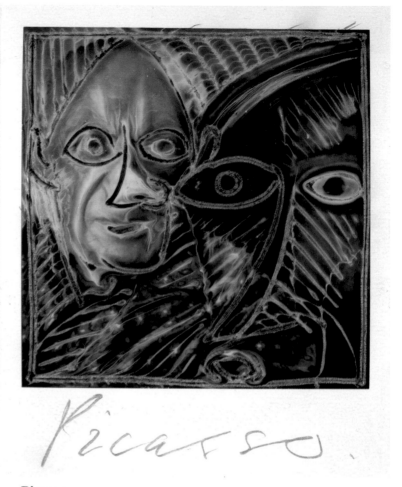

David Hockney
from *Paranoids*, Harrap, 1986
Reworked Polaroid photograph
10.8 x 9 cm
Private collection

At an event in Aspen, Colorado, Steadman
spied the painter David Hockney. Polaroid
camera in hand Steadman came up behind
him and called his name. Hockney turned
around and Steadman snapped him. 'It won't
come out you know,' Hockney told the
photographer.

Picasso
from *Paranoids*, Harrap, 1986
Reworked Polaroid photograph
10.8 x 9 cm
Private collection

Steadman is a great admirer of Pablo Picasso's
work and some of his early satires were direct
reworkings of his pictures. Here Steadman
conjures up the ghost of the revolutionary
Les Demoiselles d'Avignon (1907) out of the
gelatinous surface of the Polaroid.

Errázuriz, Panquehue Vineyards, Aconcagua Valley, Chile
1992
from *Untrodden Grapes*, Harcourt, 2005
Pen, brush, mouth atomiser, coloured inks on paper
56.4 x 78.6 cm
Private collection

In 1987 Steadman began a thirteen-year association with Oddbins Wine Merchants, producing cartoons and illustrations for their catalogues and advertising campaigns. He travelled to vineyards in Europe, Australia and North and South America, capturing the special qualities of the terrain and the winemakers.

Founded in 1870, Viña Errázuriz is one of the Aconcagua Valley's oldest vineyards.

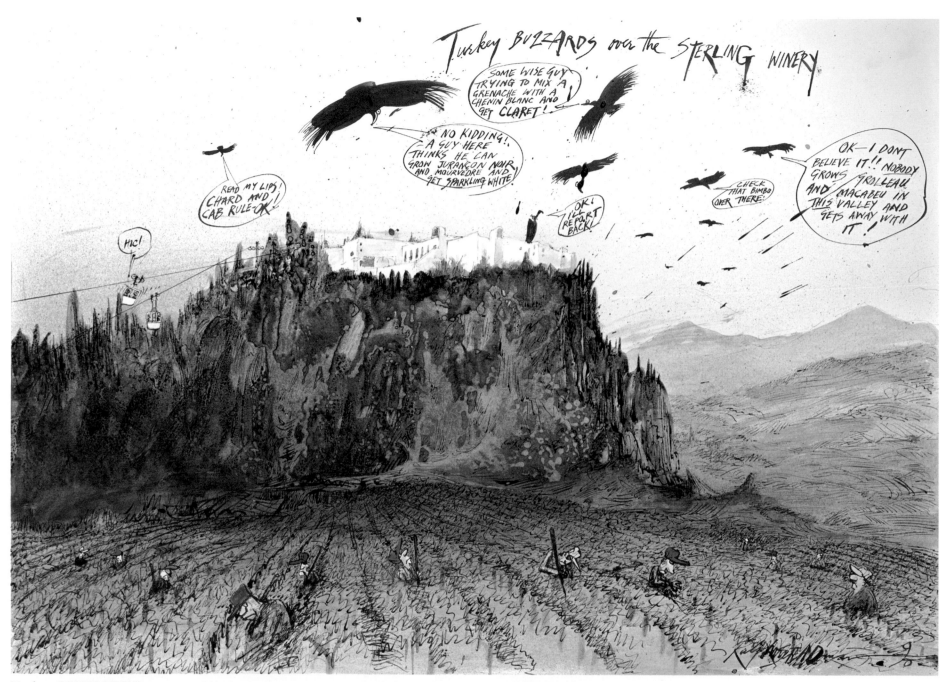

Turkey BUZZARDS over the STERLING WINERY
for Oddbins wine merchants
Ink and acrylic on paper
59.4 x 84 cm
Private collection

Perched on a rocky outcrop high above the town of Calistoga in California's Napa Valley, Sterling Vineyards is one of the most beautiful wineries in the world, reached by an aerial tramway.

Founded in 1964 by Englishman Peter Newton, the vineyard released its first vintage in 1969. A pioneer of the California wine industry, Newton was one of the first to plant grapes such as Merlot, long before it became a mainstream variety. Even the buzzards have heard of the vineyard's reputation for quality Cabernet Sauvignon and Chardonnay.

**Marc Colin – Duc de Gamay
et Saint Aubin**
1994
from *Untrodden Grapes*, Harcourt, 2005
Brush, pen, mouth atomiser, acrylic ink,
photographic collage on paper
84 x 58.4 cm
Private collection

In 1994 the artist created a series of
Arcimboldesque, Renaissance-style portraits
of Burgundy winegrowers. The distinctive
character of each face was constructed from
photos Steadman took of their vineyards.
Marc Colin's bristles are made up of vine
stakes from his estate at Saint-Aubin.

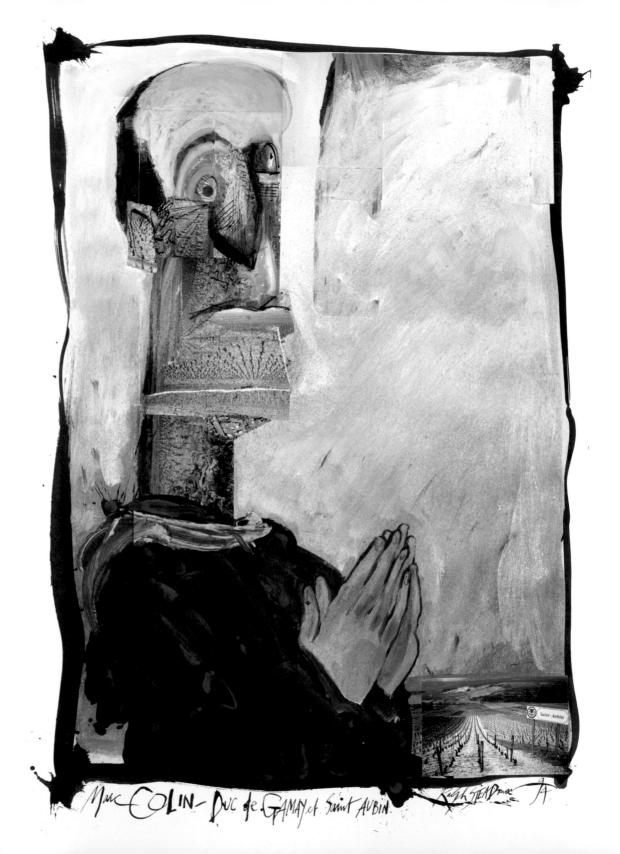

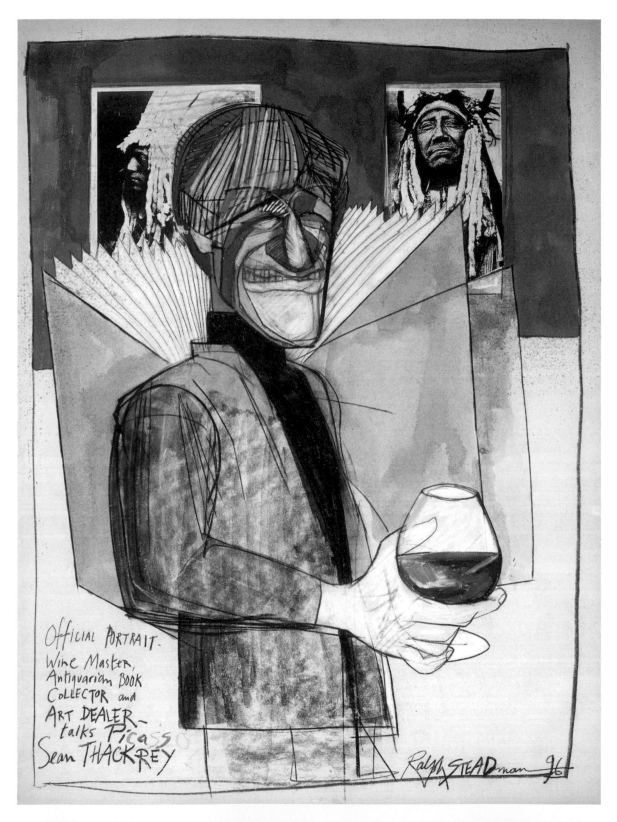

Official PORTRAIT.
Wine Master,
Antiquarian BOOK
COLLECTOR and
ART DEALER-
talks Picasso
Sean THACKREY

Ralph STEADman 96

Official Portrait – Wine Master Antiquarian Book Collector and ART DEALER talks Picasso
Sean Thackrey
1996
from *Untrodden Grapes*, Harcourt, 2005
Collage, charcoal, chalk and ink on paper
84.5 x 59.6 cm
Private collection

Steadman's role as wine merchants Oddbins' roving artistic ambassador took him to California in 1996, where he met the multi-faceted Sean Thackrey. The Native American portraits flanking former gallery director Thackrey allude to his expertise in photographic masters such as Edward Curtis, Mathew Brady, and Alfred Stieglitz.

Art rather than science has guided Thackrey's relationship with the vine. As Steadman explains, 'Winemaking to him is a natural enough process. He just lets it happen and allows the grape to tell what it has to say for itself.'

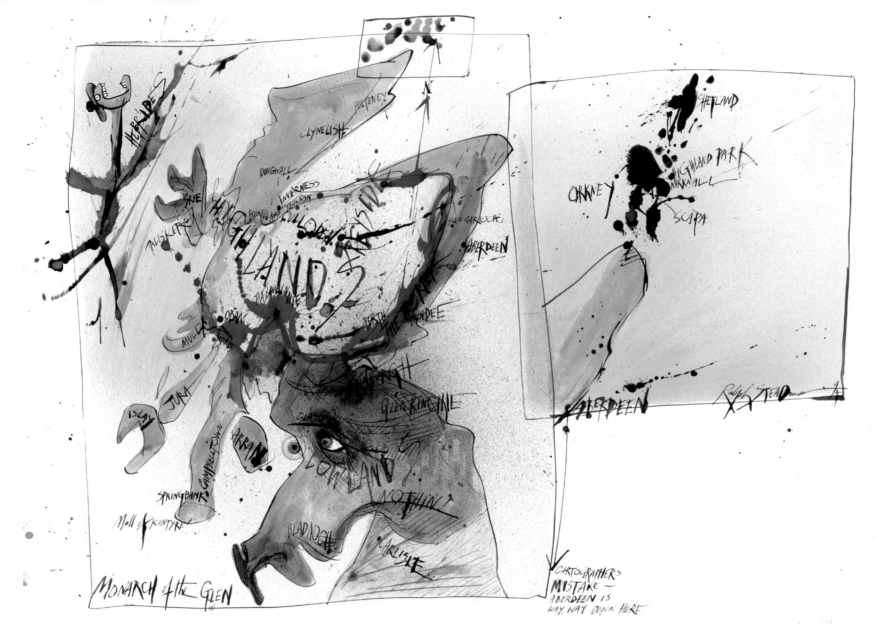

Monarch of the Glen
from *Still Life with Bottle*, Ebury Press, 1994
Pen, brush, mouth atomiser, ink and
watercolour on paper
59.4 x 84 cm
Private collection

Ralph puts whisky on the map. Steadman the cartographer marks famous centres of whisky making in Scotland such as Islay and Jura and distilleries such as Talisker, Dalwhinnie and Glen Garioch. He even references James Boswell and Samuel Johnson's *Journal of a Tour to the Hebrides* (1785), in which the great lexicographer called for a gill of whisky to find out 'what it is that makes a Scotsman happy.'

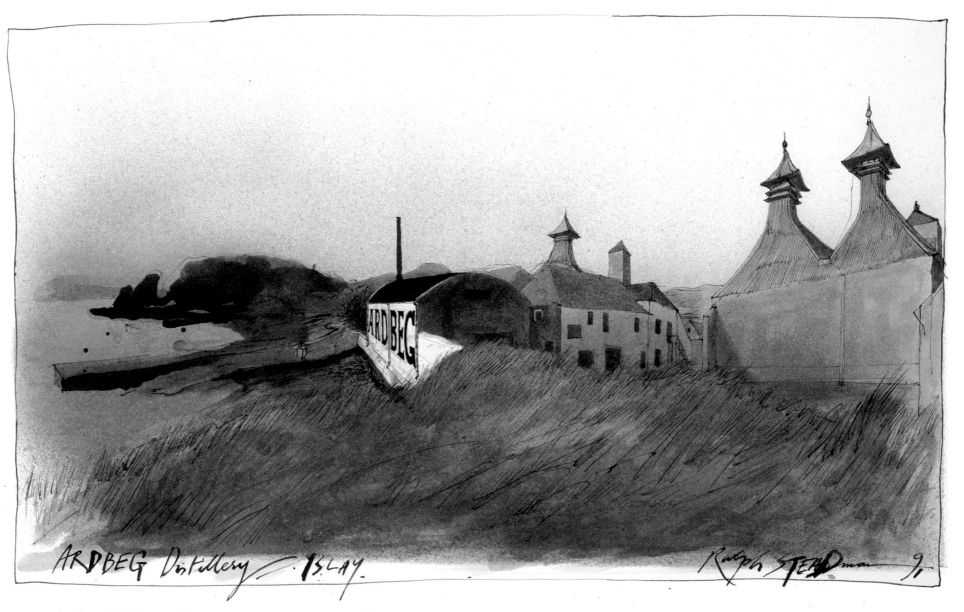

ARDBEG Distillery . ISLAY.

Ralph STEADman 9,

Ardbeg Distillery, Islay
from *Still Life with Bottle*, Ebury Press, 1994
Pen, brush, mouth atomiser and
acrylic ink on paper
57 x 76 cm
Private collection

In his 1994 book *Still Life with Bottle* Steadman explored the history
and art of distillation, as well as the lore and landscapes of Scottish
whisky. The tiny island of Islay, only 25 miles long by 20 miles wide,
is home to seven distilleries, all with different characters. In *Still
Life* Steadman pondered the mystery of how 'the same type of pot
still *and* the same water, *and* even the same brewer' can produce
such different whiskies. For example, Ardbeg whisky has a different
character to Laphroaig produced only 200 yards down the road. The
book contains many delicate and beautiful landscapes evoking the
soft evening light in the Western Isles.

Cardinal Zin
from *Untrodden Grapes*, Harcourt, 2005
Silkscreen print
76.5 x 56.6 cm
Private collection

In the mid-1990s Steadman was asked by the Bonny Doon Vineyard in California to design wine labels. One such was *Cardinal Zin* drawn for one of the company's zinfandels. In 2001 the Ohio State Department of Alcoholic Beverage Control deemed that Steadman had committed a cardinal sin as 'no advertisement or representation portraying pictures of persons, children, religious subjects… shall be permitted if the commission determines the advertising to be offensive or not in good taste.' Bonny Doon's distributors were forbidden to bring the wine into the state as long as it bore the offending label. Ohio eventually lifted the ban without any label change, and it was still being used in 2010.

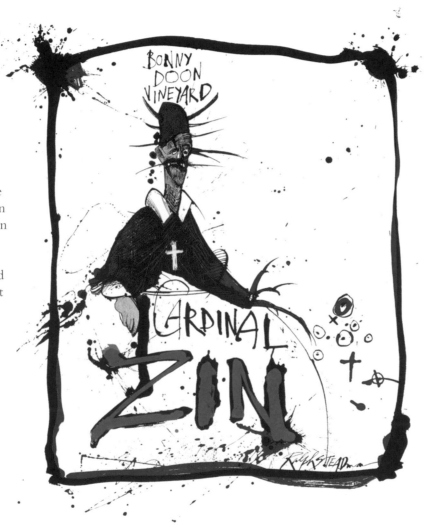

Raging Bitch
2009
Pen, mouth atomiser and acrylic ink and collage on paper
59.4 x 84 cm
Private collection

Flying Dog Brewery was originally established as a brewpub in 1990 in Aspen, Colorado. The founder and owner George Stranahan was a close friend of Hunter S. Thompson, who introduced him to Steadman. In 1995 the artist produced his first original artwork for Flying Dog's beer labels, which have since become an intrinsic part of the company's brand.

In 2009 the company commissioned Steadman to create a special label for 'Raging Bitch', their 20th anniversary Belgian-style India Pale Ale. Michigan's Liquor Control Commission withheld registration of the label, which they deemed 'detrimental to the health, safety and welfare of the general public'. Flying Dog sued the Commission in U.S. District Court, claiming that its First Amendment rights to free expression had been violated. In June 2011, three weeks after the company's first hearing before the Federal Court, the Commission decided to lift its ban. Raging Bitch has since become the company's most popular beer.

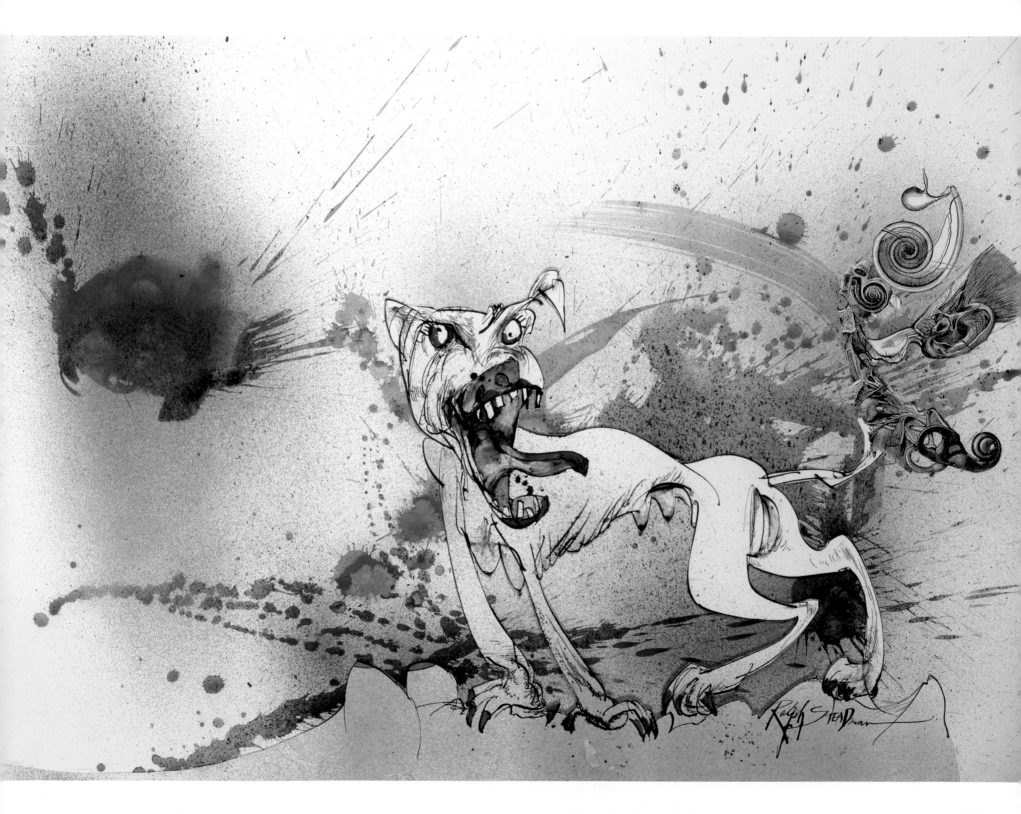

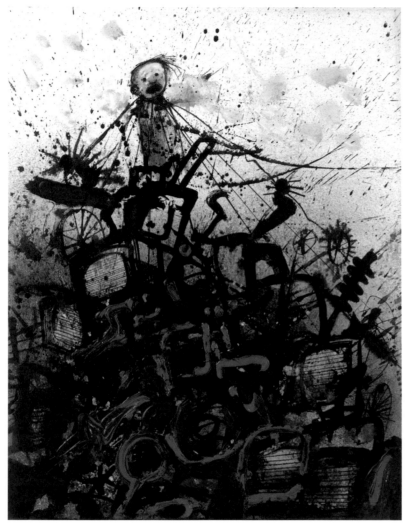

A Child's Carol
from *Plague and the Moonflower*, 1989

CHILD:
Can I have the life that's mine?
Can I sing for you?
Can I see the things you've seen?
Can I live before I go?

I've been told so many things
I've been told by you
Can I see the things you've seen?
Can I live before I go?

Hopeful Cartoons No. 1.
The Plague Demon's Lament
Independent, 10 December 1999
Pen, brush, mouth atomiser, ink on paper,
missing a flower
81.2 x 59.4 cm
Private collection

'*Plague and the Moonflower* draws us inside
a world uneasy with itself, trembling on
the brink of the millennium and haunted
by muddled dreams and sombre fears. All
around, there is evidence of rivers and oceans
soured, lands blighted and a creation sapped
and tainted by the Plague Demon, the dark
and grasping side of man's flawed nature…
Drawing on memories of pure and ancient
dreams, it leads on to a dramatic climax
in which the millennium marks a critical
moment and a chance to rebuild spoilt
lives and reshape Man's place in the world.'
(from *Plague and the Moonflower*, CD notes)

In 1989 Steadman was artist-in-residence
at the Exeter Arts Festival. He was also
commissioned to write a libretto for
an oratorio by Richard Harvey to be
accompanied by the guitar of John Williams.
The result of their collaboration was an eco-
opera and love story for the millennium,
Plague and the Moonflower, inspired by the
artist and traveller Margaret Mee's *In Search
of Flowers of Amazon Forests*, and especially by
the Moonflower *Selenicereus wittii*, a parasitic
cactus which only blooms once a year in
the moonlight. It was performed at Exeter
Cathedral in 1989 and later filmed by the
BBC at Salisbury Cathedral with sets and
paintings by Steadman, and broadcast on New
Year's Eve 1994.

HOPEFUL CARTOONS No 1
The Plague Demon's Lament

Flower by courtesy MOTHER HUBBARD'S FLOWER FARM, LOOSE VALLEY KENT.

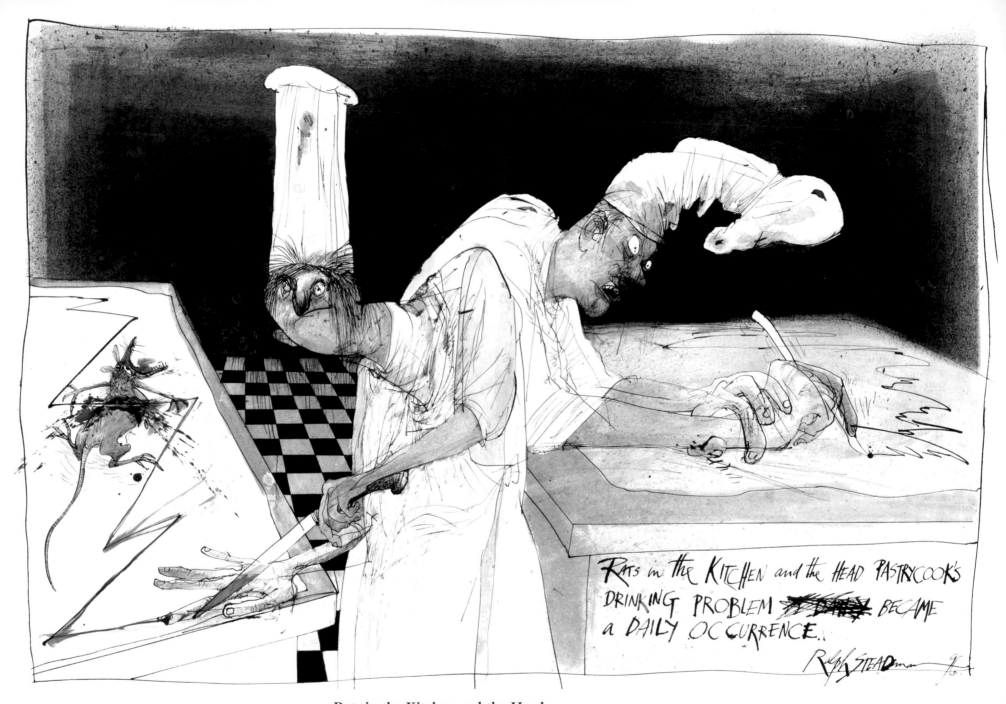

**Rats in the Kitchen and the Head
Pastrycook's Drinking Problem
Became a Daily Occurrence**
Independent, 14 November 1998
Pen, brush and coloured inks on paper
59.4 x 84 cm

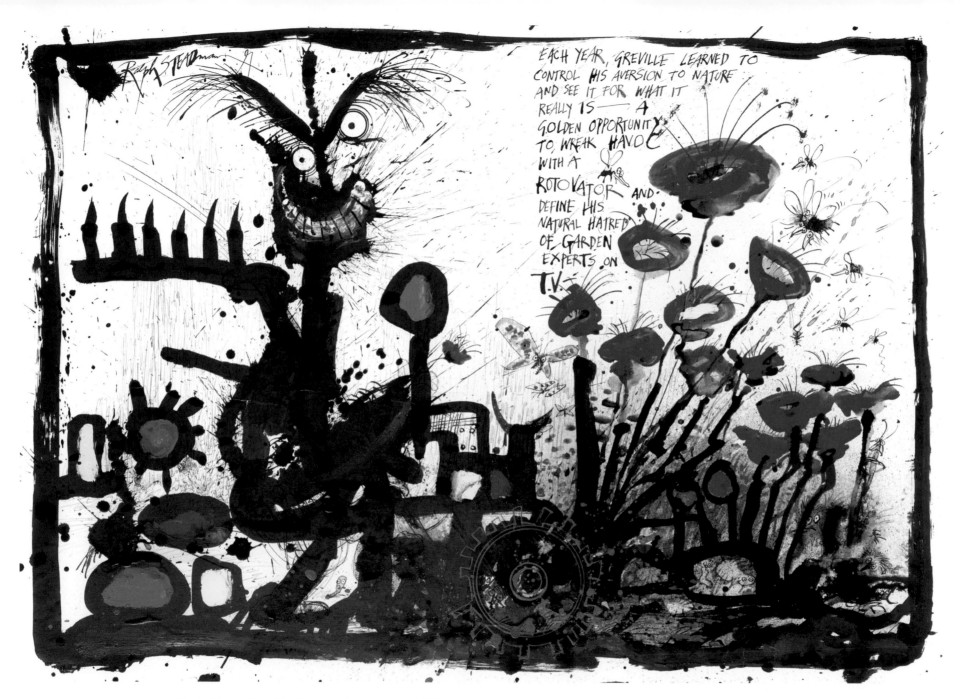

Within the illustration, handwritten text reads:

EACH YEAR, GREVILLE LEARNED TO CONTROL HIS AVERSION TO NATURE AND SEE IT FOR WHAT IT REALLY IS — A GOLDEN OPPORTUNITY TO WREAK HAVOC WITH A ROTOVATOR AND DEFINE HIS NATURAL HATRED OF GARDEN EXPERTS ON T.V.

Each Year, Greville Learned to Control His Aversion to Nature and See It for What It Really Is — A Golden Opportunity to Wreak Havoc with a Rotovator and Define His Natural Hatred of Garden Experts On T.V.
From *Gonzo – The Art*, Weidenfeld & Nicolson, 1998

Pen, brush, mouth atomiser, Indian ink and acrylic ink on paper
59.4 x 84 cm

For many years Ralph has been the unpaid gardening correspondent for *Rolling Stone*.

139

Hunter's Liver on Holiday
Liverpool, England
1996
Pen, brush and ink, acrylic paint,
poster white and collage on paper
45.7 x 61 cm
Private collection

Steadman spoke of his late friend's appetites
in 2008: 'It must have got tiresome at times
having to live up to the whole idea of
being this crazy, drug-taking, pill-popping,
booze-ridden …'

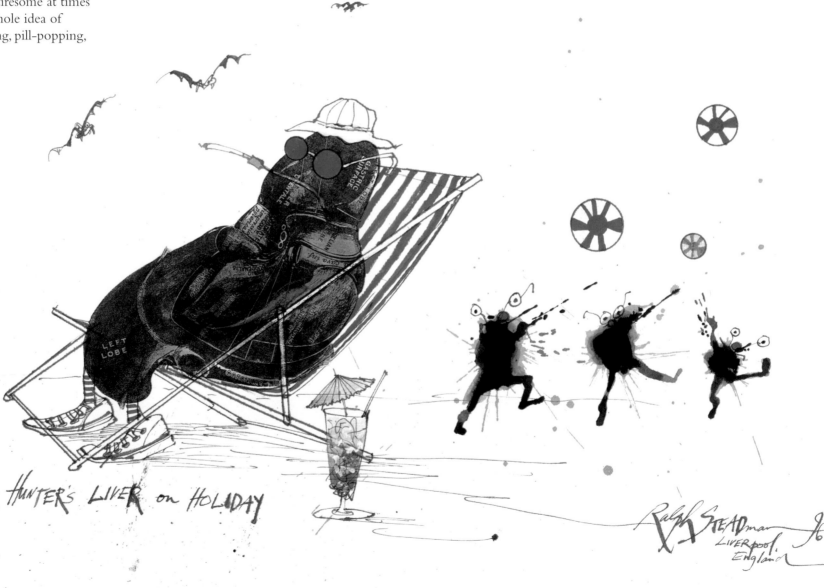

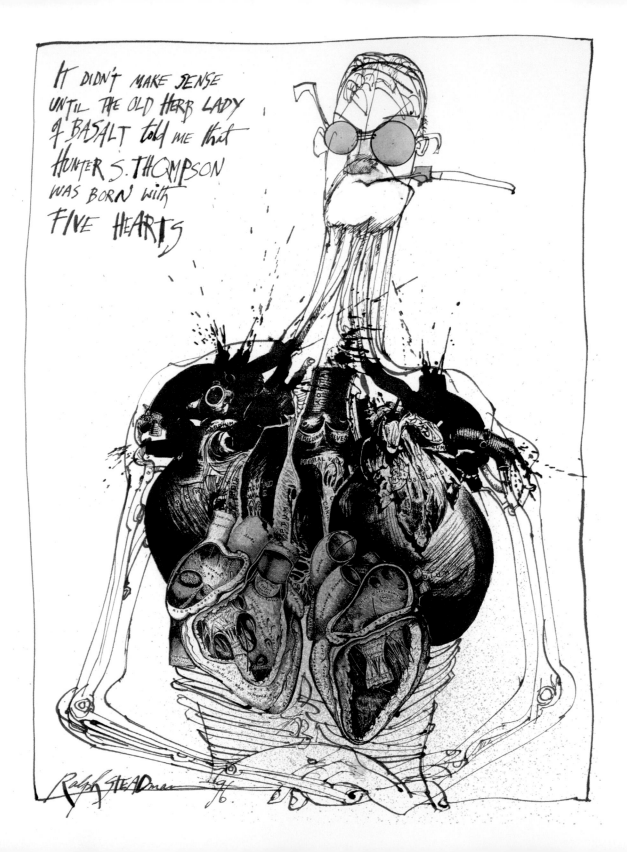

In the illustration: IT DIDN'T MAKE SENSE UNTIL THE OLD HERB LADY OF BASALT told ME that HUNTER S. THOMPSON WAS BORN with FIVE HEARTS

'It didn't make sense until the old herb lady of Basalt told me that Hunter S. Thompson was born with FIVE HEARTS'
1996
Pen, brush and acrylic and Indian ink and collage on paper
61 x 46 cm
Private collection

In the mid-1990s Steadman created a number of anatomical portraits of Hunter Thompson incorporating cut-up illustrations to *Gray's Anatomy*.

Throughout his adult life Thompson consumed a quantity and variety of drugs and alcohol that would have poleaxed most other mortal constitutions.

Basalt is a small ex-mining town near Thompson's home at Owl Farm, Woody Creek, Colorado.

Hunter S. Thompson, 1937–2005
Rolling Stone, 24 March 2005
Collage, conté chalk and ink on board
84 x 59.4 cm
Private collection

In the 1977 documentary *Fear and Loathing on the Road to Hollywood* Hunter acknowledged that he had become a prisoner of the Gonzo myth: 'I'm really in the way as a person and the myth has taken over. I find myself an appendage. I'm no longer necessary, I'm in the way. It would be much better if I die.'

It was February 2005 and to Hunter's great dismay George W. Bush had just been inaugurated for a second term. Now in his late sixties, Thompson was suffering from many ailments. There were the after-effects of hip replacements and other surgery. He had to have daily physiotherapy and was in significant pain. On 20 February 2005 he took his Magnum .44 and shot himself in the head. A month later *Rolling Stone* marked the passing of one of its greatest contributors with a special memorial issue.

Thompson stands damaged yet defiant in his Converse Chuck Taylor All Stars against an abstract cityscape which echoes Steadman's opening illustration for *Fear and Loathing in Las Vegas.* The picture accompanied an article by Doug Brinkley, Thompson's biographer.

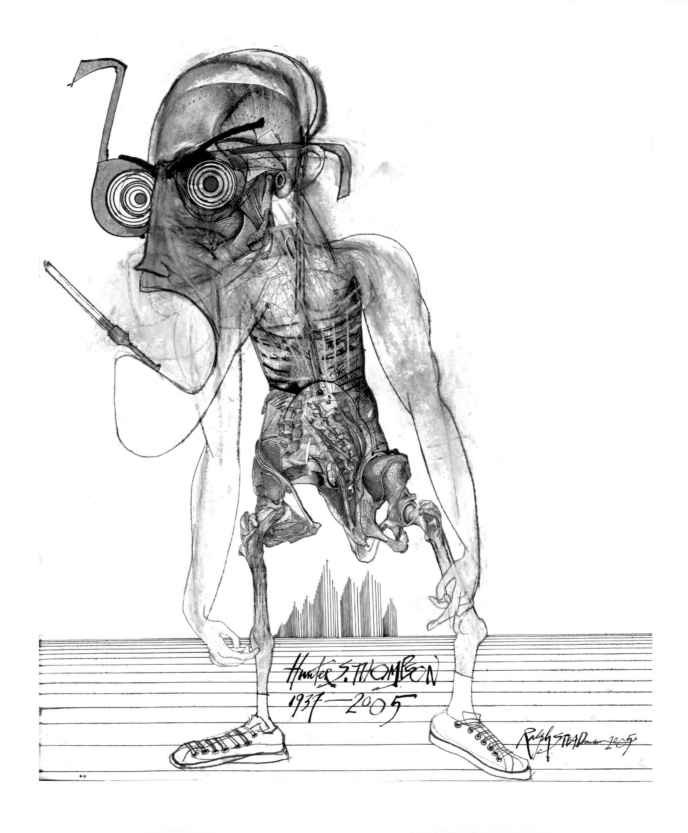

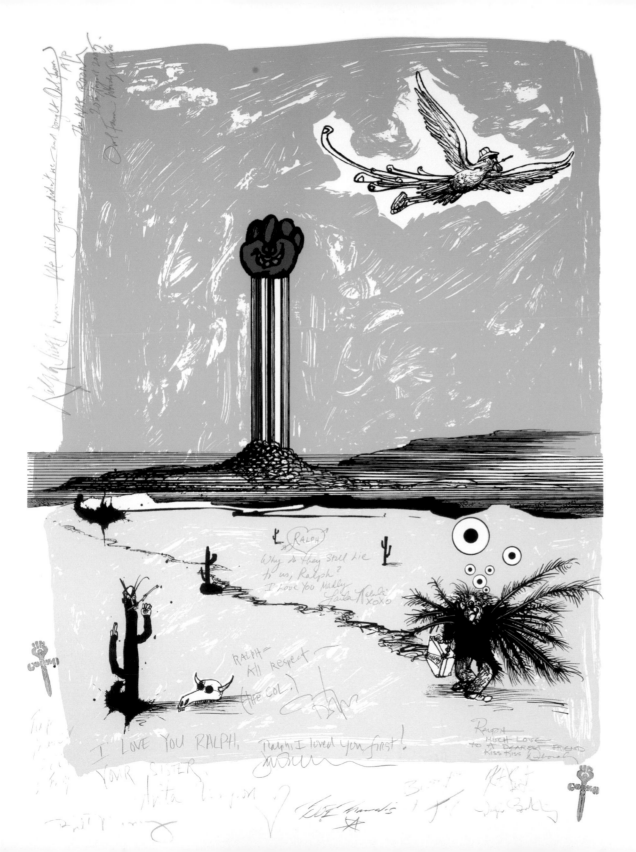

Hunter's Memorial

Silkscreen print signed 20 August 2005
76.5 x 56.8 cm
Private collection

In 1978 the BBC filmed Hunter Thompson at his ranch, Owl Farm in Woody Creek, outside Aspen, Colorado for an Omnibus documentary, *Fear and Loathing on the Way to Hollywood*. Thompson told the director Nigel Finch of his funeral plans: 'There's gonna be a pile of rocks, about a hundred feet tall, then a sort of giant chrome cylinder, conical, sort of round and tapering down to the top, 150 feet tall, hollow inside, with on top of the sort of big arm a fist with a double thumb – the symbol…Oh yes, it's in the will… After the cremation we put the ashes in a canister and shoot it out of the top of the fist over the valley – about 500 feet up. It explodes and the ashes drift down all over it. That's it. That's my funeral.' Steadman put the designs down on paper.

Six months after his death in February 2005, Thompson's dream was realised. 250 friends and family witnessed Hunter's spectacular send-off at Owl Farm. His ashes were indeed shot out of a153-foot-tall cannon over the valley in a riotous explosion of red, white and blue fireworks. On top of the column was a two-thumbed red fist with a peyote button – the Gonzo fist. Among the signatories of Steadman's print are Hunter's widow, Anita, his former girlfriend Laila Nabulsi, Bill Murray and, next to the skull, Johnny Depp.

Mad!

from *The Devil's Dictionary*
by Ambrose Bierce
Bloomsbury, 2003
Pen, brush and ink, collage on paper
84 x 59.4 cm
Private collection

Mad, *adj.* Affected with a high degree of
intellectual independence; not conforming
to standards of thought, speech and action
derived by the conformants from study of
themselves; at odds with the majority; in short,
unusual.

Ambrose Bierce began his *Devil's Dictionary*
in the pages of the San Francisco magazine
The Wasp in 1881. Parts of it – A to L – were
published as *The Cynic's Word Book* in 1906.
Bierce's irreverent lexicon was published in
full in 1911 with the author's original title.

 In a new edition published in 2003
Steadman contributed 26 original drawings,
26 alphablotical headings and a portrait of
Bierce himself. In *Mad!* a swarm of strange
whims circle the cranium of Steadman's
bombinating chimera, stitched together
with cogs and whirligigs and strange bony
processes. The inclusion of the tomb of
Cardinal Basso by Andrea Sansovino adds a
touch of Saul Steinberg to the image.

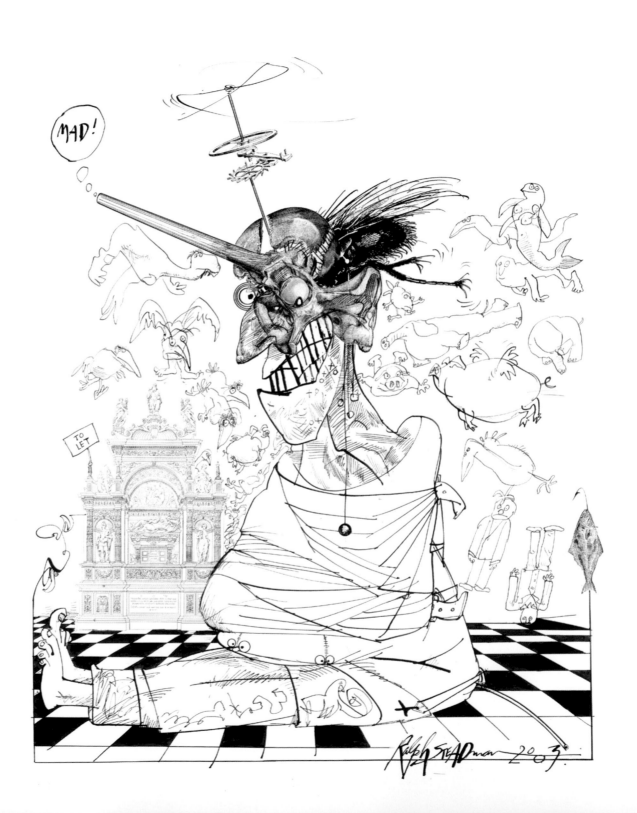

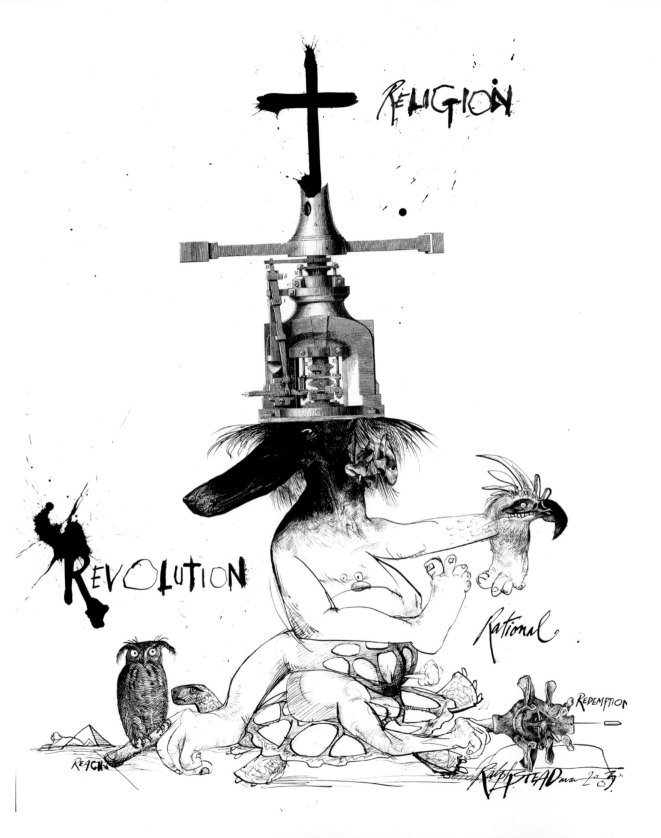

Religion, Revolution, Rational, Redemption, Reach
from *The Devil's Dictionary*
by Ambrose Bierce
Bloomsbury, 2003
Pen, brush and ink, collage on paper
84 x 59.4 cm
Private collection

Religion, *n.* A daughter of Hope and Fear, explaining to Ignorance the nature of the Unknowable.

Revolution, *n.* In politics, an abrupt change in the form of misgovernment … Revolutions are usually accompanied by a considerable effusion of blood, but are accounted worth it – this appraisement being made by beneficiaries whose blood had not the mischance to be shed.

Steadman's snouted celebrant recalls the officiating goat in Goya's 1798 painting *The Witches' Sabbath*.

145

Ernest Hemingway
c. 1993
Etching
47.5 x 42.5 cm
Private collection

The journalist and author Ernest Hemingway (1899–1961) became one of America's most admired writers of the twentieth century. His works include *A Farewell to Arms* (1929), *Death in the Afternoon* (1932), *For Whom the Bell Tolls* (1940) and *The Old Man and the Sea* (1953). Hemingway won both the Pulitzer Prize (1953) and the Nobel Prize for Literature (1954). His lifelong love of hunting and fishing inspired several of his books. His 1935 nonfiction book *Green Hills of Africa* is an account of a safari in East Africa. Here Hemingway the big game hunter proudly stands over one of his victims, a rhino.

In the early 1990s the artist created a series of steel-plate etchings of writers printed at Peacock Visual Arts, Aberdeen. Other subjects included William Burroughs, George Orwell, Virginia Woolf, T. S. Eliot and Samuel Beckett

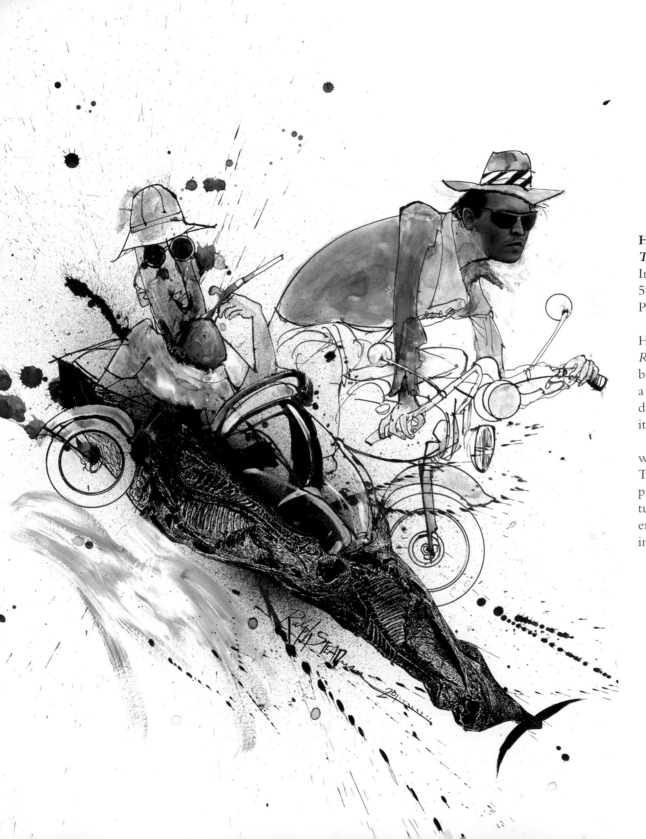

Hunter S. Thompson and Johnny Depp
The Independent, 2011
Ink, collage, acrylic and gesso on paper
59.4 x 84 cm
Private collection

Hunter S. Thompson's long-lost novel *The Rum Diary* was written in the early 1960s, but failed to find a publisher. It languished in a box at Thompson's Owl Farm until it was discovered by Johnny Depp, who encouraged its publication in 1998.

In 2011 the book was turned into a film written and directed by Bruce Robinson. The movie starred Johnny Depp, who also produced, as Paul Kemp, a failed author turned journalist and alcoholic who becomes embroiled in shady deals and extended binges in Puerto Rico.

Will Self: 'In 1802 Richard Lovell Edgeworth published the first proposal to construct railways for public transport. He envisaged rails implanted in the highways with heaviest traffic, which could be supplied with cradles on to which existing carriages could be lifted. These would then be drawn by horsepower, a principal advantage of the system being the reduction in friction … [E]lide the Frenchman and Edgeworth, and it seems to me we have a pretty accurate description of the *péage* autoroutes which a century later snake across France like blue veins through Roquefort. I know, I know, some will cavil that the highway and the vehicle moving on it don't truly constitute a machine ensemble, because the car is capable of independent motion, but try telling that to a strung-out paterfamilias piloting a people carrier full of enfants terribles from the Dordogne to Calais.'

Péages
PsychoGeography #2, *Independent*
Saturday Magazine, 11 October 2003
reprinted in *Psychogeography*, words by Will Self,
pictures by Ralph Steadman
Bloomsbury, 2007
Collage, photograph, pen, brush and ink,
dirty ink wash on paper
84.3 x 59.5 cm
Private collection

Steadman illustrated *Psychogeography*, Will Self's 'long-distance walking' tours and Debordian travelogues, in the *Independent* from 2003 to 2008.

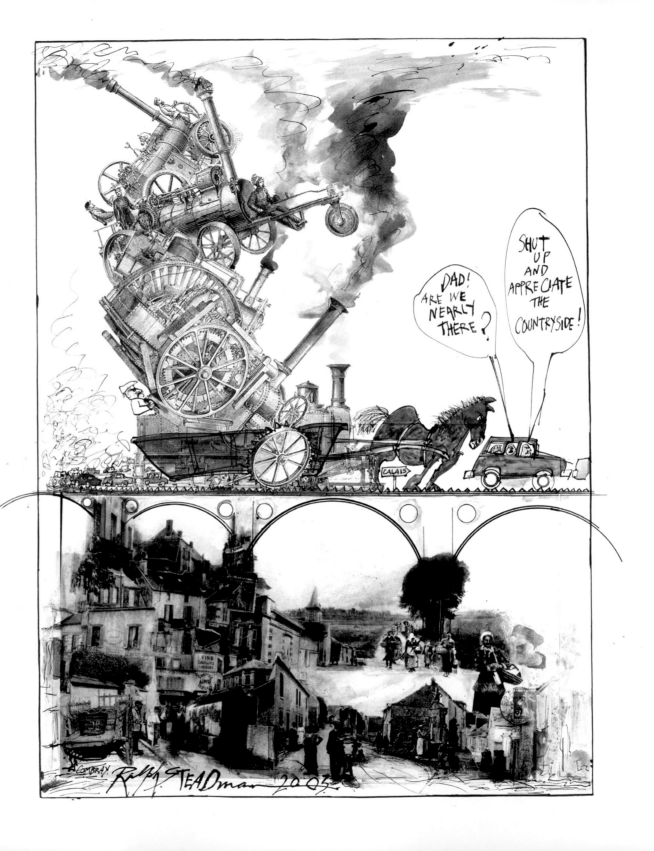

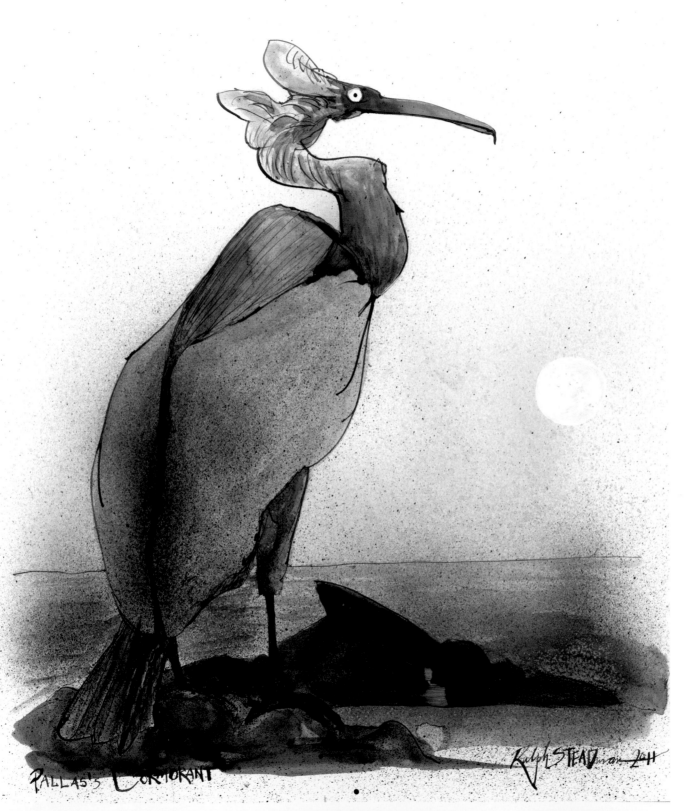

Pallas's Cormorant

Pallas's Cormorant
Phalacrocorax perspicillatus
2011 from *Extinct Boids*
Bloomsbury, 2012
Pen, brush, mouth atomiser, acrylic ink,
wash from cleaning jar on paper
84 x 59.4 cm
Private collection

Pallas's Cormorant, also known as the
Spectacled Cormorant, was a marine bird
native to Bering Island, off the coast of Russia.
From 1826 it was hunted for food by Aleut
settlers. By the 1850s not a cormorant was to
be seen on the island.

In 2011 the artist was asked by filmmaker
Ceri Levy to contribute a drawing of an
extinct bird to an exhibition, *Ghosts of Gone
Birds* curated by Levy and Chris Aldhous
in aid of BirdLife International's Preventing
Extinctions programme. Steadman responded
to the project with his customary enthusiasm
and over a year produced 100 paintings of
extinct birds and 'boids' for Levy. The extinct
birds and Steadman's 'boids' differ in their
modes of non-existence: the extinct ones
– e.g. the Great Auk, the Black Mamo and
the Mascarene Parrot – are real, but defunct;
the 'boids' – e.g. the Mottled Splatwink, the
Pink Rotten Scrawl and the Needless Smut
– are imaginary, but in rude health, and live
in harmonious confusion with the extinct
species on Steadman's own 'Toadstool Island'.

The Three Parroteers or Parrotlets!!
Indigo-winged Parrot
Hapalopsittaca fuertesi
Brown-backed Parrotlet
Touit melanonotus
Red-fronted Macaw
Ara rubrogenys
c. 2014 from *Nextinction*
Bloomsbury, 2015
Ink and acrylic on paper
84 x 59.4 cm
Private collection

In 2015 'gonzovationists' Ralph Steadman
and Ceri Levy climbed aboard the HMS
Steadmanitania for a return journey to
Toadstool Island in *Nextinction*, their follow-
up book to the acclaimed *Extinct Boids*. This
time Steadman and Levy told the world
not of the birds already gone, but of those
we can still save, the species 'next in line for
extinction'. Steadman's subjects again are
both real and fanciful: not only Critically
Endangered species on the IUCN Red List,
such as the Red-headed Vulture, the Kakapo
and the Turtle Dove, but also the artist's own
beaky denizens of Toadstool Island, such as the
'Unsociable Leftwing' and the 'Big-breasted
Conspicuous Tit'.

The Indigo-winged Parrot from
Colombia, the Brown-backed Parrotlet from
south-eastern Brazil and the Red-fronted
Macaw from south-central Bolivia are all in
decline because of human-caused habit loss.
'Birds are the greatest indicator of ecological
imbalance', writes Levy, 'and when they
disappear the drama of our collapsing ecology
will unfold further.'

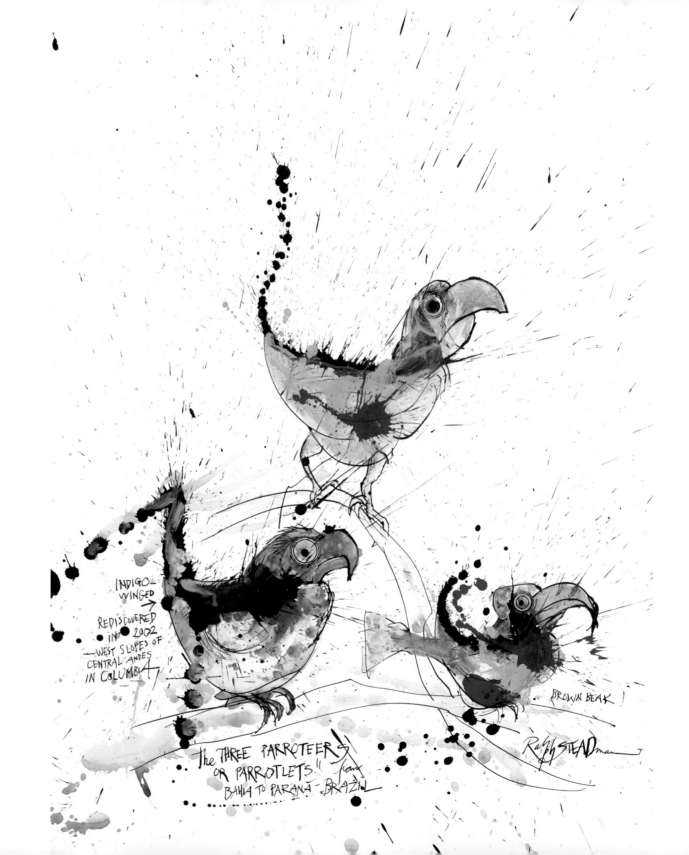

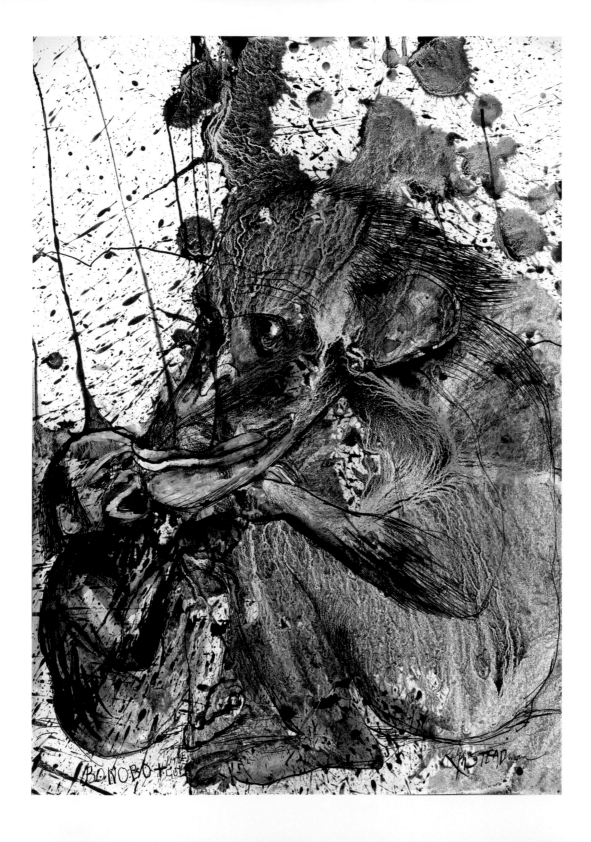

Bonobo + Little Guy,
2016
from *Critical Critters*, Bloomsbury, 2017
Ink, acrylic and gesso over wash
from cleaning jar on paper
59.4 x 84 cm
Private collection

In 2016 Steadman began working on a new book with Ceri Levy about animals on the verge of extinction – *Critical Critters*.

Throughout his career, Steadman has continued to innovate and experiment. The drawings for the 2017 book are created using the artist's 'dirty water' technique. This involves pouring water from the pot he uses to wash his brushes onto a large piece of watercolour paper. He leaves it to dry for a time and then moves the 'dirty water' around the paper until he is pleased with the result. When it is dry, he finds a shape within it and reworks it into a 'critter' with acrylic paint and Indian ink.

Steadman's inventions owe much to Leonardo's advice to the art student: 'Stop sometimes and look into the stains of walls, or ashes of a fire, or clouds, or mud or like places, in which, if you consider them well, you may find really marvellous ideas'.

Breaking Bad: Walter White
2015
Ink and acrylic on paper
59.4 x 84 cm
Private collection

The multi-award-winning, darkly comic
TV drama *Breaking Bad* ran on AMC for six
seasons from 2008 to 2013. In 2014 Steadman
was asked to create images of six main
characters for the covers of limited-edition
Blu-ray Steelbooks.

The lead character, Walter White, played
by Bryan Cranston, is an Albuquerque high
school chemistry teacher who, after being
diagnosed with terminal lung cancer, turns to
cooking and selling crystal meth to secure the
future of his family.

Steadman says of Walt and the other
characters, 'I printed out photographs of
them and then watched all the series and
some of it stayed in my head. Walt has a
certain look to him. I realised that you can
draw the top of his head with a compass.
It's perfect …Walt says he's only doing it for
his family, but one thing leads to another
and he gets deeper and deeper and there's
no going back.'

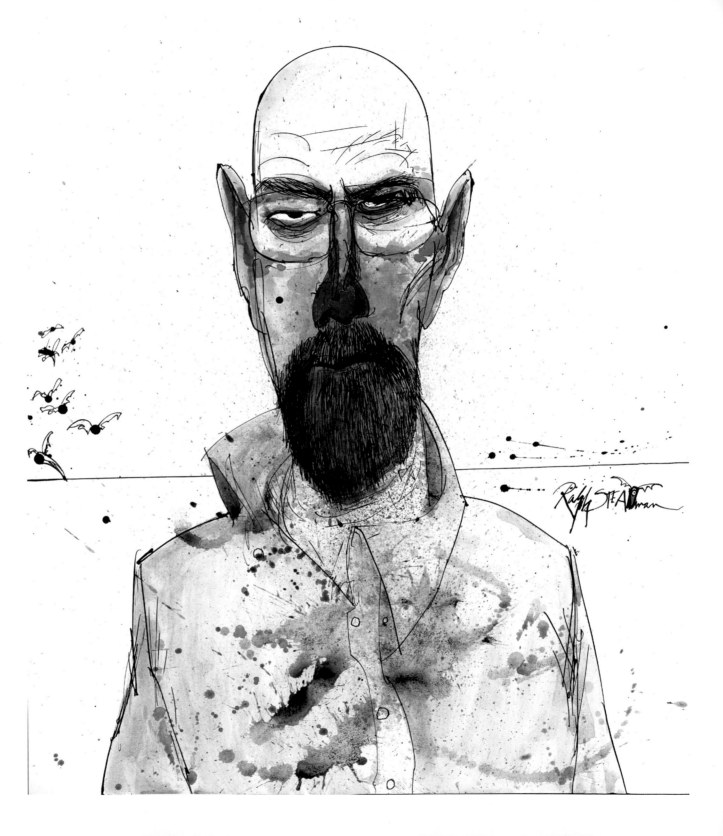

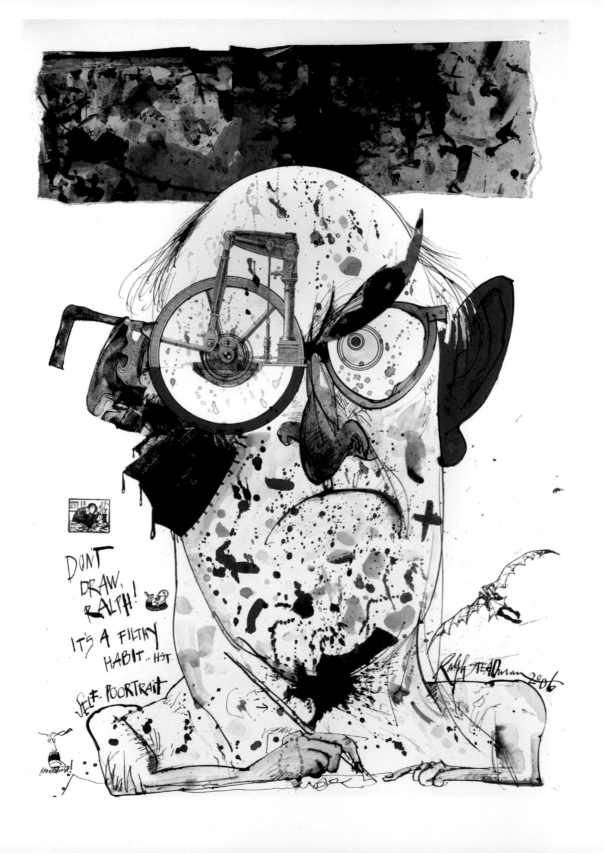

'Don't draw, Ralph! It's a filthy habit…'
HST.
Self-Poortrait
Stop Smiling – The UK Issue, Issue No. 26,
2006
Pen, brush and ink on paper with celluloid
and collage and strip of ink-splattered paper
from desk
79.2 x 56.5 cm
Private collection

Ralph – pen in hand in his piston-rod-and-
flywheel spectacles – is accompanied by four
tiny but significant vignettes of his career:
a man at a desk holds his head in his hands;
another screams; Sigmund Freud cocks a
snook; and, in a final flourish, a Leonardo
ornithopter takes flight from the STEADman
signature.

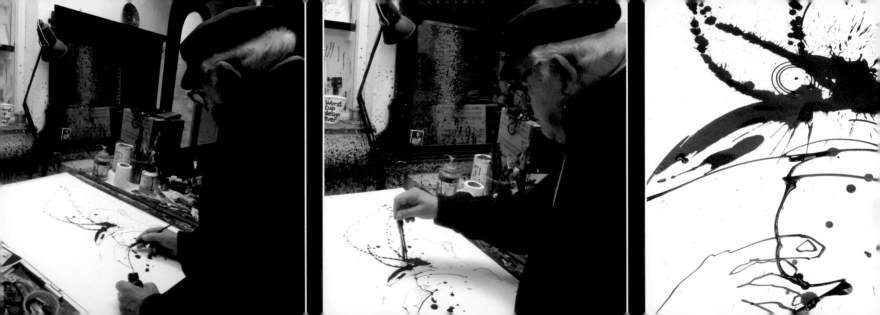

The Pessimist
New Statesman, 12 April 2013

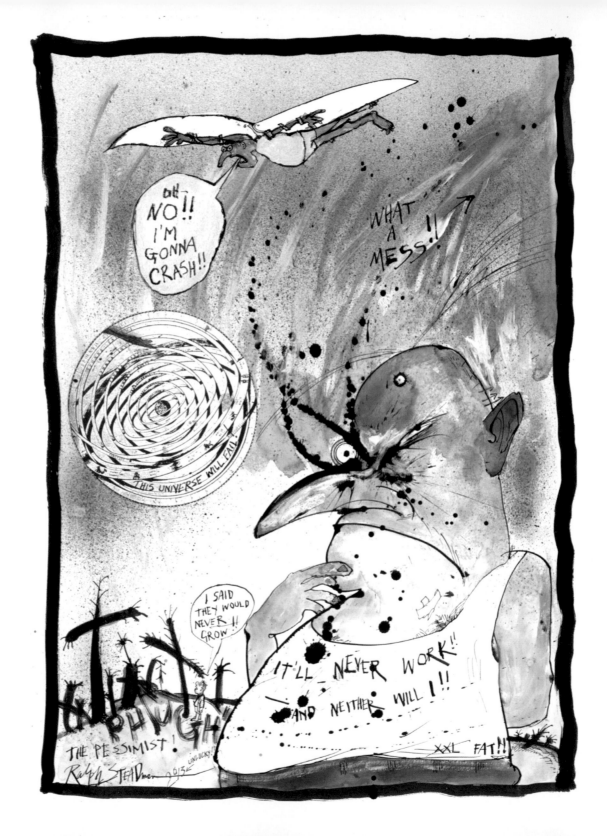

Bibliography

BOOKS by Ralph STEADman

Ralph Steadman's Jelly Book (London: Dennis Dobson, 1967;
New York: Scroll Press, 1970)

The Little Red Computer (London: Dennis Dobson, 1968; New York, 1969)

Still Life with Raspberry, or The Bumper Book of Steadman
(London: Rapp & Whiting, 1969)

Dogs Bodies (London: Abelard-Schuman, 1970;
revised edition, London: Paddington Press, 1977)

The Bridge (London: William Collins, 1972; revised edition,
Two Donkeys and a Bridge, London: Andersen Press, 1983)

Ralph Steadman's Bumper to Bumper Book for Children
(London: Abelard-Schuman, 1972; London: Pan Books, 1973)

America (San Francisco: Straight Arrow Books, 1974; New York: Random House,
1977; Scranton, PA: Fantagraphics, 1989)

Flowers for the Moon (Zurich: NordSüd Verlag, 1974; London: Andersen Press, 1983)

Sigmund Freud (London: Paddington Press, 1979; Paris: Aubier, 1980; Baarn:
Wouter Wagner B.V., 1980; Hamburg: Rowohlt, 1981; London: Penguin, 1982;
Ontario: Firefly, 1997; Toronto: Firefly Books, 2001; Paris: Flammarion, 2003)

A Leg in the Wind (and other Canine Curses) (London: Arrow Books, 1982;
reprinted as *No Good Dogs*, New York: Putnam, 1982)

I, Leonardo (London: Jonathan Cape, 1983; Paris: Aubier, 1983;
New York: Summit Books, 1983)

Between the Eyes (London: Jonathan Cape, 1984)

Paranoids. from Socrates to Joan Collins (London: Harrap, 1986)

That's My Dad (London: Andersen Press, 1986)

Scar Strangled Banger (London: Harrap, 1987; New York: Harcourt Brace, 1987)

The Big I Am (London: Jonathan Cape, 1988; Paris: Aubier, 1988)

No Room to Swing a Cat (London: Andersen Press, 1989)

Tales of the Weirrd (London: Jonathan Cape, 1990; Ontario: Firefly Books, 2002)

Near the Bone (London: Arrow Books, 1990)

Friends Echo (London: Bernard Stone, Turret Bookshop, 1990; small press edition)

The Grapes of Ralph. Wine According to Ralph Steadman
(London: Ebury Press, Random House, 1992; New York: Harcourt Brace, 1992)

Still Life with Bottle. Whisky According to Ralph Steadman
(London: Ebury Press, Random House, 1994; New York: Harcourt Brace, 1994)

Teddy! Where Are You? (London: Andersen Press, 1994)

Jones of Colorado (London: Ebury Press, Random House, 1995; as
The Book of Jones: A Tribute to the Mercurial, Manic, and Utterly Seductive Cat,
New York, San Diego: Houghton Mifflin Harcourt, 1997)

Gonzo: The Art, foreword by Hunter S. Thompson
(London: Weidenfeld & Nicolson, 1998; New York: Harcourt Brace, 1998)

little.com (London: Andersen Press, 2000)

Doodaaa. The Balletic Art of Gavin Twinge: A Triography (London: Bloomsbury, 2002)

Untrodden Grapes (New York: Harcourt, 2005)

Garibaldi's Biscuits (London: Andersen Press, 2008)

The Joke's Over. Bruised Memories: Gonzo, Hunter Thompson and Me
(London: William Heinemann, 2006; New York: Harcourt, 2010)

The Ralph Steadman Book of Dogs (London: Atlantic Books, 2010)

The Ralph Steadman Book of Cats (London: Atlantic Books, 2012)

with Ceri Levy, *Extinct Boids* (London: Bloomsbury, 2012)

Proud To Be Weirrd (Pasadena: AMMO Books, 2013)

with Ceri Levy, *Nextinction* (London: Bloomsbury, 2015)

with Ceri Levy, *Curious Critters* (London: Bloomsbury, 2017)

More BOOKS illustrated by Ralph STEADman

Frank Dickens, *Fly Away Peter* (London: Dennis Dobson, 1964, 1967; reprint,
London: Anova Books, Pavilion Children's, 2008)

Mischa Damjan, *Das Eichhorn und das Nashörnchen* (Zurich: NordSüd Verlag, 1964)

————————— , *The Big Squirrel and the Little Rhinoceros* (translation of above, New
York: W. W. Norton, 1965; reprint, London: Anova Books, Pavilion Children's, 2009)

————————— , *Die Falschen Flamingos* (Zurich: NordSüd Verlag, 1967)

————————— , *The False Flamingoes* (translation of above,
London: Dennis Dobson, 1967)

————————— , *The Little Prince and the Tiger Cat* (New York: McGraw-Hill, 1968)

————————— , *Two Cats in America* (London: Longman Young Books, 1970)

————————— , [Dimitri Sidjanski,] *Cherrywood Cannon*
(London: Paddington Press, 1978)

Daisy and Angela Ashford, *Love and Marriage*
(London: Rupert Hart-Davis, 1965; new edition, Oxford Paperbacks, 1982)

The Penguin Private Eye (London: Penguin 1965)

Daisy Ashford, **Where Love Lies Deepest** (London: Rupert Hart-Davis, 1966)

Randolph Stow, **Midnite: The Story of a Wild Colonial Boy**
(London: Macdonald, 1967)

Lewis Carroll, **Alice in Wonderland** (London: Dennis Dobson, 1967)

——————— , **Through the Looking-Glass and What Alice Found There**
(London: MacGibbon & Kee, 1972)

——————— , **The Hunting of the Snark: An Agony in Eight Fits**
(London: Michael Dempsey in association with Studio Vista, 1975)

——————— , **The Complete Alice & The Hunting of the Snark**
(London: Jonathan Cape, 1986)

Tariq Ali, **The Thoughts of Chairman Harold** (London: Gnome Press, 1967)

Fiona Saint, **The Yellow Flowers** (London: Dennis Dobson, 1968)

Richard Ingrams, **The Tale of Driver Grope** (London: Dennis Dobson, 1969)

Tony Palmer, **Born Under a Bad Sign**, foreword by John Lennon
(London: William Kember, 1970)

Kurt Baumann, **Der Schlafhund und der Wachhund** (Zurich: NordSüd Verlag, 1972)

——————— , **Dozy and Hawkeye** (translation of above.
London: Hutchinson, 1974)

Jane Deverson, **Night Edge: Poems** (Bettiscombe, Dorset: Bettiscombe Press, 1972)

Ted Hughes, **In the Little Girl's Angel Gaze** (London: Steam Press, 1972;
limited edition of 50 signed copies)

——————— , **The Threshold** (London: Steam Press, 1979; limited edition of
100 signed copies; 25th anniversary edition, 2004, 75 signed copies)

Edward Lucie-Smith, **Two Poems of Night** (London: Turret Books, 1972)

——————— , **The Rabbit** (London: Steam Press, 1973)

Hunter S. Thompson, **Fear and Loathing in Las Vegas: A Savage Journey to the Heart
of the American Dream** (New York: Random House, 1972; London: Paladin, 1972)

——————— , **Fear and Loathing on the Campaign Trail '72** (San Francisco:
Straight Arrow Books, 1973; London: Flamingo, 1994)

Flann O'Brien, **The Poor Mouth (An Béal Bocht). A bad story about the hard life**
(London: Hart-Davis MacGibbon, 1973)

John Letts, **A Little Treasury of Limericks Fair and Foul** (London: André Deutsch, 1973)

Bernard Stone, **Emergency Mouse** (London: Andersen Press, 1978)

——————— , **Inspector Mouse** (London: Andersen Press, 1980)

——————— , **Quasimodo Mouse** (London: Beaver Books, 1984)

Alan Sillitoe, **Israel** (London: Steam Press, 1981, limited edition)

Adrian Mitchell, **For Beauty Douglas: Adrian Mitchell's Collected Poems**,
1953–1979 (London: Allison & Busby, 1982)

——————— , **Heart on the Left. Poems 1953–1984**
(Newcastle upon Tyne: Bloodaxe Books, 1997)

——————— , **Who Killed Dylan Thomas?** (Swansea: Ty Llen Publications, 1998)

——————— , **Tell Me Lies** (Newcastle upon Tyne: Bloodaxe Books, 2009)

Hunter S. Thompson and Ralph Steadman, **The Curse of Lono**,
(London: Picador, Pan Books, 1983)

Wolf Mankowitz, **The Devil in Texas** (London: Robert Royce, 1984)

Robert Louis Stevenson, **Treasure Island**
(London: Harrap, 1985; New York: Harcourt Brace, 1985)

George Orwell, **Animal Farm** (London: Secker & Warburg, 1995)

Roald Dahl, **The Roald Dahl Treasury** (London Jonathan Cape, 1997)

——————— , **The Mildenhall Treasure** (London: Jonathan Cape, 1999)

Ambrose Bierce, **The Devil's Dictionary**, introduction by Angus Calder
(London: Bloomsbury, 2003)

Ray Bradbury, **Fahrenheit 451**, 50th anniversary edition
(Los Angeles: Graham, 2005; limited edition of 451 copies)

Will Self, **Psychogeography** (London: Bloomsbury, 2007)

——————— , **Psycho Too** (London: Bloomsbury, 2009)

NEWSpapers and magaZINES

*Ambit, Aspect, Black Dwarf, Daily Mail, Daily Mirror, The Director, Esquire,
Gay News, GQ, Guardian, Illustrated London News, Illustrators, Independent,
Information Research Magazine* (Pentagram)*, J.D. Journal, Knave, Los Angeles
Times, Management Today, New Musical Express, New Society, New Statesman,
New Yorker, New York Times, Observer, Oui, Oz, Penthouse, Playboy, Private
Eye, The Progressive, Punch, Radio 3 Magazine, Radio Times, Rocky Mountain
Magazine, The Rebel, Rolling Stone, Running, Running Man, Saturday Night*
(Toronto)*, Scanlan's Monthly, Scotland on Sunday Magazine, Scotsman, South,
Sunday Times Magazine, Swill, Tatler, Telegraph Sunday Magazine, Time Out,
The Times, Times Higher Education Supplement, Town, Viz, Weekend Magazine*
(Toronto)*, Zeit Magazin, Zoom*

Ralph STEADman MISC

Plague and the Moonflower – An Oratorio by Richard Harvey
with Libretto by Ralph Steadman, 1989
(CD with artwork by Steadman, Altus Records ALU0001, 1999)

Oddbins wine catalogues 1987–2000

Solo EXHIBITIONS

1968	Bath Gallery (Denzil Walker): *Alice* drawings
1969	Tib Lane Gallery, Manchester
1972	V&A, London: Francis Williams Award for Illustration show
1974	The Puck Gallery, New York: *America* drawings
1977	National Theatre, London: *The Show: 15 Years of Drawings*
1983	Royal Festival Hall, London: *I, Leonardo* drawings
1984	Royal Festival Hall, London: *Between the Eyes*
1986	Royal Festival Hall, London: *Alice and the Paranoids*
1988	Wilhelm Busch Museum, Hannover: *Visagen und Visionen*
1990	October Gallery, London: *Red Alert*
1992	Royal Festival Hall, London: *The Grapes of Ralph*
1993	Galerie Kramer, Hamburg: print exhibition
1993	Peacock Gallery, Aberdeen: *Acid and Ink*
1994	Aberdeen Art Gallery: *More Acid and Ink*
1995	Bill Havu Gallery, One on One, Denver: *Writers and Leaders*
1998	Croydon Clocktower, Surrey: *Devious Devices*
1998	Bethnal Green Museum of Childhood, London: selected works from *Alice*
1998-1999	Kent County Council: *Animal Farm* touring exhibition
1999	Maidstone County Gallery, Kent: *Aria/Leonardo*
2000	William Havu Gallery, Denver: *Making a Mark*
2006	Art Institute of Boston: *Drawing Breath*: *A Retrospective Whisper from Ralph Steadman*
2013	Cartoon Museum, London: *STEADman@77*
2013-2015	Touring exhibition, Halifax, Maidstone, Winchester: *STEADman@Once*
2016	Society of Illustrators, New York: *Ralph STEADman: A Retrospective*

TV, film and audio DOCUMENTARIES

Michael Dibb (director), ***Arena: Art & Design – Ralph Steadman***
(BBC TV, 1977)

——————— , ***The Lively Arts: Seeing through Drawing*** (BBC TV, 1978)

——————— , ***Don't Tell Leonardo*** (3rd Eye Production, Channel 4 TV, 1983)

Nigel Finch (director), ***Fear and Loathing on the Way to Hollywood***
(*Omnibus*, BBC TV, 1978)

Desert Island Discs (interview with Sue Lawley, BBC Radio 4, 2 August 1998)

Alex Gibney (director), ***Gonzo: The Life and Work of Dr Hunter S. Thompson***
(US: HDNet Films, 2008; DVD includes an extended interview with Steadman)

The Gonzo Tapes: The Life and Work of Dr Hunter S. Thompson
(Shout! Factory, 2008. Five-CD box set of Thompson's recordings)

Charlie Paul (director), Lucy Paul (producer), ***For No Good Reason***
(Itch Film, 2012; animated sequences by Kevin Richards)

AWARDS

1972	Francis Williams Illustration Award for *Alice in Wonderland*
1977	Designers & Art Directors Association Gold Award for outstanding contribution to illustration
1979	Merit Award and Illustrator of the Year from American Institute of Graphic Arts
1986	Black Humour Award, France
1987	W. H. Smith Illustration Award for *I, Leonardo*
1987	BBC Design Award for *Maybe Twice in a Lifetime* series of postage stamps
1987	Italian Critica in Erba Award for *That's My Dad*
1991	XIX Premio Satira Politica Prize, Forte dei Marmi, Italy
1992	Vlag en Wimpel Prize, Netherlands for *Quasimodo Mouse*
1993	Kent Institute of Art & Design (KIAD) Fellowship Award
1995	Honorary D. Litt., University of Kent
2007	Cartoon Art Trust Lifetime Achievement Award

The OFFICIAL Ralph STEADman WEBSITE

www.ralphsteadman.com

overleaf: **Spirit of Gonzo**
1978
Ink on paper

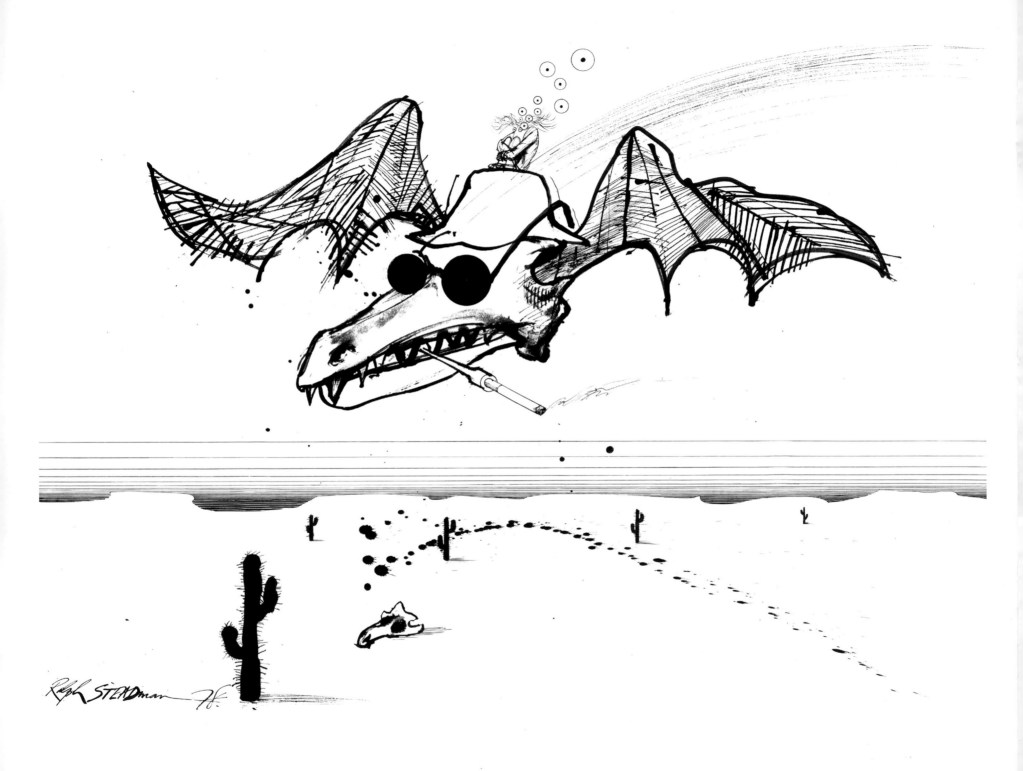